About the Author

Haje Jan Kamps graduated with a degree in International Journalism from Liverpool John Moores University, and resolutely decreed he would never work in journalism again. Instead, he started working as a freelance photographer and writer. As part of his company, Haje founded www.photocritic.org. The Web site became one of the most-visited photography blogs when one of his creations — a macro extension tube made out of a Pringles can — spread rapidly over the Internet via blogs and news Web sites.

A couple of years later, Haje decided that he preferred keeping photography as a hobby. Naturally, he started a career in journalism. Haje currently works as an editor for an automotive magazine and lives in Bristol, England. When he is not working, writing, or taking photos, Haje sleeps because there isn't a lot of time left in the day.

Credits

Acquisitions Editor
Kim Spilker

Senior Project Editor
Cricket Krengel

Project Editor
Linda A. Harrison

Technical Editor
Michael D. Sullivan

Copy Editor
Liz Lamoreux

Editorial Manager
Robyn Siesky

Vice President & Group Executive Publisher
Richard Swadley

Vice President & Publisher
Barry Pruett

Business Manager
Amy Knies

Book Designers
LeAndra Hosier
Tina Hovanessian

Project Coordinator
Adrienne Martinez

Graphics and Production Specialists
Jonelle Burns
Jennifer Mayberry
Barbara Moore
Shelley Norris
Amanda Spagnuolo

Quality Control Technician
Cynthia Fields

Cover Design
Daniela Richardson
Larry Vigon

Proofreading and Indexing
Shannon Ramsey
Broccoli Information Management

Bicentennial Logo
Richard J. Pacifico

MACRO PHOTOGRAPHY
PHOTO WORKSHOP

Haje Jan Kamps

Macro Photography Photo Workshop

Published by
Wiley Publishing, Inc.
111 River Street
Hoboken, NJ 07030-5774
www.wiley.com

Copyright © 2007 by Wiley Publishing, Inc., Indianapolis, Indiana

Published simultaneously in Canada

ISBN: 978-0-470-11876-4
Manufactured in the United States of America

10 9 8 7 6 5 4 3 2 1

Acknowledgments

This book might never have existed without the help from several people. First and foremost, the priceless input and contributions from the photographers who became involved with the project: Hilary Quinn, Amy Lane, Miha Grobovsek, Chris Nering, Katharina Butz, Matthieu Collomp, and Jasmin Junger. The encouraging words and kind cooperation from Allan Teger were invaluable. Anna Badley suffered through many of the chapters in their early guises, and without her contributions and insights, this book would have been a lot less helpful. Also, a special thanks to Daniela Bowker for help, encouragement, proofreading, and the best lasagna known to man.

Hielke, Lizeth, Chris, Ashley, Matt, Elena, and the whole FC team: Thank you for your patience and for offering distractions when they were needed the most.

A big thank you to Linda Harrison, Liz Lamoreux, and Michael D. Sullivan for your work in developing, copy editing, and tech editing: The book is much better for your input.

Finally, Kim, Cricket, and Laura: I couldn't have handpicked a better team to support me throughout the process of writing my first book if I had tried. It's been a privilege working with you. Thank you.

For Shuu-shuu.

Foreword

After 10 years of helping photographers hone their skills on photoworkshop.com, I'm thrilled to present this new line of books in partnership with Wiley Publishing.

I believe that photography is for everyone, and books are a new extension of the site's commitment to providing an education in photography, where the quest for knowledge is fueled by inspiration. To take great images is a matter of learning some basic techniques and "finding your eye." I hope this book teaches you the basic skills you need to explore the kind of photography that excites you.

© Photo by Jay Maisel

You may notice another unique approach we've taken with the Photo Workshop series: The learning experience does not stop with the books. I hope you complete the assignments at the end of each chapter and upload your best photos to www.wpsbooks.com to share with others and receive feedback. By participating, you can help build a new community of beginning photographers who inspire each other, share techniques, and foster innovation and creativity.

Contents

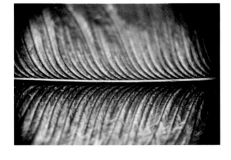

CHAPTER 3 Lighting in Macro Photography **49**

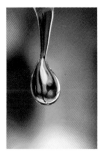

CHAPTER 4 The Macro in Everyday Objects

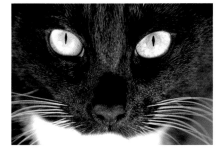

CHAPTER 9 People

CHAPTER 10 The Digital Darkroom

Introduction

The fascination photographers have for macro photography is similar to the obsession astrologers have with the sky above: There is a vast unknown to be discovered. You don't necessarily need the most expensive equipment, but you do have to go looking for it.

Look around you. Can you see anything worth having a closer look at? If your answer is no, you might not be looking hard enough. Don't worry, that is one of the things this book will help you with. In addition to giving you the tools, the theory, and the skills you need to be able to take good up-close photos, I hope the photos in this book inspire you to the point that your shutter-finger twitches like that of a gunslinger outside a saloon at high noon.

Throughout this book, I touch on all the aspects of macro photography. After a brief introduction, I jump straight into the equipment you need to work on macro photography. I talk about lighting for a while before getting into the proper photography stuff. Everyday objects, flowers, and insects are popular topics in macro photography, so I've given them a chapter each to really get your creative juices flowing. My personal favorites are photographing textures and abstract objects, so there are chapters on those topics as well, along with an interesting section about how you can use macro photography to capture the human body!

Finally, I show you how you can use digital image-editing techniques to fix small problems with your photos, and there are lots of tips on how to make your photos stand out more. If you still haven't had enough of macro photography (and why would you—it's a fantastic field well worth exploring), I've created a list of other resources you might want to look at in Appendix A.

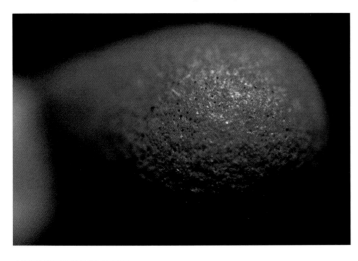

ABOUT THIS PHOTO *This photo of a match-head was taken with an extension tube I made myself out of an empty Pringles can. It was the birth of an obsession: macro photography.*

Throughout this book, I might use some photography slang and jargon. If you find yourself struggling at any point, leaf to the back of the book, where I've compiled a glossary with words you might have trouble with. Learn them all by heart, and you can impress everyone at your local photography club with random technical terms!

Use this book as a technical guide and source of ideas and inspiration. However, don't ever let it tell you what to do. Amazing photography springs from photographers who know all the rules, but break them for good reason.

Grab a camera and some macro tools, then get out there and break some rules.

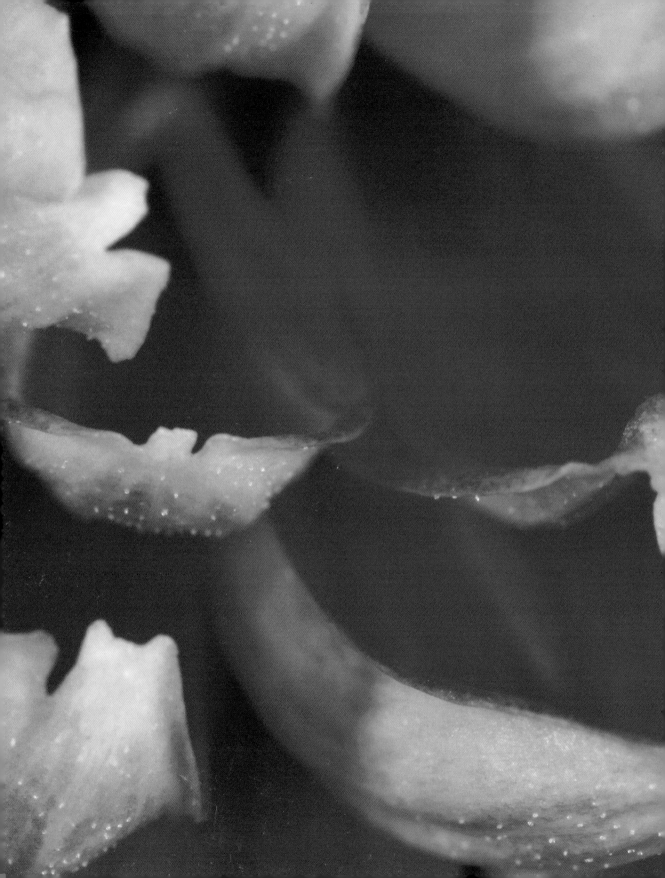

FIRST STEPS INTO A MACRO WORLD

You have purchased a camera, and you are ready to explore the world of tiny subjects, details, and small things. There is a whole new world out there to be explored, with a vast number of exciting opportunities. Everywhere around you there are fascinating patterns, shapes, and items that look amazing if you get close enough.

By the end of this chapter, you will have your first tastes of macro photography, you will understand some of the theory behind it, and you will see some astounding photos that give you something to aim for as you start honing your macro photography skills.

WHAT IS MACRO PHOTOGRAPHY?

Macro photography is the art of taking pictures of subjects up close. Some photos might be of relatively large things — such as a hummingbird or a large flower — and others might be of minuscule objects, such as the compound eye of a fly. However, macro photography isn't just about taking pictures of small things; it can also be detail shots of bigger subjects. In fact, some of the photos in this book are detail photos of skyscrapers!

To many macro photographers, taking pictures is about capturing phenomena, items, and events that cannot easily be seen with the naked eye. A droplet falling onto a plate (see 1-1), a hummingbird in flight (see 1-2), or bubbles rising up in a glass of champagne can be seen every day; but, unless you freeze their motion, it is impossible to fully appreciate their beauty or study them in detail. The delicate structure of a bubble or the intricate detail of an orchid might remain forever mysterious to us.

x-ref Capturing a droplet as it hits a surface is one of the extremely specialized branches of macro photography. It isn't easy, but it's worth a try; you will be amazed at what you can capture. Learn more about photographing everyday objects — including falling droplets — in Chapter 4.

If you are curious about the technical definition of a macro photograph, that is a grayer area. Historically, the definition was that the image had to be on the scale of 1:1 on the negative. This means that if you took a picture of a coin, you could put the coin on the developed negative, and the picture of the coin was exactly the same size as the coin.

Some sources claim that to be considered a macro photograph, the subject has to be the same size as — or larger than — its reproduction in print, as illustrated in 1-3. In other words, when you have your images printed, the prints you receive have to be a 1:1 reproduction of the coin. To me, this seems a bit impractical, because almost any photo you take can be a macro photo: You just need to enlarge the negative.

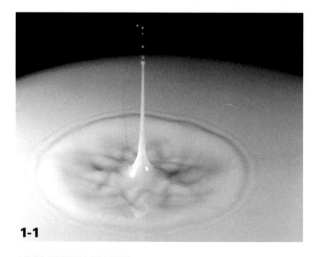

1-1

ABOUT THIS PHOTO *This photo of milk falling into a saucer was lit with 2x500W floodlights. Taken with a Canon 135mm f/2.8 Soft Focus prime lens. 1/4000 sec., f/3.5 at ISO 100.*

Ultimately, the definition of macro photography has changed over time — and digital technology has changed it even more. Macro photography has morphed into the act of taking pictures of small areas of a larger subject or of small subjects. That is as good a definition as any. I'm not here to split hairs; I'm in the business of taking pictures of them.

It is important to remember that anything can become a macro subject. Although two of the most eye-catching areas of macro photography are insects and flowers, you can explore many other subject options up close. The textures and shapes of foodstuffs, for example, might make an interesting theme for a macro photography project. Different fabrics, types of paper, animal furs,

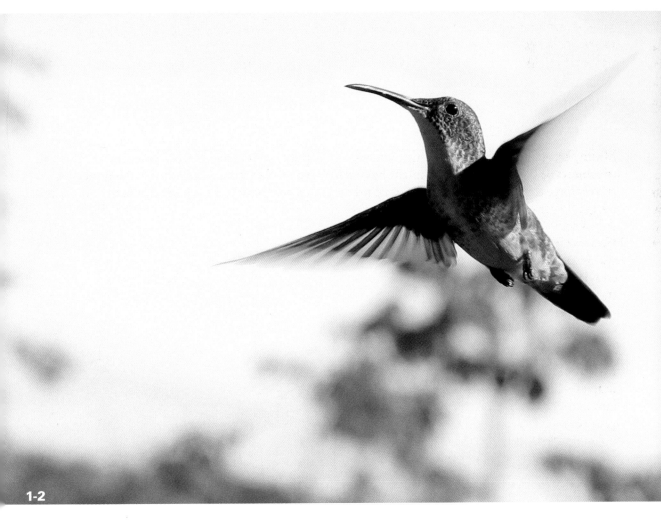

1-2

ABOUT THIS PHOTO *Hunting hummingbirds wins two prizes: Most rewarding and most frustrating photograph ever. It isn't impossible; it just takes a lot of patience and practice. Taken with a Canon 50mm f/1.8 mkII prime lens. 1/500 sec., f/6.3 at ISO 200.*

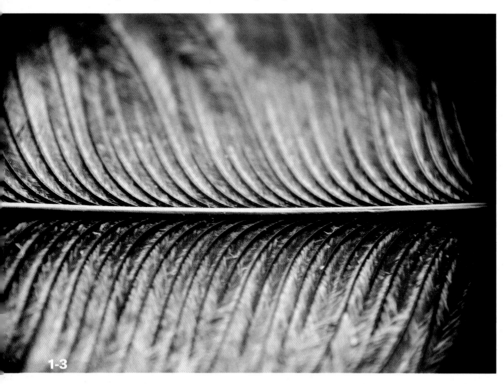

1-3

mechanical objects, and even the human body can make for exciting exploration.

Have you ever flown in an airplane over your own house and looked down, only to realize how different everything looks from a distance? You have that same kind of perspective when you get into macro photography — the world can be observed from an entirely different perspective, and the rules of how you see things drastically change. The wristwatch you have worn for five years, and look at every day, might be a patchwork of fascinating, fine scratches, beautiful materials, and intricate reflections — and that's just on the outside. The inside harbors a wide array of small cogs, levers, and springs, or a collection of exciting electronic components.

Teaching yourself to see macro photography opportunities everywhere you look is half the battle in finding the most rewarding photos. It is quite satisfying to have friends look long and hard at a photo on your wall, say they love the look of it, but admit they don't know what it is. The stunned look on their faces after you explain what they are looking at is priceless.

THE CHALLENGE OF MACRO PHOTOGRAPHY

Taking photos of small areas of larger subjects, of tiny subjects, or of small items is a rather refreshing approach to photography. Landscapes and portraits are great, of course, but you can see plenty of people nearly everywhere you go, and if you want landscapes, you can go for a walk in the countryside. In addition, you can choose to reinterpret these classic themes as macro photos.

You can't express the grandeur of a landscape as a macro photograph, but you can pick out details representative of where you are, as illustrated in 1-4. Portraiture can be done with an up close twist on things, too, commonly by photographing someone's eye (see 1-5), but as with other photography, only your imagination limits your ideas.

Macro photography is challenging because many of the rules that apply to other branches of photography are meaningless when you start getting close enough for the results you want. If you want to partake in extreme macro photography, you end up very close to your subjects. In many cases, such as when photographing insects, you might find that your lens practically touches what you are trying to photograph, which creates a variety of challenges that do not occur in other types of photography.

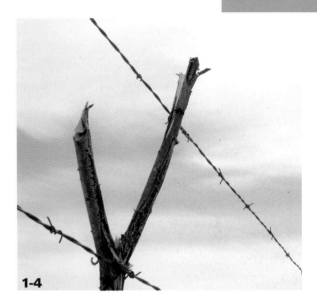

1-4

ABOUT THESE PHOTOS *Figure 1-4 is an example of a landscape in macro form. The connotations of barbed wire give it a sinister feel. Taken with a Canon 28-135mm f/3.5 macro lens. 1/350 sec., f/3.5 at ISO 100. In figure 1-5, the dramatic circular shapes make a striking photograph. Taken with a Canon MP-E 65mm f/2.8 macro lens and a MT-24EX macro Twin Lite flash. 1/125 sec., f/16 at ISO 100. Photo by Daniela Bowker.*

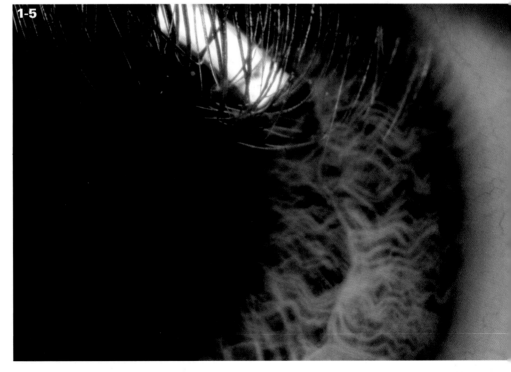

1-5

FOCUS AND DEPTH OF FIELD

Focusing is one of the biggest challenges you encounter in macro photography. To get sharp photos, your focusing has to be accurate, because the closer you are to your subjects, the lower your *depth of field (DOF)*. A low DOF means that only a limited depth of your image is in focus. See 1-6 for an example of a photo that demonstrates the limited DOF you have in macro photography.

x-ref | Find out everything you need to know about macro photography equipment in Chapter 2.

A high DOF means that a lot more of your photograph is in focus. For macro purposes, limited DOF means that the amount of your subject that is in focus is drastically lower than if you were to take portrait photos, for example.

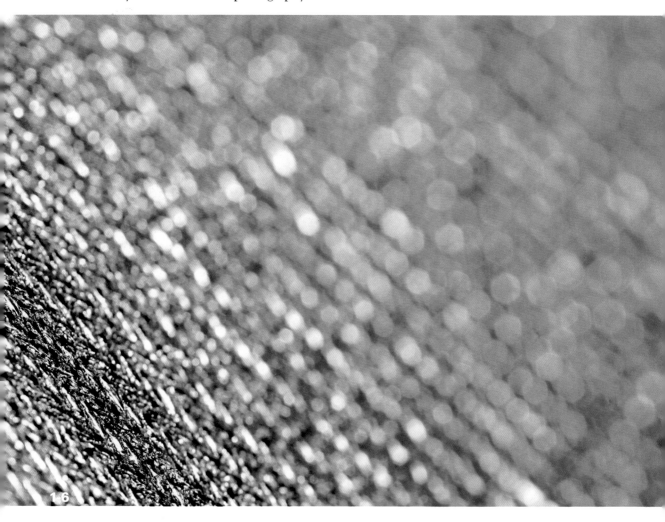

ABOUT THIS PHOTO *A brushed metal surface shows how rapidly an image falls out of focus. The area in focus is less than a millimeter wide. Taken with a Canon MP-E 65mm f/2.8 macro lens and a MT-24EX macro Twin Lite flash. 1/125 sec., f/5.6 at ISO 100.*

In addition to a limited DOF, most methods of taking macro photographs render the focusing ring on your lenses useless. With few exceptions, if you're going in close enough, you have to focus by moving your whole camera closer to — or farther away from — your subject. This does take a bit of practice, but it isn't nearly as difficult as it sounds. There are a few things that help you focus better. For example, a sturdy tripod with a macro focusing rail makes the process infinitely easier because you can make minute changes to your focus, evaluating as you go.

LIGHTING

When working with macro photography, lighting is a serious challenge. Getting in close to your subject is easy if you use the right combinations of equipment, but generally, you lose a lot of light in the process. This means that you must use longer shutter times. When you consider how sensitive macro photography is to focusing and movement of the camera, the subject, or both, these longer shutter times can present a problem. One solution is to use artificial lighting, as was done in 1-7.

When your camera is very close to what you are photographing, much of the light you need is blocked out, just when you need it the most. You can help this by making the best of available light. Using *reflectors* to guide the light where you want it, using *diffusers* to make the light more omni-directional, and reducing shadows and fill-flash can help you get extra light where you want it. Finally, it is possible to do macro photography in a studio where you have full control over all the light, for maximum flexibility.

1-7

ABOUT THIS PHOTO *By photographing in a studio with carefully controlled lights, you can create stunning images. Taken with a Canon EF-S 60mm f/2.8 macro lens and two external flashes. 1/200 sec., f/7.1 at ISO 100. Photo by Matthieu Collomp.*

x-ref In Chapter 3, I walk you through the possibilities and challenges of the light surrounding your photos. I also provide you with tips on how you can corral both the ambient light and artificial light to your advantage for the best results with your macro photos.

OTHER CHALLENGES

There are dozens of little obstacles you are likely to come across as you become more active and proficient at macro photography. Lens choice, filter use, which tripods are most suitable, choice of ISO, how to capture moving insects, use of reflectors, and the best way to enhance your photos digitally after they are captured are all examined in this book, either in Chapter 2, which deals with equipment, or in the chapter relevant to what you are photographing: flowers in Chapter 5, insects in Chapter 7, and so on.

The people around you might think you are becoming a bit loony because you are constantly exploring seemingly normal objects and getting terribly excited about things that your friends fail to understand — until they see the results of your endeavors, of course. See 1-8 for an inspiring example of making all the right choices.

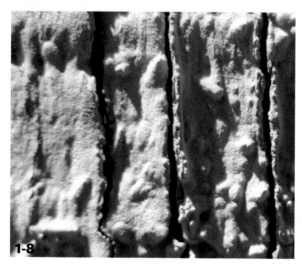

1-8

ABOUT THIS PHOTO *The dried out texture of old paint was lit by sunlight from one side. Using a reflector on the right side significantly lifted the shadows. Taken with a Canon 28-135 f/3.5 IS macro lens. 1/200 sec., f/8 at ISO 100.*

CAN I AFFORD TO BE A MACRO PHOTOGRAPHER?

There is no doubt that photography can be costly — it seems that there is no end to the gadgets you can purchase for your camera. However, macro photography doesn't have to cost you a week's wages; it can be as affordable or expensive as you want it to be. It is perfectly possible to take stunning photographs — like 1-9 — without incurring any cost at all! This photo was taken by reversing a lens: holding it back-to-front against the camera body.

If you have a compact digital camera, you already have everything you need to get started. Most compact digital cameras have a macro mode, which allows you to get in close without any additional equipment.

If you have *digital single lens reflex (dSLR)* camera body, you have more options when taking macro shots. You can start taking macro photos right now without investing more money. In addition, only your imagination and your budget limit how close you can get to your subjects.

Assuming you already have a digital camera of some description, you don't have to invest a lot of money to be able to enjoy macro photography; at least until you decide if you want to specialize further in this photography genre.

(p) x-ref Find out how and why holding a lens back-to-front against the camera body is a cheap way of trying macro photography in Chapter 2!

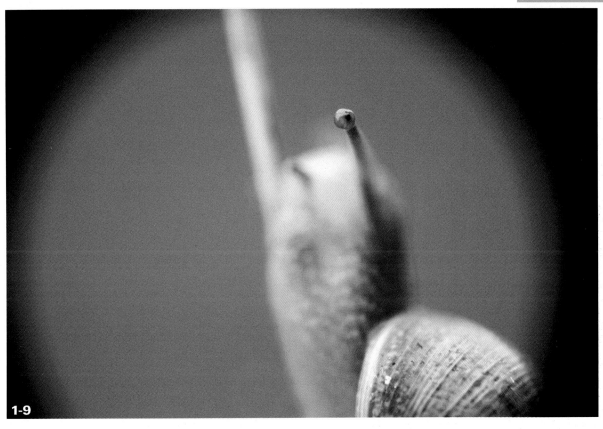

1-9

ABOUT THIS PHOTO *Getting this close doesn't have to cost you anything. This photo was taken by holding a Canon 50mm f/1.8 lens front-first against the camera body. 1/500 sec., f/1.8 ISO 250. Photo by Hillary Quinn.*

Generally, the more you want to magnify a subject, the more it costs you. You should be able to get 1:2 reproductions (meaning half life size) without spending any money. It might not sound like much, but even at this magnification, you can take stunning photos of most things, including flowers and insects (see 1-10).

If you want to get in closer than 1:2, you start to look at spending some money, but getting to 1:1 and even 2:1 (life size and twice life size) is relatively easy and doesn't have to break the piggybank. Getting beyond twice life size is where

real costs start occurring, but there are also ways around many of the costs, including using some inexpensive techniques, making some of the equipment yourself, and minimizing the cost of the equipment you select.

Although there are ways to get up close with a compact digital camera, if you are serious about macro photography, you should consider investing in a dSLR. The design of a dSLR system makes attaching, modifying, and experimenting with different lenses, attachments, and accessories easier.

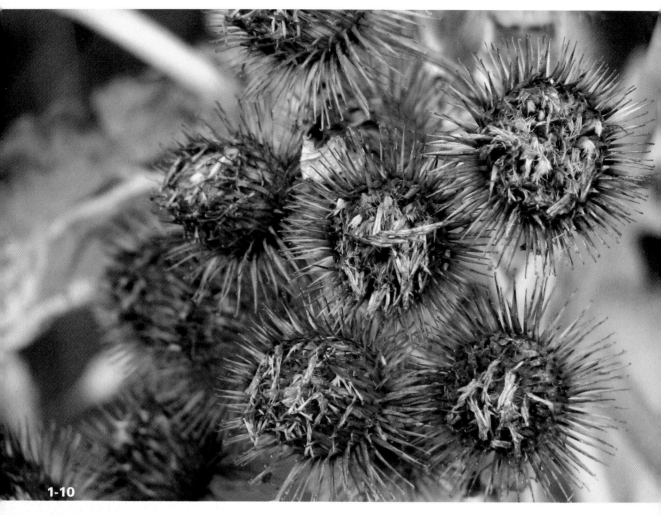

1-10

WHY ANYONE CAN TAKE GREAT MACRO PHOTOGRAPHS

Macro photography is not entirely unlike playing chess: The rules are relatively simple to learn, but even if you know the rules, you are no match to Kasparov or Bobby Fischer. The great thing about macro, however, is that everything you photograph up close looks quite unusual. Even technically imperfect photos can have a high impact because you show the world in a different way.

Macro photography isn't about having the best equipment, having the most expensive camera, having access to a studio, or being able to afford to pay expensive models to pose for you. After you have learned the basics and managed to get the hang of the techniques required to get the photos, it is all in your own hands. Spotting a photo opportunity is not something you can learn from a book, it takes practice. I hope that the wide variety of examples shown throughout this book sets you on the right track and provides some inspiration.

Because there are opportunities everywhere you look, you can take macro photographs anywhere. Indoors or outdoors, when traveling or at home, whether you like to spend hours planning and setting up a shot or if you like to take a more spontaneous approach — such as grabbing a ball-point pen that happens to be on your desk as you write a book about macro photography (see 1-11) — there are always details that merit photographing, items that can be shown in a new light, and stunning photos to be found.

With the same curiosity of a child with a magnifying glass, the only thing that differentiates you and another macro photographer is how creatively you can think about photography. If you figure that the side of a freshly cut baguette looks interesting, then perhaps it is, and maybe the photo will turn out great. Moss in a forest? Berries hanging on a bush? A fine mist of hair spray on a drinking glass? The more you manage to think outside of the box, give in to your own creativity, and go against the grain, the more unique and interesting your macro photos become.

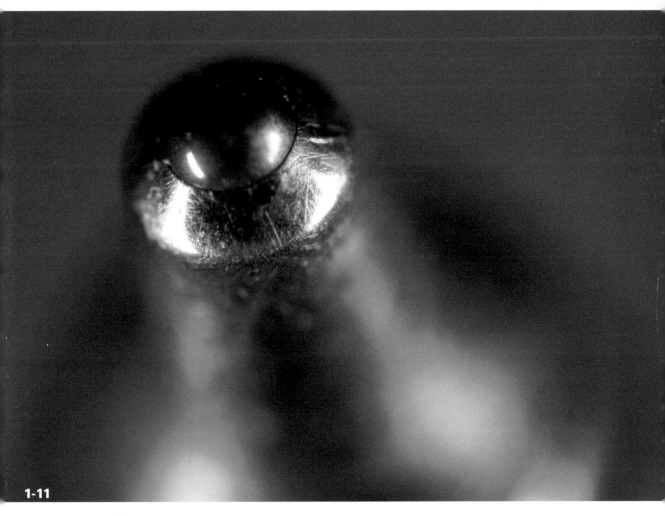

1-11

ABOUT THIS PHOTO *This ball-point pen illustrates how you can look closely at the items around you with stunning results. Taken with a Canon MP-E 65mm f/2.8 macro lens, and a MT-24EX macro Twin Lite flash. 1/60 sec., f/4.0 at ISO 100.*

TRY IT NOW

Your first attempts at taking macro photographs can be easy. In fact, grab your camera right now.

COMPACT DIGITAL CAMERAS

If you have never tried the macro mode on your digital compact, try it out now. On most cameras, there is a button or a dial somewhere on the camera that switches the setting to macro mode. The button is normally marked with a picture of a flower and a mountain. The mountain icon indicates that camera will focus at infinity, and the flower icon is an instruction to the camera to focus close to the lens.

ABOUT THIS PHOTO *The macro button on most compact digital cameras looks something like this. Taken with a Canon 50mm f/1.8 mkII lens reversed on 120mm bellows. 1/60 sec., f/1.8 at ISO 100.*

Try this easy exercise to get started.

1. **Dig a coin out of your pocket.** Coins are something that everyone is familiar with, so they are good objects for your first attempts.

2. **Hold your camera about two feet from your subject and press and hold the shutter button halfway down, so that your camera attempts to focus on the coin.** With most compact digital cameras, if the camera can focus, a green light illuminates on the back of the camera, indicating that the camera is focused and ready to take a photo.

3. **Now move a little bit closer, let go of the shutter button, and then press it halfway down again.** See how close you can get before the camera can't focus anymore. After you are so close that the camera can't find a focal point, move back slightly until you have found the closest focal distance of your camera. If you want to cheat, this is usually printed on the camera lens or in the documentation that came with your camera.

4. **Press the shutter all the way to take the photo.** Make sure to hold the camera very still as you do this, because even the slightest movement is likely to cause blurring of your photo.

5. **Admire your handiwork.** Examine the picture on the *LCD display* of your camera to see if the lighting is even, if the coin is properly in focus, and if you are happy with the composition. If you can find any flaws in the photo, go back to Step 2 and try again! You can see what I came up with in 1-13.

On some compact cameras, the macro mode works only when the camera is fully zoomed out, whereas others can focus up close throughout the whole zoom range. Check your camera's manual, or try both to find out how your camera reacts. If your camera can focus up close throughout the whole zoom range, you can zoom in even closer, allowing for bigger magnification.

Experiment with your camera, and get to know its up close capabilities. You might be pleasantly surprised about how good the macro mode on your camera is!

ABOUT THIS PHOTO *This Portuguese 50-cent coin was photographed with a digital compact camera in macro mode. 1/60 sec., f/2.8 at ISO 50.*

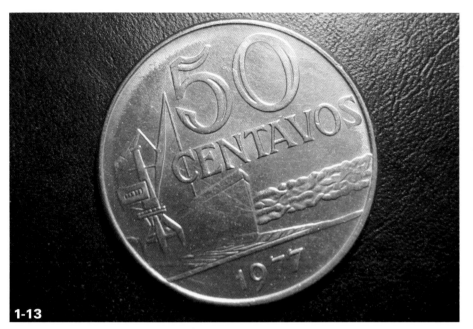

1-13

DSLR CAMERAS

If you have a dSLR camera, why not try and see how good your lens is at getting in close? The easiest way to find out is to put the camera into manual focus mode and set the focus to as close as possible. That means you turn the focus ring all the way away from infinity (which is usually marked as ∞ on most lenses). Now, see how close you can get to your subject and still have it in focus. When you reach this point, you have achieved the minimum *focal distance*.

If you are trying this with a zoom lens, attempt to get in close with the lens zoomed all the way in, as well as zoomed out. Different lens constructions mean that different lenses might have different characteristics while fully zoomed in or out. If you are lucky enough to already have a macro zoom lens, you should be able to focus up close on full zoom for maximum magnification.

1. **Find a postage stamp.** Because everybody is familiar with stamps, it means it is easy to relate to them as macro subjects: Seeing a shot of the tiny details made by the printing press is a good way to show exactly how close you can get.

2. **Select a lens and inspect the focusing ring to find out how close you should be able to get.** Most lenses have markings on them that show where the focal points of the lens are. These are normally shown as a scale on the focal ring itself and range from infinity (shown as ∞ on most lenses) to the minimum focal distance.

ABOUT THIS PHOTO *For this image I tried several different lenses before I settled on using a reversed 50mm lens, holding it against the camera body. Taken with a Canon 50mm lens, f/1.8, 1/200 sec., f/1.8 at ISO 100.*

3. **Set your lens into manual focus and turn the focusing ring all the way away from infinity.** This ensures that your lens is set to the closest possible focal range.

4. **Align your camera with the coin and hold your camera at the closest focal distance.** The focal distance of a dSLR is measured from the imaging sensor, rather than from the front end of the lens. Most cameras have the focal plane marked on the camera body, usually as a small circle with a longer line through it, which runs parallel with your lens. Don't worry about actually measuring this distance — just guesstimate. Then move your camera closer or farther away until your coin is in perfect focus. This is the closest you can get with this particular lens.

5. **Take the photo.** With your subject in perfect focus, carefully press the shutter button. See 1-14 for my result. Any camera shake at this point will translate into blurry photos, so be careful!

6. **Admire your handiwork.** Examine the picture on the LCD display of your camera to see if the lighting is even, if the coin is properly in focus, and if you are happy with the composition. If you're not happy, just try again.

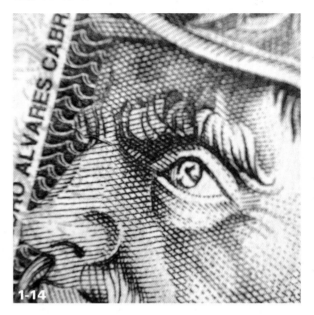

1-14

7. **Try it with all your lenses.** It is useful to know how your different lenses react up close when you are working with macro photography; this is a good time to experiment with all the lenses you have. You might be pleasantly surprised about some of your lenses and disappointed about others. However, after you know the capabilities of all your glass, you are better prepared to select lenses for exercises later on in the book!

Congratulations, you have just taken your first macro photo!

Assignment

Colors, Candy, and Cameras, Oh My!

You should now understand that macro photography is not necessarily about the equipment you have. Anyone from a compact digital camera owner to a dSLR owner with a fancy lens can take an unusual and interesting macro photo with a little imagination.

For this assignment, try your newfound talent out on creating a high-impact, colorful photo using Skittles, M&Ms, or a similar multi-colored candy. Be bold and try to find a way to make the photo different, standing out from anything you have seen before.

I have done some setup to get my image to work the way I want it to. You'll notice that I arranged the candies so that most of the warm-colored ones were in the background and a single lighter-colored one was in the foreground to catch the eye. For the lighting, I used a makeshift softbox and a flash on an off-camera cord. I took this photo with a Canon 28-135mm f/3.5 macro lens and a 24mm extension tube. The exposure was set to 1/250, f/3.5 sec. at ISO 100.

Don't forget to go to www.pwsbooks.com when you complete this assignment so you can share your best photo and see what other readers have come up with for this assignment. You can also post and read comments, encouraging suggestions, and feedback.

Macro photography is a specialized form of photography. In this chapter, I show you how you can take macro photos with your current equipment. However, if you want to get closer, you are going to need some extra equipment. The good news is that you don't have to spend too much money to get a good taste of macro photography. If you subsequently want to go farther in depth and discover more of the macro photography world, you can always invest in some of the higher quality (and more expensive) equipment.

MACRO ON A DIGITAL COMPACT CAMERA

Nowadays, you are most likely to first hear about macro photography when you pick up a digital compact camera. Most of these cameras have a macro function, which is usually identified with a flower icon.

On digital compact cameras, the macro function allows the camera to focus on subjects that are closer to the lens element than is possible without turning on the macro function. "Why bother?" I hear you ask, "Why not always allow the camera to focus closer?" There is some method to the madness. An auto focus camera automatically finds focus by searching through its *focal range* (the distances in which a lens can focus sharply on a subject) — much as you would if you were to focus manually. Interestingly, the macro function often provides images of good quality, as shown in 2-1.

To understand what the macro mode on a digital compact camera does, we have to take a look at the way focusing works. The focusing process starts at one end of the focal range, and then continues focusing until it finds the point with the

highest contrasts. This is how the camera decides when something is in focus. If there is a sharp difference in the *contrast levels* (amount of contrast), something is in focus. If there is none, the camera thinks it is looking at something blurry, and that the scene is out of focus.

After the contrast levels start going down again, the camera realizes it has gone past its *focus point*, the lens position where the subject is in perfect focus. The camera now starts focusing back toward the other extreme, and it continues this process until it determines where the focus point is. This does sound a bit complicated, but it happens quite quickly because the camera assumes that the object on which you are trying to focus is between 3 feet and an infinite distance away from the camera. In effect, the camera is saving time by not even looking for the correct focus really close to the camera.

If you do want to take a picture of something that is closer than 3 feet, you have to tell your camera by pressing the Macro mode button. It then switches modes, searches for the focal point close to your camera, and ignores all the distances far away. It seems like a complicated way of doing things, but you would be rather cross with your camera if it took 4 seconds to focus every time because it was searching for the correct focal distance.

CLOSE-UP FILTERS

Because digital compacts don't have interchangeable lenses, it means that the compact camera approach to macro photography is a little more limited than the approach you can take if you use a dSLR camera. Don't let this discourage you. There is a lot you *can* do to get up close and personal with the world around you.

ABOUT THIS PHOTO *The macro function built into many digital compact cameras can be powerful. Taken with a compact camera, 5 sec., f/2.7 at ISO 50. Photo by Amy Lane.*

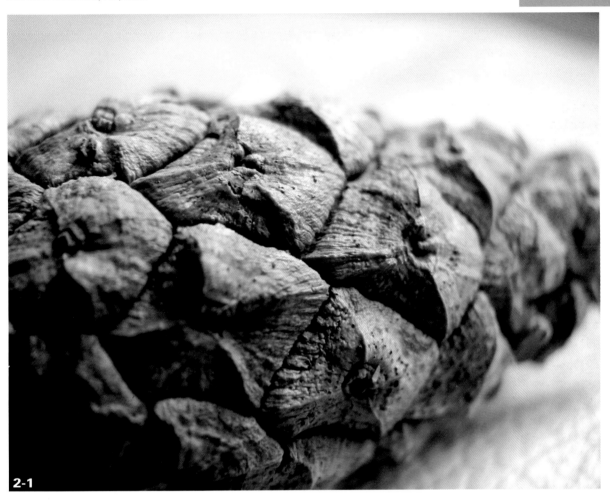

2-1

Apart from using the built-in macro functionality on digital compacts, the easiest thing you can do to improve your ability to take macro photos is to borrow or purchase some close-up filters (also known, incorrectly, as close-up lenses), as shown in 2-2. These items are called filters because they are screwed into the filter threads of a lens, but they aren't technically photographic filters. A *filter* changes something about the light that goes into the camera without altering its direction. The close-up filters actually bend the light, just like a lens. As such, a more correct name for them is close-up lenses.

> **ⓟ note** Technically, a close-up filter is rated in diopters, with the formula "1000mm / diopter rating." This means that a lens fitted with a 1x close-up filter can focus at the farthest to 1 m (1000mm). The maximum distance that a lens with a 5x close-up filter can focus down to is 1000mm / 5 = 200mm = 20 cm. To get in closer, you can just focus your camera at a closer focal distance or stack the filters.

2-2

Close-up filters work as a magnifying glass and allow you to focus more closely on a subject by bringing the entire focal range closer. If your digital camera has lens threading, you should be able to use these filters. If not, you can often add filter threading by using an adapter that slides onto the lens or clips onto the camera. Check with your camera manufacturer or your local camera store to find out if these threading adapters are available for your particular camera.

Close-up filters are generally available in *diopters* (magnification sizes) of 1x, 2x, 3x, 4x, 6x, and 10x. It is possible to stack several filters on top of each other for increased magnification. If you decide to stack close-up filters, make sure that you stack the largest magnification closest to the lens and continue in decreasing order of magnification. Image 2-3 is taken with two close-up filters stacked on top of each other, mounted on a threading adapter. The crystals are around a third of an inch across.

Optically, close-up filters are not nearly as good as a proper macro lens, and the results you get with them are often disappointing, compared to other techniques. Unfortunately, many of the techniques available to dSLR users — such as specialized macro lenses — aren't available to users of digital compacts. On the other hand, close-up filters are inexpensive, easy to take with you in the camera bag, and can serve as an inexpensive entry into the world of macro photography.

FILTER THREADS ON COMPACT CAMERAS If your compact camera doesn't have filter threads built-in, don't worry. You aren't the first photographer to be disappointed about this. People have found ways to attach filters and lenses. You can, of course, just hold the filters and lenses you want in front of the camera, but this is not a good solution. The front of your lens might scratch the filter, and you have to use two hands to keep the lens and filter together.

The best alternative is to use an *adapter tube*, which enables you to mount filters in front of your camera lens. These adapter tubes slide around the lens barrel of your camera and are secured by screwing into the tripod mount or by clipping onto the camera body somehow. After the adapter tube is attached to the camera, you can screw filters into the adapter tube.

Some manufacturers offer these types of tubes as part of their accessory catalog, whereas others are made by third-party manufacturers. A good camera store should be able to help you, but be aware that adapter tubes aren't available for all cameras.

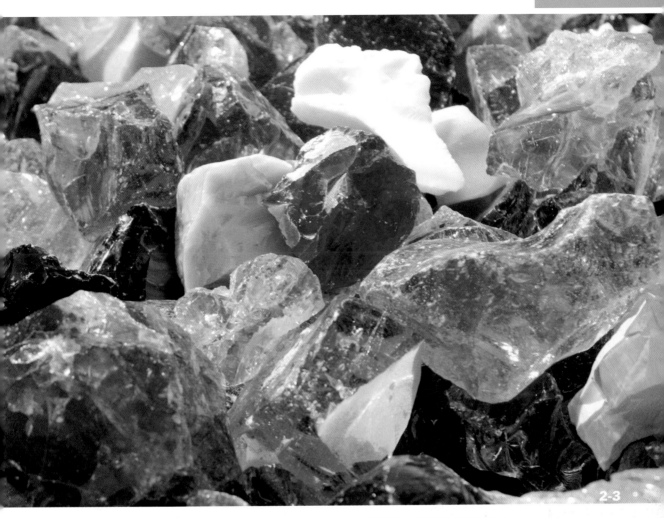

2-3

ABOUT THIS PHOTO *Colored crystals would have been difficult to photograph if I couldn't get close enough. Taken with a compact camera with a +3 and a +1 close-up filter fitted on a threading adapter. 1/90 sec., f/5.6 at ISO 100.*

 note If you're handy with a set of tools, you can always make your own. A piece of PVC piping combined with a filter ring (carefully break and remove the glass from an old filter), glue, and some rubber bands can be turned into an adapter tube. See www.pbase.com/sinoline/casio_adapter for an example.

ADDING LENSES TO A COMPACT CAMERA

By definition, compact cameras don't have interchangeable lenses; however, that doesn't mean all hope is lost. There are many photographers who take incredible macro photos using creative solutions with their compact cameras.

One way to get closer is to add lenses to the camera. In professional terms, this is known as *stacking lenses* and is achieved by attaching a

reversed lens to the lens that is already mounted on the camera. A *reversed lens* means that the front of the lens you are mounting is facing the front of the lens on the camera.

The great thing about stacking lenses is that you can use just about any lens as the reversed lens. The highest quality comes from using a *prime lens* (a non-zoom lens). For that reason, many photographers swear by them. Prime lenses can be found inexpensively in second-hand stores because serious photographers have moved on to shiny new digital SLRs and new lenses. That means that the second-hand market is flooded with perfectly fine prime lenses at low prices. If you go to your local second-hand camera shop, you can pick up an old Canon EF lens for about the same cost as a

decent lunch and a cup of coffee. Alternatively, you can use an online auction site such as eBay. If the lens has mechanical faults (for example, the focus ring doesn't work), even better. You can't use the focusing ring when working with reversed lenses anyway. If the glass elements on the lens are clean and scratch-free, you can bag yourself an incredible bargain. Photo 2-4, for example, is taken with a lens that has a defective aperture mechanism. I rescued it from the garbage can in a photography shop!

As a general rule, the wider the angle of the lens, the closer you can get to your subject. Using a reversed 28mm prime lens enables you to get closer than if you used a reversed 85mm prime. Experimentation is the key — don't hesitate to

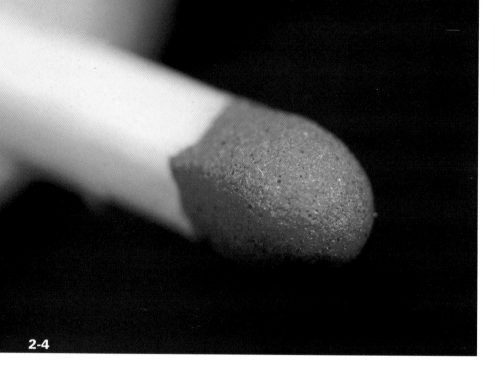

2-4

ABOUT THIS PHOTO
Reversing a lens on a compact camera allows you to get up close and personal with your surroundings — in this case, a match. Taken with a compact camera with a reversed 28mm prime held in front. 1/2 sec., f/5.6 at ISO 100.

go to a local camera shop and ask to try a few of their used camera lenses so you can get a feel of what works for you.

Now that you have your lens, all you need to do is to mount it back to front. To attach the lens to the camera, you can use a lens stacking adapter, known as a male-to-male coupling ring. This is a metal ring that has a male filter ring on both sides, allowing you to attach the camera lens as if it were a filter. It helps if the lens you are attaching to your camera is large, because you are likely to experience serious *vignetting* (light fall-off toward the edges of the frame) of your subject. Some photographers (such as Hillary Quinn, whose photos are scattered throughout this book) have made this vignetting part of their photographic

style with great effect — see 2-5 for an example. So, vignetting is not necessarily a bad thing.

To use this lens set-up, all you need to do is to zoom your camera in all the way on the optical zoom. You have to focus by moving your lens closer or farther away from the subject. Your camera might have problems focusing and might refuse to take photos. If this happens, use the macro/infinity button to set your camera to focus on infinity (that's the little mountain icon). This way, the camera ignores the focus and takes the photo anyway. If your camera has manual focus, try to get it to focus on the closest possible focal range — that way, you can get closer to your subject. Photo 2-6 illustrates how a good macro mode can help you create beautiful images.

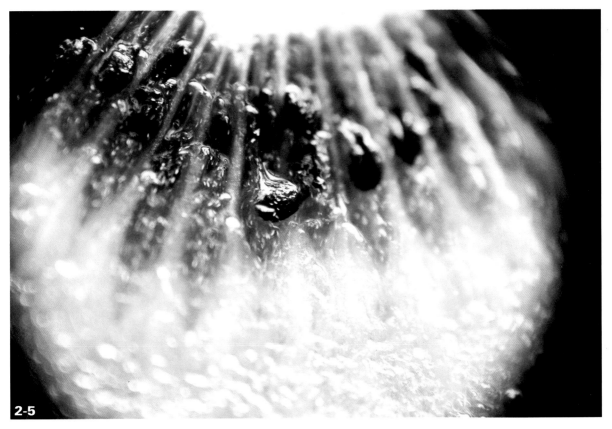

2-5

ABOUT THIS PHOTO *Photo of a kiwi fruit taken with a reversed lens. Note the vignetting. Taken with a compact camera with a reversed 55mm prime lens held in front. 1/125 sec., f/5.6 at ISO 400. Photo by Hillary Quinn.*

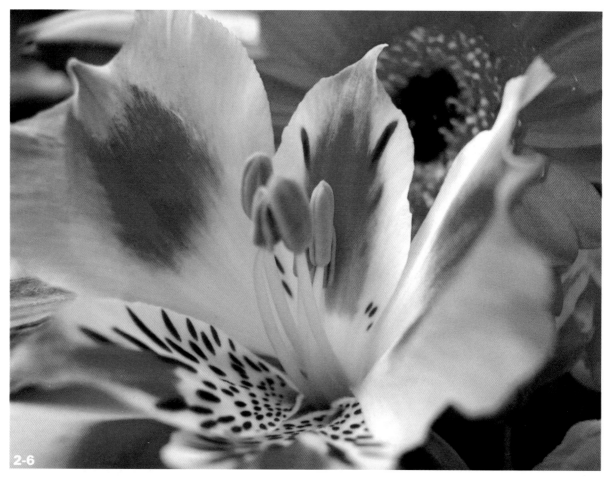

2-6

MACRO WITH A DSLR CAMERA

Digital Single Lens Reflex (dSLR) cameras have revolutionized the world of photography. Now affordable to amateur photographers, they provide all the flexibility of a traditional film SLR system, including interchangeable lenses of vastly higher quality than those on compact cameras, the possibility of using external flashes, and the better availability of accessories and tools to make taking photos easier and more creative.

The big question facing photographers is: "What brand of camera should I choose?" The two brands that instantly spring to mind are Canon and Nikon. The ongoing argument centers around Nikon being better at X, Canon having more Y, and nitpicking at silly little details. In all honesty, it does not matter which brand you choose. dSLR cameras are generally of extremely high quality. Ultimately, the decision on which camera to buy comes down to the photographer's preference more than the camera equipment used.

I chose Canon about 15 years ago. When my father gave me my first camera, a Canon A1 SLR, it was the start of a life-long addiction to photography — and a string of Canon cameras.

I'm sure that if he had given me a Nikon, I'd still be a Nikon user to this day. The point is: It is utterly irrelevant which brand you choose, as long as you know how to use your camera and manage to capture the moments you want.

MACRO WITHOUT BUYING ADDITIONAL EQUIPMENT

If you just want to have a go at macro photography without buying any additional equipment, there are a few things you can do. The first thing to try is to see how close you can actually focus with your lenses. Set the focus to manual focus and turn the focusing ring all the way away from infinity focus. Now, zoom all the way in and see how close you can get. You may be surprised by the results!

CLOSE-UP FILTERS

If you aren't up for buying a dedicated macro lens, close-up filters can be the first step toward photographing small things. The results are of lower quality than reversing a lens or using a proper macro lens, but close-up filters are cheaper than a macro lens, and they are easier to carry with you, if you only occasionally do macro work.

DEDICATED MACRO LENSES

If you are willing to spend some money on getting started in macro photography, try a macro lens, which is manufactured in a special way to make the lens especially suitable for up close photography. Normal, non-macro lenses are designed so the sharpness and contrast of the lens gets better the closer you focus to infinity. The thinking behind this is that most of the photos you take are toward the end of the focusing range. With a macro lens, however, it is the other way around. Most macro lenses are quite good on the longer

focal ranges, but they really excel on sharpness, contrast, and overall photo quality in the other extreme of the focus range — up close. See 2-7 for an example. Notice that the close-up subject is in focus, while the background is a bit less focused.

In practice, using a macro lens means that you can take pictures at shorter focal distances than you can with a normal lens. The most extreme macro lenses can focus down to 2 cm (approx. 0.8 inch). Such lenses are often found on digital compact cameras, in particular the models from Casio and Nikon, but this isn't necessarily the best way forward for SLR cameras. Instead, macro lenses are usually lenses that have a longer focal length, combined with the ability to focus at relatively short distances — typically 1 m or closer.

Macro lenses are available from around 50mm to as high as 300mm. Shorter focal lengths can give higher sharpness, but you have to get really close to get a full macro reproduction of your photo. If you are photographing insects or animals, a 50mm macro lens won't be of much help. To be able to focus at that magnification, you need to be practically touching the subject. Let's face it, the butterfly will be long gone by the time you trip the shutter. In addition, the lens itself is likely to cast a shadow on what you are trying to photograph, which makes things more difficult.

note When handholding a camera, be careful of camera shake! As a general rule, you can hold a lens at shutter times that are the reciprocal of the focal length of your lens. In other words: You can photograph as slow as 1/50 sec. with a 50mm lens and as slow as 1/180 with a 180mm lens. Longer shutter times require a faster lens, an image stabilized lens (which can gain you a couple of stops), a tripod (to eliminate camera shake), or a higher ISO value on your camera.

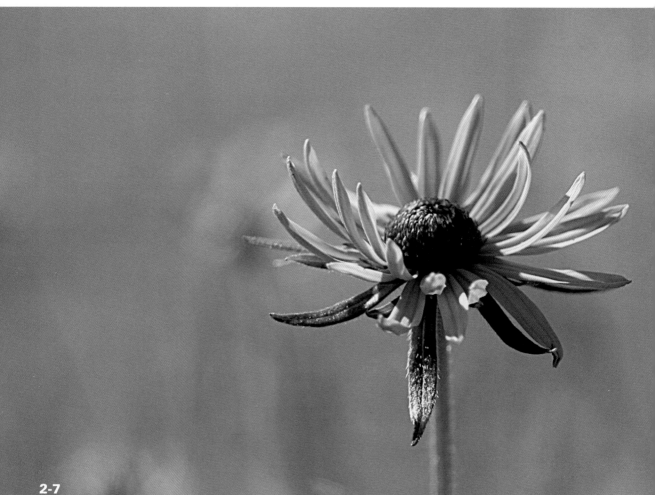

2-7

Longer focal lengths, then, make a lot of sense. There are fine 180mm macro lenses out there; however, they present another challenge. By using a longer focal length, you start to lose a lot of light due to the way the lenses are designed. Handholding the lens becomes more difficult. Many photographers find that using a 100mm macro photo lens is the best approach. It is no coincidence that most camera systems have a 100mm macro lens in their arsenals. Canon has the excellent Canon 100mm f/2.8 Macro USM. Nikon has the mighty fine 105mm f/2.8D AF Micro-Nikkor. In addition, third-party lens manufacturers, such as Sigma and Tamron, have a series of macro lenses that cover the whole range from 50–300mm, all with full macro capabilities. The main advantage of using dedicated macro lenses is that you don't have to worry about accessories and attachments. A photo like 2-8 can be taken with a single lens, which allows for impulsivity and makes it easier to bring your macro equipment with you when you go traveling looking for macro opportunities.

In terms of price, macro lenses are usually more expensive than their non-macro counterparts. On the other hand, they are usually of significantly better quality. Even if you never plan to do any macro photography it's worth considering a macro lens if you are in the market for a high-quality lens.

More than anything else, a dedicated macro lens offers you the flexibility of being able to do macro photography on a whim — the lens you bring with you is good enough to photograph anything you come across. If you were to go on safari on a budget, for example (see 2-9), it would be highly advisable to take something like the Sigma

70-300mm APO DG MACRO lens (see 2-10) with you. Not only do you get the flexibility of a good quality tele-zoom lens, but the macro function is available at focal lengths of above 200mm, allowing you to focus at distances down to 95 cm, for reproductions of 1:2. At around $220, it's an absolute bargain.

In addition to all-around lenses that are particularly good for macro photography, there are a few special lenses out there particularly built for macro photography. Canon's MP-E65 is widely recognized as being one of the best available specialized lenses for macro photography. MP-E65 is a unique manual-focus lens designed exclusively

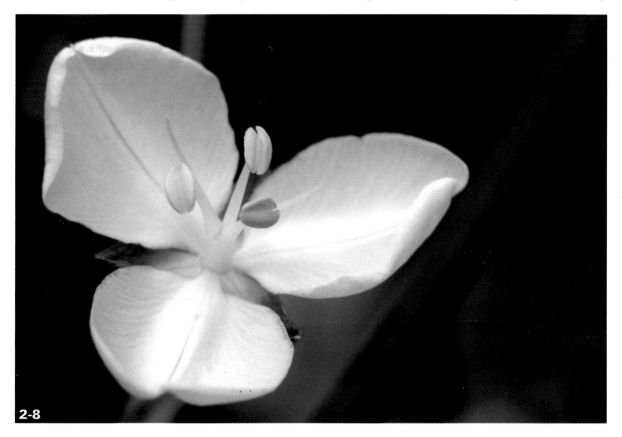

2-8

ABOUT THIS PHOTO *Dedicated macro lenses take a lot of the hassle out of macro photography. Taken with a Canon 100mm f/2.8 macro lens 1/60 sec., f/9 at ISO 100.*

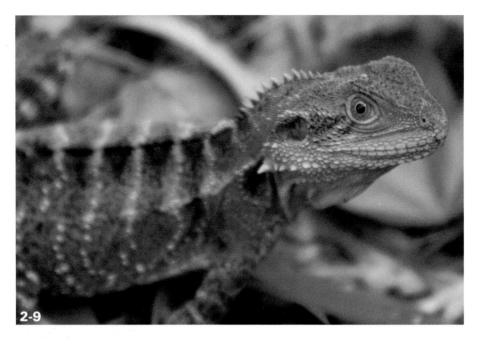

2-9

for macro shooting, at magnifications starting at 1:1 and going all the way up to 5:1, and it has a maximum aperture of f/2.8. That means at its maximum magnification, you can fill a 35mm frame with a grain of rice — or a detail of a razor blade, such as in 2-11.

The lens comes with all the strengths of using bellows and reversing rings, but keeps full *TTL* (Through the Lens) metering. For all its good qualities, this lens is useless for anything but macro photography, and it is rather pricey as well. However, if you are serious about extreme macro photography, this lens (see 2-12) is the ultimate match for ease-of-use, photo quality, and incredible magnification.

TELE CONVERTERS

Tele converters (see 2-13) go between your camera body and your lens, and usually come in 1.2x, 1.4x, and 2x magnifications. Tele converters allow you to trade lens speed for longer focal lengths. If you have a 100mm f/2.8 macro lens, for example, adding a 2x tele converter quarters the brightness of the lens to an f/5.6, but turns it into a 200mm macro lens. The minimum focal distance is unchanged. If you use a 1.4x tele converter, the lens becomes a 140mm lens, with a maximum aperture of f/4.0.

2-10

ABOUT THIS PHOTO *The Sigma 70-300mm f/4.5 APO DG MACRO is an amazing lens if you're on a tight budget. Photo courtesy of Sigma.*

ABOUT THIS PHOTO
Gilette Mach 3 razor blade, uncropped,. Notice the incredible magnification this lens is capable of. Taken with a Canon's MP-E65 f/2.8 macro lens. 1/60 sec., f/4.0 at ISO 100. Lit by a Canon Macro Twin Lite MT-24EX flash.

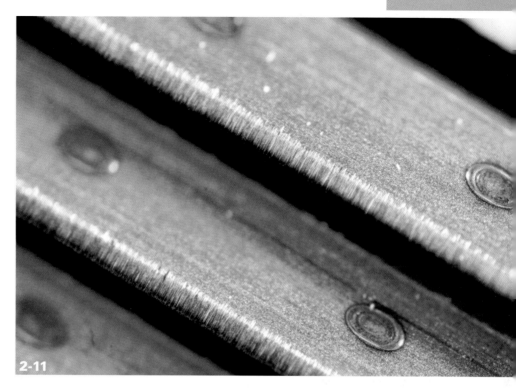

2-11

The Canon 100mm f/2.8 macro lens has a 1:1 macro magnification factor, so adding a 2x tele converter turns this into a 2:1 magnification factor. As an alternative to a tele converter, you can use an extension tube (which essentially is a tele converter without any optics in it).

Tele converters are generally a bad substitution for buying appropriate lenses. If you want a 200mm, buying a 200mm lens gives far higher quality results. On the other hand, tele converters come in handy when working in telephoto genres, such as photographing animals, sports, and similar subjects. As such, a tele converter might be a better investment if you want to buy a photo accessory that is usable beyond macro photography.

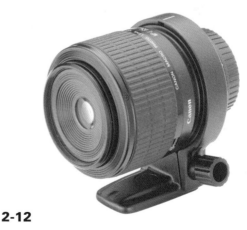

2-12

ABOUT THIS PHOTO *The Canon MP-E65 doesn't look like much, but it is, in fact, one of the most powerful macro lenses you can connect to a dSLR camera body. Photo courtesy of Canon.*

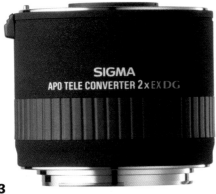

2-13

When considering tele converters, there are many choices, but the quality of the glass element is important, and — as with much else in photography — you generally get what you pay for. Because a bad tele converter can ruin your photos quite spectacularly (just look at 2-14, it's distinctly unimpressive), it can be worth sticking to the original manufacturers' tele converters.

Canon calls them extenders and sells them in 1.4x and 2.0x varieties. Nikon's versions are known as TC-14E, TC-17E, and TC-20E, with 1.4x, 1.7x, and 2.0x multipliers, respectively.

EXTENSION TUBES

An *extension tube* has much of the same effect as a close-up lens, but generally has higher quality. See 2-15 for an example of a photo taken with a relatively inexpensive lens and an extension tube.

Physically, an extension tube is a piece of metal tubing with a *bayonet fitting* (the connection you use to connect a camera to a lens) on both sides. You attach the extension tube to the camera as if it were a lens and the lens to the extension tube as if it were the camera. Good extension tubes connect the electronics of the camera up to the electronics of the camera lens, which means you retain control of the aperture and auto-focus of the lens.

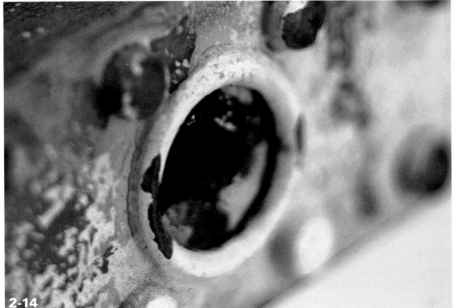

2-14

ABOUT THIS PHOTO
Old padlock. Using a tele converter makes it possible to take macro photos with standard lenses, at the expense of light loss. Taken with a 28-105mm f/3.5 lens at 105mm with a non-branded 2x tele converter. 1/20 sec., f/5.6 at ISO 100.

ABOUT THIS PHOTO *Snow crystals. Extension tubes make it easy to try extreme macro photography without making a big investment. Taken with a Canon 28-105mm f/3.5 lens at 105mm with a 24mm Jessops tele converter. 1/125 sec., f/13 at ISO 100.*

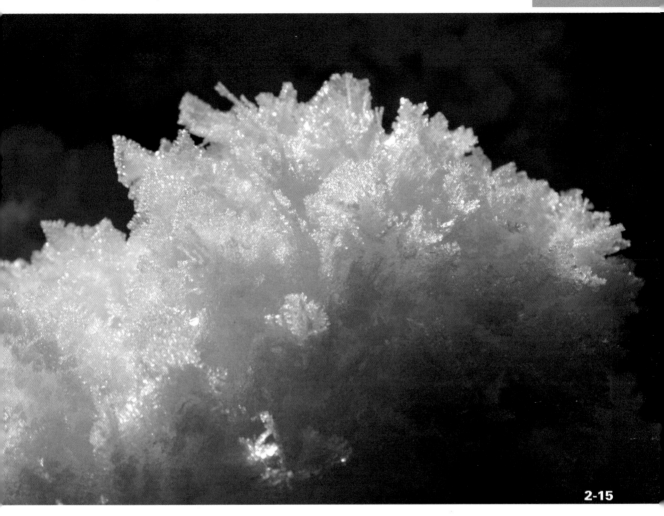

2-15

Extension tubes often come in sets ranging from 13mm to 24mm, but they can be combined into other lengths. Add a 13mm extension tube to the 24mm tube, and you get a 37mm extension tube.

When using extension tubes, the longer the combined length of the tubes, the more light you lose. Generally, this isn't actually much of a problem. When working in high magnification, you'll want to use a tripod anyway, and most modern cameras use TTL light measuring, and measure the light correctly for correct exposures despite the extension tubes.

You can put almost any lens on an extension tube. Longer lenses offer a lower magnification, and wider-angle lenses allow you to get closer — up to a point. Connecting a 25mm extension tube to a 28mm lens, for example, is an optical impossibility. You will never be able to focus.

Extension tubes are really simple devices with nothing but air inside them, and there is no reason why you should buy famous-brand extension tubes. If you make sure they are metal, that the insides of the tube are non-reflective (for instance, matte black), and that the bayonet fittings fit your camera properly, you can't go wrong.

MAKE YOUR OWN EXTENSION TUBE Because extension tubes are such simple devices, you can easily make one yourself. If you have a spare camera body cap and a lens cap, just glue them together back-to-back and then cut out the interior, so you can see through it. Depending on the type of body and lens caps, it should give you roughly a 15mm extension tube — enough to get a taste of what extension tubes can do.

If you want to get more serious, you can make your own reversal-extension tube. This combines an extension tube with a mechanism to mount a lens back-to-front inside the tube. A quick Internet search provides several different recipes for how to make your own reversal-extension tubes, such as the one I wrote a few years ago, showing how to making one out of a Pringles can (see www.kamps.org/g/?ovah).

REVERSING RINGS

Reversing a lens, either directly on the camera body or on bellows, is a low-cost yet effective way to participate in macro photography, often with fantastic results, such as in photo 2-16. Although it is possible to just hold lenses up to your camera, I don't recommend it. Cameras are expensive, and lenses are as well. You don't want to drop either of them, scratch anything, or otherwise do damage to them. Using a *reversing ring* allows you to get up close, but as with all extreme macro photography efforts, getting the focus right can be difficult. A reversing ring is a metal ring that has a bayonet fitting on one end (the same type you already have on your camera lenses) and a screw fitting on the other.

The best way to avoid ruining your equipment is to make sure that the camera and lens are securely connected to each other. That is where reversing rings come in. The ring shown in 2-17 costs less then $10 at a local camera shop. Notice that it is unbranded. However, because it is essentially a bayonet fitting (the side that is up in the photo) with a filter thread on the other side, there is not a lot that can go wrong.

If you have several lenses you regularly reverse on your camera, you may want to buy a reversal ring for each of the filter thread sizes of your lenses, or you can buy stepping rings.

Reversing rings are inexpensive and can be purchased from most camera stores. If you are planning to experiment with macro photography, a good reversing ring is the first investment to make.

> **tip** To avoid buying the same filters or reversal rings for several lenses, buy *stepping rings*. These are filters without glass in them that have a different size thread on each side. A 52-55 stepping ring is known as a *step-up ring*. It screws into a 52mm lens thread and accepts a 55mm filter. Conversely, a 55-52 stepping ring is a *step-down* ring. The first number is always the number closest to the camera.

> **note** When you reverse a lens, all the electronics and couplings that normally are protected by your camera body are exposed. To avoid damaging these parts, you can cannibalize a lens protection cap: Cut a hole in it and connect it to your lens. It helps to protect the lens internals.

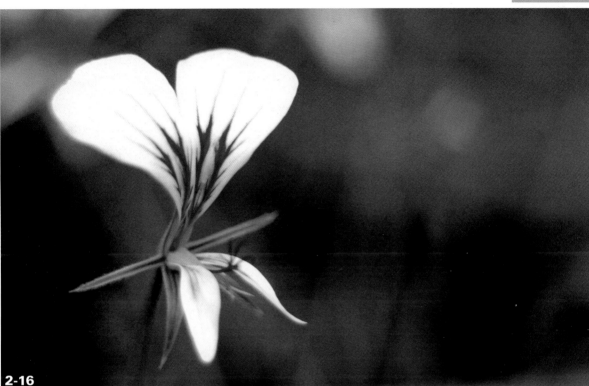

2-16

ABOUT THIS PHOTO *Flower in botanical garden. Taken with a 50mm f/1.8 prime lens on an inexpensive, no-brand reversal ring. 1/125 sec. lens stopped down to f/3.5 at ISO 100.*

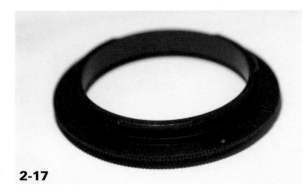

2-17

ABOUT THIS PHOTO *Look for the words "reversed lens" in the image captions to see how useful this simple, inexpensive accessory has been in the creation of this book.*

STACKING LENSES

Stacking two lenses, which I described earlier in this chapter, is quite similar to reversing a lens. Instead of reversing the lens directly on your camera body, you reverse it onto another lens. This allows for high magnifications at low cost. You can use lenses you own already, and the extra equipment needed is available at a fraction of the price of a dedicated macro lens.

The main advantage of stacking lenses instead of, say, extension tubes, is that you get minimal light loss with this method. In addition, it's inexpensive. Photographing insects up close can

35

be trickier with reversed lenses than with other macro photography methods, as reversing lenses means you have to get really close to your subjects. In the case of 2-18, however, the bumblebee was too busy to notice.

The best combination of lenses is to connect a shorter focal-length prime lens (50mm is perfect) to the camera body, and then reverse-mount a longer focal-length lens. In theory, the magnification size of the lenses is the ratio between the two lenses used. So, mounting a 100mm lens on a 50mm lens results in a 1:2 magnification — twice life-size.

The limitation with this technique is the vignetting apparent because of the reversed lens. To overcome this problem, you can add a tele converter between the camera and the first lens, or use a longer focal-length lens closest to the camera. If the vignetting is not too severe, you can just ignore it while shooting the photograph and crop it off after you download the images to your computer.

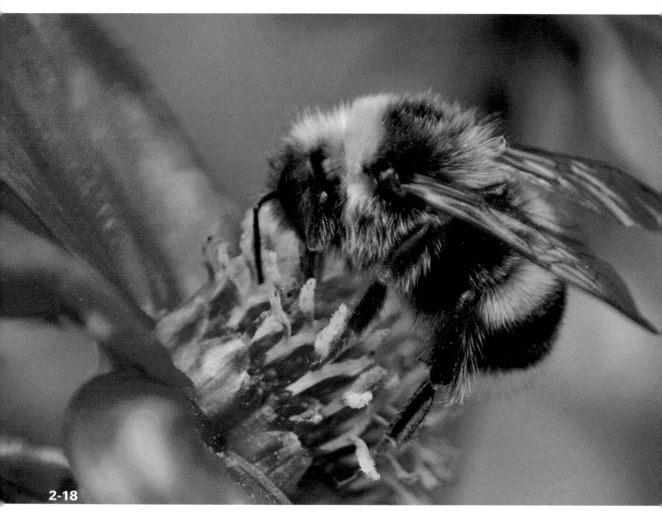

2-18

ABOUT THIS PHOTO *Bumblebee in action taken with a reversed 35-70mm f/3.5 Canon EF zoom lens. 1/400 sec. at ISO 400. Photo by Miha Grobovsek.*

BELLOWS

I have discussed how extension tubes come in various sizes. The reason for this is that you need different size extension tubes for different magnifications. Now, what if you could make an extension tube that was variable in size? This is exactly what *bellows* are.

Bellows come in a few different designs, but generally, they are a pair of metal frames mounted on rails that attach to the camera body on one side and have a lens mount on the other side. Mounted between these frames is dark cloth, rubber, matte plastic, or paper, which extends like a small accordion. One (or both) of the frames can move along the rails to create a variable extension tube ranging from about 10mm (depending on the design of the bellows) to as much as 200mm.

Bellows can be expensive, but inexpensive variations are also available. I bought my bellows via eBay, and I paid around $25 for them from a seller in Hong Kong. The build quality is not amazing, but there are no light leaks from around the bellows themselves, and the rack-and-pinion adjustment (the little cogs and wheels shown in image 2-19) allows for precise adjustment. The pictures taken with this low-cost bellows are indistinguishable from ones taken with a much more expensive bellows system.

A good set of bellows should have a rack and pinion on at least one of the rails (two is more precise, but not strictly necessary) for accurate adjustments of the bellows length. This is important because you can use the bellows themselves to focus your macro work.

ABOUT THIS PHOTO
Bellows, such as these made by Novoflex, work by allowing you precise adjustment of the length of what essentially is a variable extension tube. The camera connects on the left side, and the lens connects to the right hand side. Photo courtesy of Novoflex.

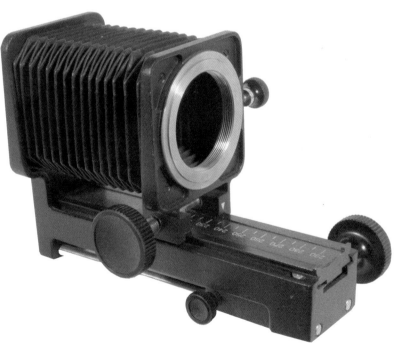

2-19

To use the bellows, you attach one end of the bellows to the camera and attach a lens to the other end of the bellows. When using this system, you lose quite a bit of light, and camera shake becomes quite difficult to avoid. A good tripod is vital, and a focusing rail comes in handy, too.

If you want even more magnification than what bellows offer on their own, try combining a reversal ring and bellows. The bellows go on the camera and the reversed lens goes on the other end of the bellows. This offers the highest magnification

short of employing microscopes or similar specialized microphotography equipment. Look at 2-20 and make up your own mind!

Determining the shutter time when using bellows used to be rather complicated, because the camera's internal light measuring can't be trusted. However, with digital photography, it is a lot easier. Let the light meter make its best guess and set the camera to manual exposure. Then just take a photo. If it's too dark, use a longer shutter time and vice-versa.

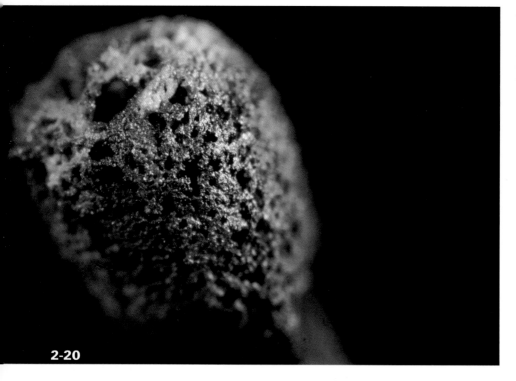

2-20

ABOUT THIS PHOTO
For absurdly high magnifications, you can't beat a reversed lens mated with bellows. This match head image is straight out of the camera. Taken with bellows extended to approx. 135mm, reversed 28mm lens. 1/30 sec., f/11 at ISO 100.

FLASH AND LIGHTING

When working with macro photography, you experience serious light loss. The problem with this is that the longer shutter times required make imaging chip noise an issue, and even minor vibrations can cause camera shake. In fact, the movement of the mirror inside a dSLR camera can be enough to ruin a photo — that's how sensitive macro photography is. The answer is using some form of external lighting to provide the light boost you need such as flash units, macro flash units, reflectors, and diffusers.

EXTERNAL FLASH UNITS

One way to get around the problem is to illuminate your subject with a flash (as shown in 2-21). This allows you to use much shorter shutter times. If your flash is powerful enough, you can take all your photos at your fastest sync time — which means faster than 1/60 second with most cameras, and as fast as your fastest shutter time with extra fast electronic flashes. Camera shake means little if you manage to use 1/4000 second exposure times!

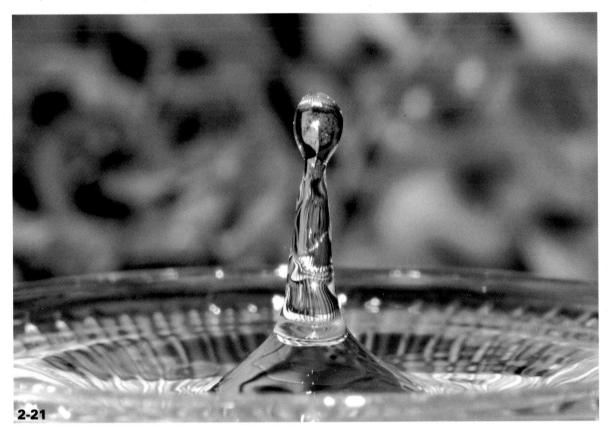

2-21

ABOUT THIS PHOTO *Using a flash unit on an off-camera cord made it possible to completely freeze the motion in this photo. Taken with a Canon EF-S 60mm F/2.8 Macro. 1/250 sec., f/3.5 at ISO 100. Photo by Matthieu Collomp.*

The problem that arises with using a flash is that flashes normally aim forward. In addition, the lens assembly is likely to get in the way of the light from your flash, but there is a solution: The easiest (and least expensive!) way to use a flash unit with macro is to use an off-camera cord, as shown in 2-22. It allows your flash to be operated as normal, but to be moved away from the hot-shoe on the camera. By using a bracket or by mounting the flash unit on a separate tripod, you retain full control of the flash without having to use one hand to aim the flash. These cords are available for all systems, both as original accessories and through third parties. Prices start at around $40. Apart from use with macro photography, an off-camera cord is most useful in portraiture and is a sound investment to improve the flexibility and creativity of all your flash photography.

2-22

ABOUT THIS PHOTO *An off-camera flash cord like this one works by moving the hot-shoe of your camera farther away, which means your flash retains all its metering and communications with the camera and makes flash photography a lot more flexible. Photo courtesy of Canon.*

MACRO FLASH UNITS

For even more control over what you are doing, consider using a specific macro flash. These come in several different types, but they are generally ring-flashes or small flash units that can be mounted on the front of the lens.

Ring flashes are unique in that the light comes from a circular shaped flash tube unit, or a series of small flash units mounted inside a circular diffuser. The idea is that the flash goes around the lens, so the light comes from all directions. In addition, it gives a halo-shaped reflection on reflective surfaces, which some people find attractive.

For Canon systems, the macro ring flash is called MR-14EX, and sells for around $500. It has lights built-in that help you focus when working up close, and the intensity of the flash discharge can be adjusted from one side to the other of the flash unit. The Nikon variant is known as Nikon SB-29s, and costs around $375. In terms of specifications and functionality, they are roughly the same. Third-party versions are also available, such as the Sigma EM-140 DG (around $375), the Sunpak DX-8R (around $175), and lots of other options. Try a Google search for "ring flash" to find yourself a bargain!

Another method of lighting your subjects is to use on-lens flashes, usually in pairs (see 2-23). The flash capacitors are kept in a unit that is placed in the hot-shoe of the camera, and the two flash heads are placed on the lens. Each of the flash heads are detachable, aimable, and separately controllable from a control panel on the back of the hot-shoe unit.

ABOUT THIS PHOTO
A specific twin flash macro photography flash system offers great flexibility and superior results, allowing both handheld macro photography and full control of light conditions. Photo courtesy of Canon.

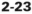

2-23

Canon (MT-24EX, around $675), Nikon (R1 wireless macro flash, around $400), and most other SLR manufacturers have twin flash solutions in their product line-ups, but at this time, I'm not aware of any third-party manufacturer who is making twin macro flashes.

Twin flashes offer more flexibility than ring flashes. You can detach the twin flash units and backlight your subject, for example. This is something that isn't possible with ring flashes. Furthermore, twin flashes tend to be slightly more powerful than ring flashes. As an example, photographing the

ball inside a ballpoint pen is difficult. Doing so without a tripod is a preposterous idea, but with the power of twin macro flashes, it is entirely possible. See 2-24 for an incredible example of one of these flashes in action!

REFLECTORS AND DIFFUSERS

Whether you are working with natural light, floodlighting, or flash lighting, chances are that you will have to shape your lighting. Reflectors and diffusers come in extremely handy in this respect.

2-24

For macro work, it is worth buying a small hand-held reflector. There are some big-name manufacturers of reflectors, but light doesn't know the difference between one brand or another, so if you can find a good deal on any reflector, go for it. Having said that, making your own reflector is also easy. A piece of cardboard wrapped in aluminum foil that has been crumpled a few times makes an excellent reflector and doesn't cost you anything. In an emergency, a white sheet of paper or fabric can work miracles. In 2-25, a garden candle is photographed against a pale blue sky in direct sunlight. This picture is taken into the sun and would have been impossible without the use of a makeshift reflector: A white T-shirt held up just to the left of the candle. A polarizer filter was used to turn the sky into a deeper shade of blue.

For some macro photography subjects, especially jewelry and similar shiny objects, a *light tent* is important to avoid reflections of your surroundings. Some macro photographers use diffusers outdoors: A light tent is able to take the strong, directional sunlight and turn it into a softer, more omni-directional light source. The added benefit is that inside the light tent there won't be any wind to disturb plants and so on.

ⓟ *x-ref*

You can learn more about how diffusers work in Chapter 3.

ABOUT THIS PHOTO
A white T-shirt held up just to the left of the candle lifts the heavy shadows to the left of the image. Taken with a Canon 28-135mm f/3.5 IS Macro lens at 100mm, with a circular polarizer fitted. 1/350 sec., f/4.5 at ISO 100.

2-25

TRIPODS

To be able to work effectively as a macro photographer, a good, sturdy tripod is vital. The tripod has to be able to keep your camera completely still, no matter how many weird and wonderful macro attachments — such as focusing rails and specialized macro heads — you connect to it.

A good tripod should be made out of metal and be quite heavy. Lighter tripods can be used, but I find lightweight aluminum and plastic tripods too flimsy to be of any use in macro photography. Of course, if you have the sense to buy a carbon-fiber tripod, then I hardly believe you need tripod advice!

The best tripods I have been able to find for macro photography are made by Velbon and have legs that are individually adjustable in all directions. They lock off at various degrees outwards (see 2-26), and the sturdy screw-tightening extending legs are rock solid.

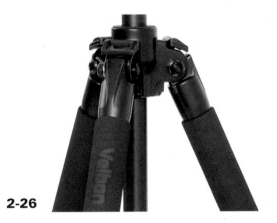

2-26

ABOUT THIS PHOTO *A good tripod for macro photography work should have legs that can splay to various angles, as shown here, as part of the excellent Sherpa Pro tripod by Velbon. Photo courtesy of Velbon.*

Whichever tripod you decide to go with, make sure that it has a way of attaching weight to the center post. This makes a lot of difference in terms of stability.

Some tripods offer the possibility to take the center post all the way out of the tripod and then re-insert it upside-down. The idea is that you can then get closer to the ground. Although this is a great idea, I find working with the camera upside-down infuriating and can't get used to it. Instead, for my macro work, I have a tripod whose legs splay all the way out, and I used an angle-grinder to cut the center post to about 3 inches in length. That way, the tripod can be touching the ground with all three legs and the center post, and the camera can be as low as 5 inches from the ground.

TRIPOD HEADS

In addition to a sturdy tripod that has all the functionality you need, you are going to need a good *tripod head*, the piece that connects the legs of the tripod to the camera. A lot of the functionality of a tripod head is taste and preference. Some people like to use fluid video heads to allow for adjustments, others like the flexibility of a pistol-grip, ball-jointed tripod head, and others prefer a two-way adjustable head with two different levers for adjustments.

It is difficult to make a recommendation, as everybody's needs are slightly different. Do be aware, however, if you are buying a professional tripod, they normally don't come with a tripod head. Don't hesitate to ask to try a few different types before you make a selection that works for you.

FOCUSING RAILS

The most difficult thing to get used to as you start crossing into extreme macro photography is the fact that autofocus is impossible. The focusing rings on your lenses are useless. It takes some time to get used to focusing by moving the camera closer to, or farther away from, the subject.

When you hold your camera in your hands, moving a camera closer or farther away is easy. You just move your hands or upper body. After the camera is on a tripod, it becomes an entirely different matter, especially because the movements often are only a couple of fractions of an inch. Having to reposition a tripod by 3mm all the time is not only annoying, it turns even the most patient photographer away from macro work for life.

The solution is to use a *focusing rail* (as shown on the bottom of the Novoflex macro bellows, see 2-19). Not entirely unlike the rails attached to a bellows system, a focusing rail is basically just a rack-and-pinion driven system that moves the entire camera backward and forward. You attach your camera to the focusing rail, and secure the focusing rail to the tripod.

There are several types and makes of focusing rails out there. Some are even built into tripod heads or into higher-quality bellow setups. The general rule is that you get what you pay for, and focusing rails can be purchased for anything between $40 and $600. I would argue that even an inexpensive focusing rail is better than no rail at all.

If you remain unconvinced about focusing rails, then don't buy one. I'd be willing to bet that you'll be crying out for one within a few hours of shuffling your tripod back and forth!

SPECIAL TRIPODS

If you travel a lot, you might find that it is tempting to leave your tripod behind: They are often quite heavy and unwieldy. Luckily, some manufacturers have come up with clever solutions to the problem. Joby (www.joby.com), for example, created the popular Gorillapod, which is a lightweight tripod with flexible arms that can be wrapped around anything. Their newest product, the Gorillapod SLR, is sturdy enough to hold a full-size dSLR with a hefty lens (just see 2-27), and it is perfect for on-site macro photography.

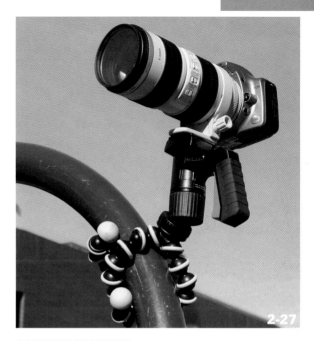

ABOUT THIS PHOTO *The Gorillapod is a good solution as a lightweight traveling companion when you can't bring your full-size tripod. Photo courtesy of Joby.*

Assignment

Your Favorite Assignment

We all have favorites — a favorite color, favorite camera or lens, and maybe you have a favorite musician and song. If you hadn't guessed yet, this assignment is all about favorites. Think about your favorite song and your favorite color. The title of your favorite song is the title of the photo in the assignment.

Use your favorite camera and your favorite macro lens arrangement, listen to your favorite song by your favorite artist, and take a macro photo that somehow illustrates the song. Make sure your favorite color is contained within the photo!

One of my favorite songs is a version of "Somewhere Over the Rainbow," performed by Israel Kamakawiwo'ole. The song has such a playful innocence and warmth. It reminds me how beautiful the world really is. I'm a big fan of earthy tones, but obviously, there are no earthy tones in the rainbow, so I had to think for a long time about this assignment. (Why did I make it so difficult?) Then my eye fell on the dream catcher hanging over my desk in my office. I looked at the colors of the feathers and thought about the connection of feathers, birds, sky, and rainbow. I love this photo, because the vast bulk of it is out of focus, but it is still obvious what the subject is. The parts that are in focus have the most beautiful colors (courtesy of a flash unit held on an arm's length, with a piece of orange paper wrapped over the flash head). Taken using a Canon 28-135mm f/3.5 IS Macro lens at around 65mm on a 24mm extension tube, with my equipment all safely mounted on my Slik 504QF II tripod. Lighting is done with two Canon 550EX flash units — one on the camera and one with a make-shift orange filter held in front of it. 1/60 sec., f/4.5 at ISO 100.

Don't forget to go to www.pwsbooks.com when you complete this assignment so you can share your best photo and see what other readers have come up with for this assignment. You can also post and read comments, encouraging suggestions, and feedback.

LIGHTING IN MACRO PHOTOGRAPHY

In many ways, macro photography is like a carefully crafted film noir spy thriller. You are the lonely detective looking for answers, and absolutely everything is against you. In your struggle to find a solution to the mystery, you have to overcome several obstacles, but eventually, with a bit of help, you solve the case and get the girl (or boy). Who is your nemesis, your archenemy, and the worst troublemaker on the block? You guessed it: The Evil Archduke Light — or the fact that he is nowhere to be found.

In this chapter, I guide you through all aspects of lighting macro photography. I can't guarantee you'll get the girl (or boy) after you've solved the whodunit, but trust me on this one: After you know how to use available and artificial lighting to your best advantage, nothing can stop you from taking the best macro photographs on the block. Case closed.

WHY DO YOU NEED GOOD LIGHTING?

The easiest way to light a subject is to realize that it is already lit. Look around you: If there were no light, you wouldn't be able to see your subject. In theory, if you can see it, you should be able to photograph it.

The truth is slightly different: The human eye is more forgiving to low-light conditions than photographic equipment. This is doubly true for digital photography: Taking photos in low light usually requires a longer shutter time, but this causes problems in itself. When working with macro photography, both the camera and the subject are susceptible to vibration and

movement, which is something made even worse by having to use long shutter times. Lighting is your most important tool to overcome the limitations imposed by the photographic equipment used in the world of macro photography.

LONG SHUTTER TIMES

When making a long exposure with a digital camera — such as with the candlelit bottle in 3-1 — the imaging chip that catches the light gets hotter, which emphasizes the inherent weaknesses in CCD and CMOS chips (the two main imaging chips used in digital cameras). These weaknesses cause light to be measured unevenly across the chip. This weakness is manifested as *noise*, or a digital artifact, which degrades your image quality. In other words: Shorter shutter times (meaning less than half a second) are great for reducing digital noise in your images. In addition, dSLR cameras are generally less affected than digital compact cameras.

Although camera technology is getting better and digital cameras are increasingly more adept at handling long shutter times, the noise developed during long exposures is still a weakness you should be aware of. Keeping shutter times at less than a second minimizes the problem; however, if you feel your camera creates too much noise at shutter times of less than a second, work around it by working toward even faster shutter times.

Apart from overcoming problems, lighting can be used with great creative effect as well. Good lighting is what separates a good photograph from a great photograph, and the more time you put into perfecting your lighting technique, the better your photos will be.

3-1

VIBRATIONS AND MOVEMENT

Even if your cameras were flawless, creating pure, pristine, true representations of what's in front of the lens, longer shutter times are still a problem. That problem is manifested in the form of vibrations. Any type of motion of your camera or your subject while you are taking a photograph causes a blur, and it's easy to understand why: Imagine you are trying to photograph a fly, such as the one in 3-2. You use a shutter time of 1/10 second, but the fly is walking across a leaf. Although 1/10 second is not a long time — if you're a very quick reader, you can maybe read one word of this sentence in 1/10 second — if the fly has moved during this period, it comes out as a blur.

As you get closer to your subject in the world of macro photography, shutter times begin to matter more. If a person moves 1mm during a portrait photo, you would be hard pressed to notice the movement in the final photo. If a fly walks 1mm during an extreme macro photo in which you are trying to capture its eye, it has wandered out of frame altogether.

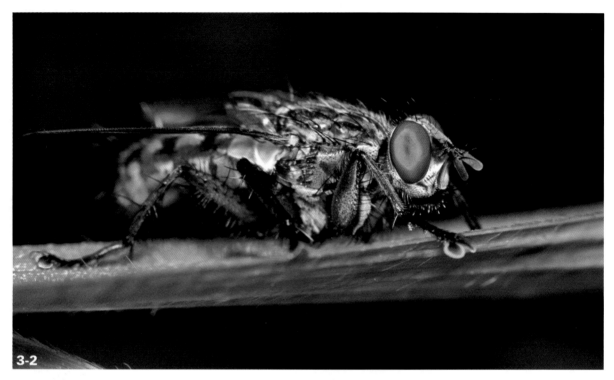

3-2

The relatively huge impact of even the tiniest motions when you get to extreme macro photography doesn't just extend to what you are photographing. Vibrations can come from your subject, of course, but holding the camera creates vibrations, and the camera itself can cause vibrations, too. That loud "click" you hear when you press the shutter is a mirror moving up and a curtain moving across inside your camera. In most forms of photography you wouldn't be able to tell, but the tolerances granted in macro photography mean that the mirror slap can cause enough vibrations to cause a visible impact on your photo — even if your camera is firmly secured on a tripod! This is particularly true if you are taking extreme macro photos — such as of the cumin seed shown in 3-3.

SOLUTION: LIGHT — AND LOTS OF IT!

All the obstacles discussed in the previous two sections have an obvious and ingenious solution: Reduce the shutter time and steady the camera. The photo in 3-4 is an excellent example. By using a very short shutter time and an electronic flash, the photographer managed to avoid a lot of noise and blur from movement. When you reduce the time the shutter is open, you reduce the effects of any vibrations that are present; you eliminate the issue of your subject walking (or flying) off; and you do away with the problem caused by your imaging chips at long exposure times.

ABOUT THIS PHOTO
This cumin seed is about 2mm across. Needless to say, even the slightest movement can induce motion blur. Taken with a Canon MP65-E f/2.8 macro lens and a MT-24EX Macro Twin Lite flash. 1/125 sec., f/5.6 at ISO 100.

3-3

ABOUT THIS PHOTO
Up close and personal with a sea shell, the photo was taken by holding a reversed lens against the camera body, lit by a flash unit on an off-camera cord. Reversed 50mm f/1.8 lens, 1/500 sec., ISO 100. Photo by Hillary Quinn.

3-4

As with everything else in photography, if you change one parameter, you have to change another to make up for it. Faster shutter times can be counteracted in several different ways:

- **You can use a bigger aperture.** Because with macro photography you already have an extremely limited depth of field, this option isn't necessarily the best.

- **You can increase the ISO value.** However, noise is already a problem with the higher ISOs used for low-light photography.

- **You can increase the amount of light on the subject.**

Only one of these three solutions doesn't have a drawback, and that's why I've dedicated a whole chapter to lighting!

MAKING THE MOST OF NATURAL LIGHT

Natural lighting has several advantages over other forms of light. For one thing, it usually looks more natural, but more importantly, it is readily available almost everywhere you go. Outdoor photography in the bright sunlight, especially midsummer at noon, can be done largely with the light available to you. Sometimes, you can even get away with photographing directly into the sunlight by placing your subject in front of the sun, as I did in 3-5, with a piece of natural glass I found outside an old factory.

When working outside, you might come across situations in which you must work with direct sunlight, shade, or a mixture of the two. Although your eyes easily adapt to the different lighting scenarios, it is important to remember that a camera does not adapt nearly as easily. It sees a shaded area in a vastly different way than it sees a sunlit area, and your photo technique has to reflect the difference.

SHADE VERSUS DIRECT SUNLIGHT

Direct sunlight is by far the brightest form of natural light. It has lots of advantages: It opens more possibilities for photographing freehand, using short shutter times, and moving more freely than other types of lighting for macro photography projects. It allows you to be more spontaneous, which is especially useful if you are just starting out in macro photography.

On the downside, if you set your exposure to center on an area of your subject that is lounging in sunlight, any shadow cast by the subject itself or by other items around you (including yourself and your camera) are going to be vastly underexposed.

With some photos, the contrast between the brightness of the foreground and the darkness of the background works well. In other circumstances, the contrast simply makes the photos look staged. Sometimes everything comes

3-5

ABOUT THIS PHOTO *Ingredients: Colored glass and the sun. Taken with a Canon 28-135mm f/3.5 IS macro lens. 1/250 sec., f/8 at ISO 100.*

together effortlessly, as it did in the backlit leaf in 3-6. Backlighting can really add pizzazz to a photo. In 3-6, the *vignette* (the darkened areas along the edge of the photo) created by using a reversed lens adds to the mystique of the photo.

Whenever it is a bright sunny day, you can easily find some shade as well. Most beginning photographers are surprised to find how bright shaded areas actually are. In comparison to a sunlit area, it is quite dark; however, compared to an indoor setting, shaded areas are relatively bright. An

area in the shade has the additional benefit that the light is far less directional — and thereby throws less harsh shadows — than what you encounter with direct sunlight. Light appears to come from all directions, which means that nothing casts shadows and lighting is even.

When photographing outside, the choice of making your pieces of art in the sunlight or in the shade is mostly an artistic consideration. If you like the brash look of the stark contrasts, amazing colors, and abundance of light offered in the

sunshine — great. If you prefer the more subtle lighting of the even light, more muted color, and higher degree of detail you can capture in the shade — superb. The important thing is to be aware of the vast differences in settings and to know that if you can't get an image working in the shade, you might want to try the same idea in direct sunlight and vice versa.

Figure 3-7, for example, might not have worked out this well if it hadn't been taken in the shade. The bottom of the insect's body would have been too dark. It would have been possible to counteract this partially with a reflector (more on this later in this chapter), but moving large shapes near to this little fellow would probably have chased him off.

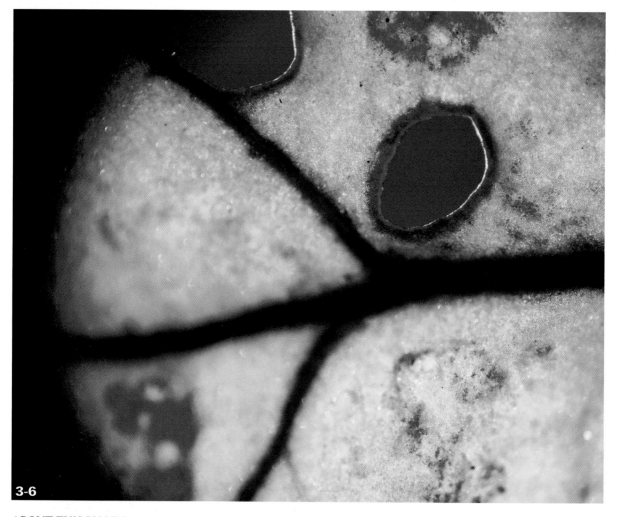

3-6

ABOUT THIS PHOTO *This backlit leaf photo was taken with a 55mm macro lens with another lens reversed on the front, 1/60 sec., f/5.6 at ISO 400. Photo by Hillary Quinn.*

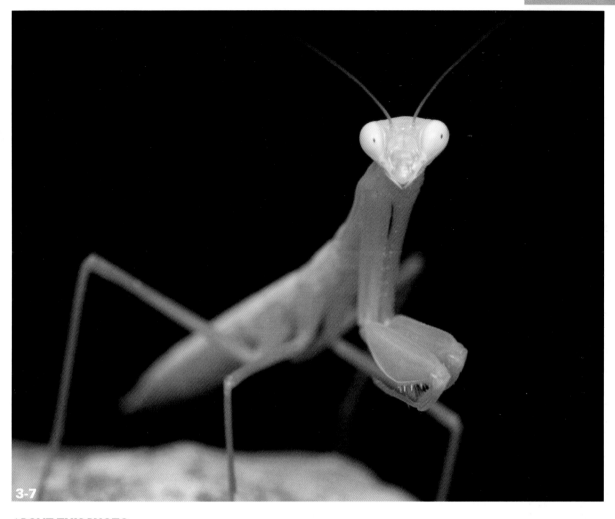

ABOUT THIS PHOTO *Some photos work better in the shade than in direct sunlight. Taken with a Canon 60mm f/2.8 macro lens and an extension tube. 1/180 sec., f/5.6 at ISO 100. Photo by Matthieu Collomp.*

MANAGING NATURAL LIGHT

As you become an experienced macro photographer, you will begin to note to yourself, "Hang on a minute, sunlight or shade? I can think of half a dozen ways to blur the boundaries between the two!" You will be right. A photographer doesn't

as much take a photo as make it, and limiting yourself to the light that is available to you at any given time is pointless. If you don't like the lighting — change it! Sometimes, it is the best way to capture a photo, and bring out the elements on which you want to focus. In 3-8, for

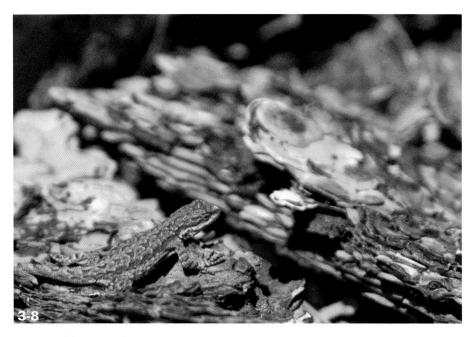

3-8

ABOUT THIS PHOTO
*Poor lighting turns this photo
into a distinctly average
photograph.* Taken with a
Canon 28-105mm f/3.5 macro
zoom lens. 1/1500 sec., f/4.5
at ISO 100.

example, the lizard completely disappears in the photo. If there were any way to block out some of the light falling on the wood behind the animal, or to increase the light falling on the lizard itself, the creature would stand out more in the photograph.

Managing natural light is an important sub-discipline of macro photography, but in effect, there are only three things you can do to manipulate it.

- **You can block directional light.** This turns a sunny scene into a shaded one.

- **You can change the direction of, or reflect, the light.** This can help lift shadows or add light to parts of your composition that were dark before.

- **You can diffuse the light.** This means you take a directional light source and spread its effect over a larger area, creating a less directional source of light.

BLOCKING LIGHT

Blocking light is the easiest of the three options. Because the subject of a macro photograph is so small or such a small area, you can probably use your hand or body to stand in the way of the light source. Compare 3-9 with 3-10 for a simple example of this technique from a flower show. The only difference between the two photos was that I asked a friend to cover up a spotlight that was illuminating the background with his hand for one and not for the other.

When blocking out only a small amount of light, be aware that even though the photo subject is shaded, your lens might not be. If direct sunlight hits the front lens element of your camera, at best the light meter built into the camera under- or over-exposes your photo. At worst, you get unsightly *lens flare* (a form of light reflection from within the lens itself) in your photo.

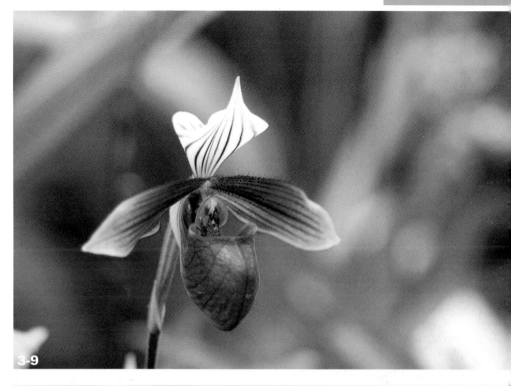

3-9

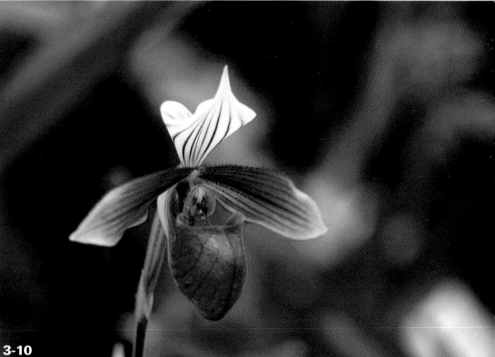

3-10

ABOUT THESE PHOTOS
Making the background darker makes the foreground jump out — a simple but effective trick. Both photos were taken with a Sigma 70-300mm f/3.5 APO DG macro lens at approx 200mm, 1/60 sec., f/5.6 at ISO 100.

REFLECTORS

There are many ways to reflect, but essentially a reflector works as you could expect: Light hits the reflector and is bounced back. You can use this to your advantage, especially when photographing in direct sunlight, because you can actually counteract many of the disadvantages of taking photos in the sun. The photo in 3-11, for example, was taken in full sunshine. If I hadn't used a small handheld Lastolite reflector to lighten the shadows, it would have had a sharp, dark shadow on the left side of the crystal

Ⓟ x-ref

For buying advice and information on how you can make your own reflectors and diffusers inexpensively, check out Chapter 2.

Imagine you are trying to take a photo of a flower. If the sun comes from the top left, you see a lot of heavy shadows on the bottom right of your flower. Placing a reflector to the bottom right reflects the light back, significantly reducing the lack of light on the bottom right of the flower. When doing this, the shadows are not completely removed, but you can effectively brighten the shadow areas and regain some of the detail in the darker sides of the flowers that would otherwise have been lost.

You can even use differently colored reflectors to apply creative effects, and you can adjust how much light is reflected by holding the reflector closer to (for more light) or farther away (for less light) from the subject. If you are using a colored reflector, the intensity of the color is affected in the same way.

ABOUT THIS PHOTO
By using a reflector, this photo has natural, even lighting, without shadows that are too dark. I took the photo using a Canon 28-105mm f/3.5 macro zoom lens. 1/1500 sec., f/4.5 at ISO 100.

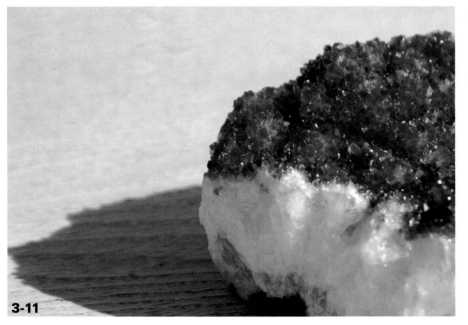

3-11

DIFFUSERS

The concept of how a diffuser works can be difficult to grasp, but let's try: Imagine you are outside on a day with bright sunshine. If you look directly at the sun, your eyes can be damaged. If you hold a sheet of paper up to the sun and look through it, you can look at the sun without much trouble. The difference is that the sunlight is coming from a larger area when you are looking through the paper — the direct light you see without the paper is diffused by the entire surface area of the paper. This is particularly effective in scenes where there is a lot going on, as in 3-12, where you might want to re-introduce a softer, more even lighting.

Professionally built diffusers are often made out of milky, translucent plastic or finely textured white fabric. You can easily make your own out of anything that is semitransparent and neutral in color: Regular copier paper or a white sheet does

3-12

ABOUT THIS PHOTO *A large diffuser held over this plant softened the sunlight. Taken with a Canon 135mm 2.8 lens on bellows extended to approx 30mm, 1/90 sec., f/2.8 at ISO100.*

the job perfectly. A diffuser makes a light source bigger. If you stretch a white sheet over an area in your garden, you won't lose too much light, but the light becomes a lot more even. In the studio, a similar effect is applied by using a soft box, which is material stretched over a frame in front of a flash.

Diffusers, soft boxes, light tents — whatever you want to call them — are invaluable in macro photography precisely because they offer a means to use even lighting from all angles. While reducing the opportunity of using light as a part of your artistic creation, soft boxes let you reproduce an item more accurately.

MINIMIZING VIBRATIONS

As mentioned previously, vibration is a major problem in macro photography. Vibrations can spring from different sources, including movement of the subject, movement of the camera, and internal vibrations caused by the camera itself. You can see the effects of natural motion of the subject in 3-13.

QUIETING YOUR SUBJECTS

Your subject generally causes the biggest movements with which you have to contend. There are a few tricks you can use to keep your subject stationary.

When photographing plants, try to determine what it is that causes the vibration. You can't do much about water flowing past the bottom of the plant, and stopping an earthquake might be difficult, but the usual culprit is the wind. Setting

ABOUT THIS PHOTO *Unless you manage to get the flower to stand still, it is impossible to capture it sharply. Taken with a Canon 135mm 2.8 lens on a 24mm extension tube. 1/350 sec., f/4.5 at ISO100.*

3-13

up a rudimentary wind screen can be as easy as positioning yourself between the wind direction and the plant you are trying to photograph. An umbrella positioned so the wind is guided around your subject can also come in handy.

Alternatively, a few gardening stakes and some string can be used to hold a frame sturdy — drive a stake into the ground on each side of the plant, and tie it to the stakes with the string. You might want to make sure you have permission to do

this, however, as the most public botanical gardens frown on a spot of amateur gardening, even if it is in the name of photographic art.

 x-ref If you are photographing living things, such as insects, preventing your subject from moving might prove difficult (unless you have ether at hand or other tricks up your sleeve). I discuss some of the tricks you can use in dealing with insects in Chapter 7.

If it turns out to be nearly impossible to keep your subject still (try telling a hummingbird or the creepy looking little monster in 3-14 to stop moving for just a second — I doubt they'd obey), you have to work around it. Minimize the impact of the movement by using as short a shutter time as you can.

SECURING YOUR CAMERA

The second biggest contributor to movement is the movement of your camera itself. It doesn't make any difference if your subject is the Great (and non-moving) Wall of China if you are waving your camera around as if it were a feather duster. As a general rule, you can't get away with

holding your camera freehand while working with macro photography. When every tenth of a millimeter vibration has substantial impacts on the final image, even the steadiest of hands are not steady enough. The first step, then, is to link your camera firmly to something unmovable. The ground is usually a good place to start. Sometimes — as for photo 3-15 — you have to secure both the camera and your subject properly to eliminate movement.

To make sure your camera isn't going anywhere, a good tripod is essential. The best tripods for macro photography are the ones that are quite heavy and well put together. The tripod shouldn't wiggle if you try to flex it sideways or along its axis.

ABOUT THIS PHOTO
Sometimes, it's futile to stop your subjects from moving — you might just have to be quick, before they scurry off! Taken with a Canon 100mm macro lens and 24mm of extension tubes. 1/125 sec., f/5.6 at ISO 100. Photo by Chris Nering.

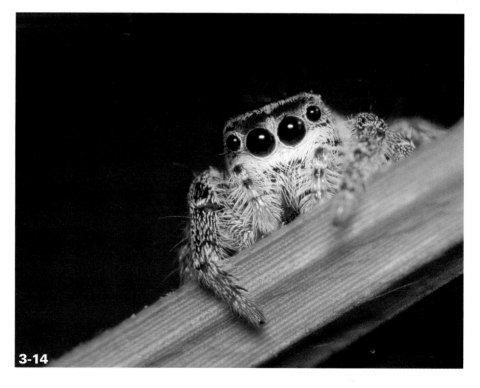

3-14

3-15

When setting up your tripod, make sure you do so in such a manner that preserves the integrity of the tripod. If you have to raise it, raise the thick telescopic legs first. If the tripod has to reach even higher, raise the thinner telescopic legs. If you need even more reach, you can consider raising the tripod head on the center stem, but be aware that the higher you raise the tripod, the less stable it becomes.

If you are working in environments in which movement is still possible, for example, if there is a lot of wind, it is a good idea to put gravity to the best possible use. Making a tripod heavier means it gets more stability and is less likely to be affected by forces acting on the camera, including wind, sound, and other vibrations. Some high-end tripods come with an unimaginatively named *stone bag*. This is a piece of cloth that attaches either to

the center stem (the one that can move up and down) or clips on to each of the tripod legs. You fill this bag with whatever you have at hand: stones or blocks of wood work well. If your tripod didn't come with a stone bag, you can always add a hook to the center stem by drilling a hole in it, for example, and hanging your photography equipment bag, your lunch box, a plastic bag filled with water, or something else heavy from the hook.

Now that the tripod is as firm as possible, you need to make sure you don't introduce vibrations. One way you might inadvertently be causing camera shake is by pressing the shutter on your camera. Every time you touch your camera, you cause some degree of movement, and if the movement hasn't died down by the time the camera is taking the photo, you are degrading your images. The first tip, then, is to

get a remote control release for your camera. These are radio-controlled, infrared, or cable-released triggers, which means that you don't have to physically touch your camera to take a photo. Of course, all these cost some money. Luckily, virtually all cameras have a cheaper version built-in: the self-timer. By letting the camera time ten seconds before clicking the shutter button and taking the photo, any vibrations you introduced by touching the camera vanish. You are left with pure, vibration-free photographs. You can use a self-timer effectively both for dSLR cameras and, as shown in 3-16, compact cameras.

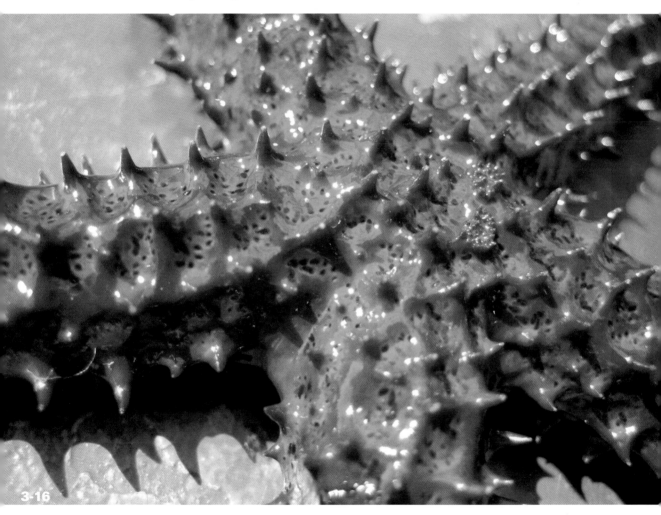

3-16

ABOUT THIS PHOTO *Digital compacts don't suffer from internal vibrations, but vibrations can still occur when you press the shutter. Using a self-timer can help eliminate them. Taken with a compact camera in macro mode. 1/350 sec., f/2.8 at ISO 200. Photo by Katharina Butz.*

QUELLING MOVEMENT FROM THE CAMERA

The final problem you might encounter when you are working with magnifications beyond life size is the fact that the camera itself can cause movement. When you take a photo, you hear a click and feel a slight movement inside the camera body. In some circumstances, this sound, and the slight movement it represents, can be enough to have an impact on your photo. The sound you hear is known as *mirror slap*. It is the movement of the mirror inside your camera moving out of the way of the imaging chip, so that the chip can record your photo. On most SLR cameras, there is a way to avoid this by making the mirror move out of the way ahead of the actual exposure, known as *mirror lock-up*. Consult your camera's manual to find out how you can enable mirror lock-up. It is usually accomplished by adjusting custom functions, or special settings, in the menu

system of your dSLR. After it is engaged, your camera tucks away the mirror the first time you press the shutter, and takes the photo on the second press of the shutter. Alternatively, you can still use the self-timer, which moves the mirror after you depress the shutter button and then takes the photo after the timer runs out.

ARTIFICIAL LIGHTING

When artificially lighting a scene, there are two options available to you: *continuous* or *instantaneous* lighting. The former can be best imagined as a light bulb or a floodlight. There is no difference in the light, whether you are taking a photo or not. Instantaneous lighting, however, is lighting that is available to you only as you are taking the photo, such as when you use an electronic flash. You could try to combine both types of lighting, as I tried in 3-17.

3-17

ABOUT THIS PHOTO
With a combination of a 1200 W work lamp and a Canon MT-24EX Macro Twin Lite flash, a discarded Stanley blade can get a second life as a piece of art. Taken with a Canon MP65-E f/2.8 macro lens. 1/125 sec., f/5.6 at ISO 100.

The advantage of continuous lighting is that it works similar to natural lighting. If you aren't happy about how something is lit, you can move the lights or vary their intensity accordingly. High-powered continuous lighting is energy intensive, however, and big lamps can generate a lot of heat. That heat can cause flowers to wilt a lot more quickly and can be uncomfortable to work with. In addition, you don't get nearly as much light using a continuous light source as you do when you use a flash.

Flash photography has the advantage of speed. A blink of an electronic flash can be as short as 1/10000 second — faster than the fastest shutter time available on cameras. As such, a good flash can freeze time at a particular moment. The intensity of a flash far exceeds the light available to you with even the brightest floodlights. The downside of using a flash is that it takes a lot of experience to use flash units efficiently. Getting the exposure right can be tricky, and many electronic flashes do not provide a way of previewing what the light will look like, so knowing how the final photo will look can involve a lot of guesswork.

Both continuous light and flash illumination have a place in macro photography. The following sections discuss how.

CONTINUOUS LIGHTING

Floodlighting a subject is the cheapest way to work with artificial lighting in macro photography. Using what you have at hand — or what you can purchase cheaply — will dramatically improve your indoor macro photography.

You probably already have a continuous lighting source close at hand. Halogen spotlights are focused, bright, and cheap to buy. They are sold as desk lamps from most lighting and home improvement shops and offer easy-to-use sources of light. Because the spotlights have tightly focused beams, they can easily be used to light your subjects, and if you need even more precise lighting, you can always create a *snoot* out of a piece of paper rolled to a cone with the tip cut out.

Many halogen desk lights come with dimmers, so you can create complex lighting setups with a little fiddling — like the setup used to catch the dragonfly shown at 3-18. Be aware that halogen is an *incandescent light* source, which means that you have to take care in selecting an appropriate white balance for your photos (more on white balance later in this chapter).

For a lot of photography, you can improvise on what you use as a light source, both as a cost-saving measure and in an effort to come up with new creative angles on lighting. Using a flashlight, for example, allows you to have a highly maneuverable light source that can be any color (hold colored gel in front of it), can be aimed easily, and is great for experimenting with different directions of light.

For even more creativity in lighting, try using other objects that emit light as your light source. Macro photography by candlelight gives an eerie warm glow; using a green, red, or blue laser pointer gives an unreal, space-age feel to the images; and if you use a laptop monitor as a light table, you can add any number of colors, shapes, and other awesome effects to your final images.

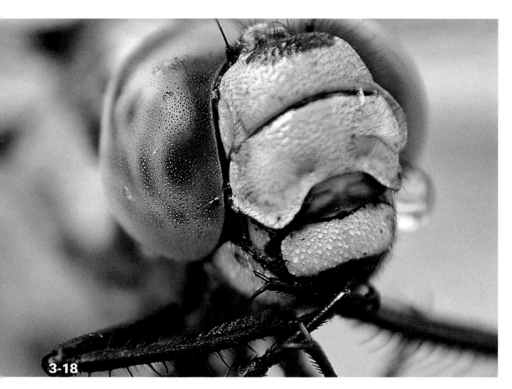

3-18

ABOUT THIS PHOTO
Even advanced lighting can be done cheaply with a halogen desk lamp. Taken with a reversed Canon 50mm f/1.8 prime lens on bellows. 1/200 sec., f/1.8. at ISO 400. Photograph by Miha Grobovšek.

I, personally, have a weakness for the cheap, high-intensity light source provided by the type of lights people often use in workshops. Available from your local hardware store, inexpensive shop lights are available in strengths from 300 to 2000 watts. If you need more light, you just add more lights to the loop. It's a cheap solution, but as you can see from 3-19, there is no arguing with the results.

tip Although shop lights can generate a lot of heat, because of their immense brightness, they can be used for many different purposes. If you are looking to save some money, these lights can be used for different genres, including portraiture, product photography, fashion, and, of course, macro photography.

3-19

ABOUT THIS PHOTO *A simple shop light can give powerful, moody lighting for macro photography, such as in this flower photo. Taken with a Canon 50mm f1.8 prime lens and a 24mm extension tube. 1/250 sec., f/1.8 at ISO 100.*

INSTANTANEOUS LIGHTING

Flash photography is easy to learn and difficult to master. As far as macro photography is concerned, it is difficult to avoid as well. You can use flood lighting up to a point, but as your photographic aspirations become more advanced, you will be held back unless you choose to use electronic flash lighting.

If you already have an external electronic flash, there are several tricks you can use to continue using your current flash units. The problem of all-round, on-camera flashes is that they generally are made for photographing objects at longer distances rather than illuminating something that can be only inches away from the front of your lens.

There are two ways to adapt an electronic flash for use in macro photography. The cheapest way to do this is simply to redirect the light from the front of the flash unit to wherever you want it to go. The other way to adapt your flash is to use an off-camera *hot-shoe adapter,* also known as an off-camera flash cord. These cords allow you to use the flash away from the camera's flash mounting point. By repositioning the flash unit closer to the subject, you have full control over how you want to use your lighting. You can either hand-hold the flash and fix your camera on a tripod, or you can use a *flash bracket* to secure your flash unit to your camera.

ⓟ *x-ref*

You can learn a great deal more about the different types of flash-units and their accessories in Chapter 2.

ⓟ *x-ref*

To judge if the exposure for a photo came out right, you can consider checking its histogram on your camera. Learn more about histograms and how they work in Chapter 10.

With film photography, calculating the exposure of a macro photograph when using a flash was a time-consuming and complicated affair. If you want the right exposure the first time, every time, things are still rather bewildering; however, with the development of digital cameras, a clever shortcut has arrived: trial and error. Set your camera to about 1/60 second shutter time, about f/8 aperture, and set the flash unit to any setting. Try taking a photo, and look at your LCD screen or, better yet, look at the histogram of your photo. If the image is too bright, use a smaller aperture or lower the flash output, or vice versa.

If you are more serious about your macro photography, you might want to consider investing in a flash unit specifically adapted for macro photography. These come in two guises: as ring flashes and Twin Lite flashes, both of which affix to the front of your camera lens. You use these specially developed macro flash units in a similar manner to the way you use the simpler flash units described previously, with the exception that positioning the flash heads is easier.

High-end flash units, such as the Canon Twin Lite, can operate in a near-foolproof automatic mode, which means that the exposure comes out correctly, regardless of what combination of aperture and shutter time you choose. The photo in 3-20, for example, was the first photo in a series.

3-20

Despite the difficult subject, the flash unit got the exposure right on the first try. In fact, in experimentation, this particular flash unit managed to correctly expose photos ranging from 1/10 to 1/500 second shutter time, and ranging from f/2.8 to f/16 aperture, automatically. The strength of these top-end macro flash units is not just their automatic options, but also the fact that you can override some aspects of the automatic exposure — such as choosing to let one of the flash heads go off with a higher intensity than the other, which adds depth to the image, or overriding the overall light metering. Of course, you can also use it in fully manual mode, giving you 100 percent control of what each of the flash heads is doing.

Studio strobes are typically only used for high-precision product photography. Jewelry, the intricate internals of wristwatches, and other fine mechanics are all suitable to studio photography. Generally, a studio is desirable when you need full control of your surroundings and lighting, but with the diminutive areas you're likely to be working with in the macro world, you can easily attain the same level of control on a corner of your kitchen counter or in a makeshift photo area.

Having said that, studio flashes can be many times more powerful than portable flash systems. If you use either a snoot or a *honeycomb filter* (a filter that filters out all non-directional light) on the flashes, you can control them in a precise manner as well. Studio flashes also have the advantage that most of them come with continuous modeling lights, which means that you can get a preview of how the final photo will appear after the flashes fire.

The downside of studio flashes is that they generally are rather bulky. Portable external on-camera flashes are far smaller and can be positioned between the lens and your subject; a positioning you might find cumbersome with studio equipment, due to its size. For example, 3-21 would

ABOUT THIS PHOTO
By using carefully sculpted light, you can take dramatic photos of jewelry. Taken with a Canon 28-135 f/2.8 IS lens on bellows. 1/180 sec., f/4 at ISO 100.

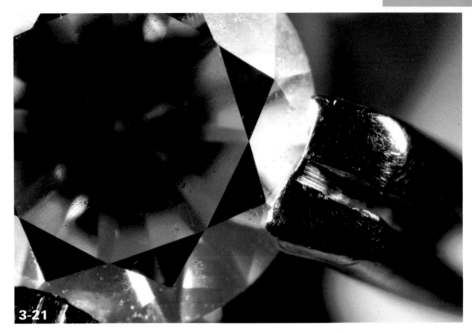

3-21

have been very difficult to capture without portable flash equipment. As a rule of thumb, portable external flashes are essential if you are working with large magnifications that necessitate the lens element and your photo subject to be in close proximity.

If you have access to a photo studio, or are interested in finding one, you can use the same techniques you use for a regular flash unit to choose your background, set up, and use the studio flash.

USING LIGHT TO SET THE MOOD

The color, quality, and direction of the light, including the reflections, have a large impact on how your final photo looks. By taking control of these elements of the light, you can create photos that have greater impact. Where you have a larger degree of impact, you tend to increase the artistic value and emphasize the mood of a

photograph. An excellent example of the managing reflections and refractions can be seen in 3-22.

LIGHT DIRECTION

Because people are so used to overhead lighting from light fixtures and the sun, light coming from diagonally above your subject looks most natural. However, there is no rule that says you have to make your photos look natural. Some of the most impactful macro shots are created by experimenting and playing with what is normally expected. By doing so, you can add a new dimension to the final photograph.

The next time you are photographing a flower, for example, try to use an electronic flash to illuminate it from beneath. If you take the photo from the side and manage to make the top of the flower shaded, the whole photograph can have an eerie feel. You can also try to *backlight* photos (light an item from behind), as shown in 3-6, at the beginning of this chapter.

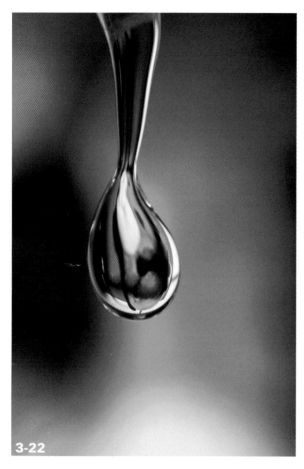

3-22

You can still use a reflector to lift some of the shadows from the top of the flower, regaining some of the balance in the photo. This creates an uncanny atmosphere with which the viewer might not immediately be able to identify the subject, constructing a mystique and intrigue that can draw in viewers, inviting them to inspect an image more closely.

Finally, if you are working with items that have a sharp relief — such as an item of jewelry as pictured in 3-23 — sharp side lighting brings out all the details.

COLORED LIGHT

For the most part, people use white light when working with photography, because it typically gives the most authentic reproduction of whatever you are photographing. If you aren't looking for an accurate reproduction, a rainbow of other opportunities can be used. Using colored bulbs in light fittings or colored gels over your flash units can create amazing, colorful scenes. Photographing a white flower using two flash units with two differently colored filters mounted in front can give some unusual results. The air gun pellet photographed in 3-24, for example, was not particularly interesting until I placed two small pieces of blue-purple plastic in front of the heads of the flash unit.

Personally, I find the intricate world of up-close photography so exciting that I haven't found colored lighting to be of much use, but I have seen photos created by other photographers who put the technique to good use. If you feel that the backgrounds of your images lack impact, or if you want to create a higher contrast in several elements of a photo, you might find it worthwhile to experiment with colored light.

LIGHTING THE BACKGROUND

One way you can make the foreground stand out spectacularly well is by lighting the background differently. A yellow flower with a bright blue background can have a powerful impact and isn't difficult to do. If you have two flash units or two light sources of any type, making sure that the background is as well-lit as the foreground can be as easy as making sure that some of the light is directed at the background. You probably want a separate light for the foreground and the

ABOUT THIS PHOTO
By using only one of the flash units on the MT-24EX, the side lighting shows off every scratch and imperfection. Taken with a Canon MP-E macro lens and a MT-24EX Macro Twin Lite flash. 1/125 sec., f/16.0 at ISO 100.

ABOUT THIS PHOTO
Covering your flash unit with colored plastic or photographic filters can give exciting results. Taken with a Canon MP65-E f/2.8 macro lens and a MT-24EX Macro Twin Lite flash. 1/60 sec., f/4.0 at ISO 100.

background to make sure that you can adjust the two separately. Getting the balance right might take a bit of trial and error, because you do not want to let the background be brighter and have a higher color intensity than the foreground.

When thinking about ways of lighting the background, keep in mind that you are not limited to single, solid colors. You can project patterns onto the background with an over-head, slide, or digital projector; you can put objects in the background and light them carefully so they become part of and add to the photograph overall; or you can try to use several colored light sources to create an intricate background mood.

Although it is tempting — and quite beneficial — to spend a lot of time thinking about what is going on in the background of your photographs, keep in mind that the foreground is most important. Whatever you decide to add to the background should never draw the attention away from the main subject of your photo. The background should complement it — like the wine complementing a main course of a fine meal, for example.

WHITE BALANCE

The human eye and brain are an amazing combination capable of adapting to a wide range of types of light. As such, you are able to identify a surface as white, even if the general light tones in a room are warm (as is the case when a room is lit by light bulbs), particularly cold (such as when it is lit by halogen light sources), or somewhere in between. You can even consistently tell what color something is — and identify an area that is purely white — when a room is lit with a series of different types of light.

A camera isn't even in the same league as a human eye when it comes to color correction. A camera can accurately capture the light and its colors in a room (much like our eyes do), but might have problems compensating for irregularities in light. All digital cameras have an automatic white balance setting, but this system can be confused by the prevalence of a particular color in a frame. *White balance*, then, is the camera's interpretation of what is "white" — or rather, what people would perceive as neutral white in a particular scene.

When working with macro photography, you capture only a small slice of reality at a time, which is a situation with which a camera might have particular trouble. Because of this, you want to use manual white balance. The way you set the manual white balance on a camera varies from camera to camera. Some let you use a photo of a *gray card* (a piece of plastic a color-neutral shade of gray) as a basis for calibration of white balance. On others, you have to select a scene such as sunlight, incandescent light, shade, or flash lighting.

The best way to select the right white balance depends on your style of working and what you are used to. Read the manual that came with your camera to find out which options are available to you and give it a try. If you are unsure what you should be trying, be aware that many current dSLR cameras allow you to take photos that use *white balance bracketing*, in which the camera processes the photo three times, for three different color temperatures.

x-ref

Learn more about white balance, color temperature, and how it all fits together, in Chapter 10.

Assignment

Baby, You Can Drive My Car

Lighting is one of the most important and difficult parts of photography because it has such a huge impact on your final image. To practice what you have learned in this chapter, bring your camera outside and take a detail shot of an automobile. Perhaps there is a part in the engine bay you find intriguing, or maybe the car you choose to take a photo of has an intricate chip in the window. For this photo, use only natural lighting. You can, of course, use a diffuser, a reflector, or block out direct sunlight if you feel that makes your shot a better photo.

When completing this assignment, I decided to use an approach that would allow me to use a juxtaposition of the main image element and some of its surroundings. This photo was taken some time ago, when I was working on a photography project in Arizona. I feel that the Ford Escape logo, combined with the subtle lighting and the palm trees in the background says more about the car than the car itself. To me, this photo screams adventure, and the clean, new paint-work points to the beginning of an adventure as well. The photo was taken with a Canon 28-135 f/3.5 image stabilized macro lens, 1/30 sec., f/4, ISO 200.

Don't forget to go to www.pwsbooks.com when you complete this assignment so you can share your best photo and see what other readers have come up with for this assignment. You can also post and read comments, encouraging suggestions, and feedback.

THE MACRO IN EVERYDAY OBJECTS

To me, one of the strongest appeals of macro photography is the fact that even the most mundane items can become works of intricate art. You and I live in a world in which stereotypes are completely necessary, where a single glance is expected to tell you everything you need to know about a place, an item, or even a person. People don't often have the time or inclination to go in for a second look, to explore the world more closely, and to ask questions.

By using macro photography, you have a tool to change all that. The kitchen chair you've sat on every day during the past five years can be an opulent patchwork of wood grain, tiny scratches, and old, weathered red-wine stains. The handsaw you've used for some do-it-yourself projects on your house is a collage of textures, materials, shapes, and colors. Even your fruit basket is a collection of weird and awe-inspiring colors, textures, shapes, and potential excitement. Just when you finish indoors, there's the big outdoors to explore. Who would have thought that a fence in winter could be a study in intricacy? Check out 4-1 if you have any doubt.

Armed only with a camera, a lens, a brain full of photography knowledge, and this book as a cheat sheet, you can transform the ordinary items around you into works of creative and inspired expression. Life is short, art is long — get cracking.

4-1

ABOUT THIS PHOTO *Frost on a fence. Taken with a Canon 28-105 macro lens. 1/1500 sec., f/5.6 at ISO 100.*

A DIFFERENT WAY OF LOOKING AT THE WORLD

Think about macro from a completely different perspective: the full size of the world. There is a famous photo (see 4-2), taken by NASA in 1968, on the Apollo 8 mission. It is a photo of the Earth. The lazy wisps of clouds wound around the deep-blue planet, suspended in space. When that photo was first publicized, the world stood still. The new perspective offered by clicking the shutter of a relatively simple Hasselblad camera (a high-end, high-precision medium format film camera) through a space shuttle window was a watershed to the way most people looked at the world.

4-2

ABOUT THIS PHOTO *An image that changed the world — but there is a world of photography opportunities within arm's reach, too. Photo © NASA.*

You don't need a multimillion dollar space rocket to see things from a different perspective. If you take portraits, taking them from a low-angle view offers a new frame of mind. If you take a photo of a car from directly above it, you achieve something people rarely see. In both cases, it is nothing new, and the photo doesn't even take a lot of work or preparation. What is unique, however, is the fact that you, as the photographer, were ready to do something special to add a unique quality to your art.

In macro photography, the need for creativity applies strongly as well. Instead of trying to diversify, setting off on the difficult task of showing the whole picture in all its subtlety, you do the exact opposite thing. I'm not interested in showing the whole house. I don't want to show a full person. I'm not even particularly interested in showing a head-and-shoulders portrait, but perhaps just an ear — with an earring.

By ignoring most of a scene in front of you, you have the chance to fragment reality to perceive facets, divide to examine components, and deconstruct with the idea of revealing the building blocks. Show people an image of something that looks distinctively like fiber-optics and state-of-the-art technology — like the photo in 4-3 — and then tell them that they are looking at a toothbrush, and you are instantly affecting the way people think about your photograph and perhaps even the world around them.

The reason chemists find atoms interesting and biologists get excited about DNA sequences is the same thing that drives macro photographers: Finding something special about the mundane and discovering the details that make something unique.

4-3

THERE ARE MACRO OPPORTUNITIES EVERYWHERE

There are an abundance of macro photography opportunities around you, and the more you magnify your subjects, the more opportunities there are. Life-size wallpaper, carpet, fabric (as shown in 4-4), or a metal surface can look interesting. However, if you get in closer, even the simplest items open up an ocean of possibilities. A simple box of matches or a bowl of milk has enough complexity to keep a keen macrographer going for days.

The difficulty isn't in finding opportunities for macro photography, but rather in recognizing the opportunities for what they are. Sadly, recognizing photographic opportunities is

4-4

difficult to teach, but you can develop your eye for photography: All it takes is a combination of practice, inspiration, persistence, and time. After you capture an inspiring macro photograph of something unlikely, you will be unstoppable in your quest to explore the world around you.

EXPLORING THE WORLD AROUND YOU

Where can you expect to find macro opportunities? The true answer is everywhere! A triple-bladed razor blade, a rusty saw blade (as seen in 4-5), or even a ream of paper can provide interesting results. The secret is look for the unexpected, even the uninspiring.

I'll never forget a riddle I spotted in an old magazine when I was young. It was a closely cropped picture of an everyday item. For the longest time, nobody knew what it was. My sister was unable to help and both my parents gave up. I found it infuriating, because — like that tip-of-the-tongue feeling you get when you just know there is a word for something — I recognized the shape of the item, but was unable to place it. Eventually I got it: The item was the rotating part of standard audiocassette tape.

The art of showing your audience just enough that they think they should know what they are looking at, and just little enough to keep them interested, is a careful balance.

4-5

Although it is fun to infuriate your viewers, this isn't the chief purpose of macro photography. The goal of this chapter is to illustrate some of the possibilities for photographing the environment around you.

In school, journalists learn that all good stories are about people. Instead of writing about the 500 people who are affected by an event, you write the story of one of them because people can relate to a single person more easily than a group of 500. The same is true for macro photography: A beautiful photograph can stir feelings and cause emotions. Often the image does not mean anything until it has a story to tell.

Everyday objects can contain a world of subtle stories. Seen up close, a pair of European election ballots (see 4-6) can become symbolic of the frayed struggle between two parties and the black valley of nothingness and disagreement that separates them. Wallpaper, being the skin of a house, can be a landscape of wounds and repairs that are invisible to casual observation, but become fascinating if you look closely enough. Just look at 4-7!

You might have heard the expression, "Eyes are a window to the soul," so why wouldn't pets' eyes be the same? Nobody is going to argue with the fact that getting your cat to sit still long enough to take a picture is like, ...um..., herding kittens. Although the photo shown in 4-8 isn't strictly a macro photo, it illustrates how closeness can add to a portrait. It was the only picture that came out of more than 200 attempts, but this only means that if you do manage to get a good,

ABOUT THIS PHOTO
*Sometimes the simplicity of
strong colors and an interesting
texture can be enough to make
a great photo. Taken with a
Canon MP-E macro lens and a
MT-24EX Macro Twin Lite flash.
1/60 sec., f/8 at ISO 100.*

ABOUT THIS PHOTO
*Wallpaper scratched by a kitten
scar the walls of a house. Taken
with a Canon MP65-E f/2.8
macro lens and a MT-24EX
Macro Twin Lite flash. 1/180
sec., f/8 at ISO 100.*

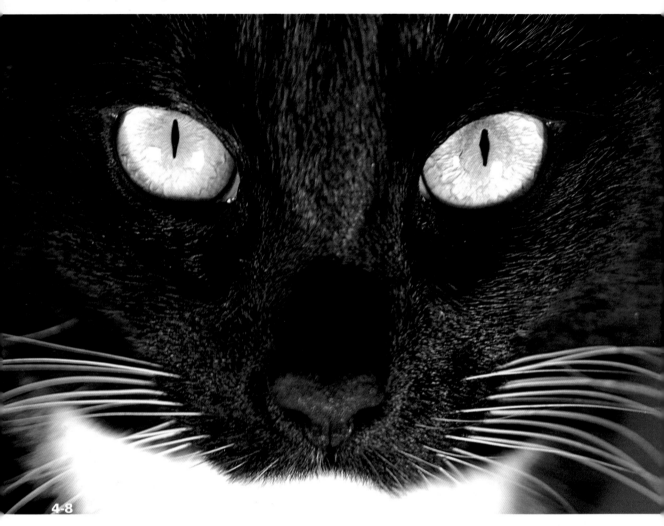

4-8

intimate photograph of your pet, the achievement is all the greater.

Every time you can pick up an object and say, "Oh, this reminds me of the time when...", you have an emotional attachment and a story. All you need to do is to dig out your camera and try to capture the essence of your story somehow.

Another good starting point is games. If you like poker, chess, or perhaps even miniature figures

from role-playing games, you have a wide array of opportunities just waiting for you. I'm particularly fond of chess, so a glass chessboard and some candles are enough to inspire me on a rainy day — just look at 4-9. This image also illustrates what happens if you don't hold the camera still during a long macro exposure. The slight blur is due to vibrations caused by clicking the shutter and *mirror slap* — the movement caused by the mirror moving inside the camera.

ABOUT THIS PHOTO
*With lighting provided only by a
pair of lit candles, this is a good
way to practice macro photog-
raphy. Taken with a Canon
50mm f/1.8 prime lens on a
13mm extension tube. 1/4 sec.,
f/1.8 at ISO 100.*

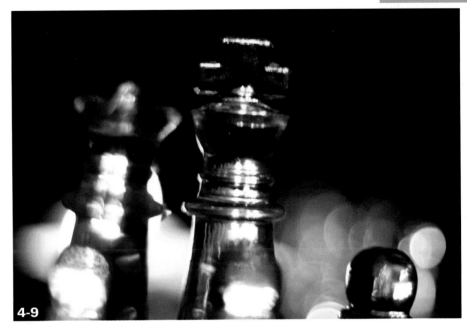

4-9

ACTION MACRO PHOTOGRAPHY

One of the strengths of photography has always
been its ability to freeze time. Before the advent
of photography, it was impossible to see how a
hummingbird moves its wings, how a tennis ball
deforms as it is served, or what it looks like when
a bullet hits an apple at the speed of sound.

In the microcosmos explored by macro photogra-
phers, there are hundreds of similar quick-moving
phenomena that lay unexplored. I have a fascina-
tion with falling water and the way matches flare
up as you strike them, so I decided to take a
closer look.

FALLING DROPLETS

There are photographers out there who have
driven themselves to the brink of insanity trying
to capture the perfect droplet photo. Harold
Edgerton, for example, worked several years of his
life in the mid-1950s hoping to one day capture
the perfect corona — the splash impact of a
droplet in a layer of liquid transforming into a
perfect crown of droplets thrown back from the
liquid. Eventually, through years of trial and
error, he managed to capture his droplet.

Today, photographers have the advantage of
being able to share experience online. Because
most photographers work with digital cameras,

the experimentation time also decreases drastically. Imagine the poor people who had to wait for their film to develop properly, just so they could see if they had finally captured the perfect corona!

Despite the fact that the technical side of capturing droplets is a lot easier, it is still a labor- and time-intensive mission on which to embark. There is something unique about seeing liquids and their motion frozen in time, however, and as a macro photography project, it is excellent.

I have tried capturing droplets on impact on many occasions throughout my photography

lifetime, and every time, I did it a little differently. On the first few attempts, I tried it with an old flash unit connected to a Kodak DC4800 with a PC lead (the same type of connection that connects cameras to studio flashes). The results were not terrible, but the limitations of a digital compact camera turned out to be prohibitive of capturing the photos I wanted. The second time I gave it a shot, I had graduated from digital compacts and was using my first dSLR — one of the first Canon EOS D60s, bought on the very day it was released. The result wasn't too bad, as you can see in figure 4-10, but it wasn't great either.

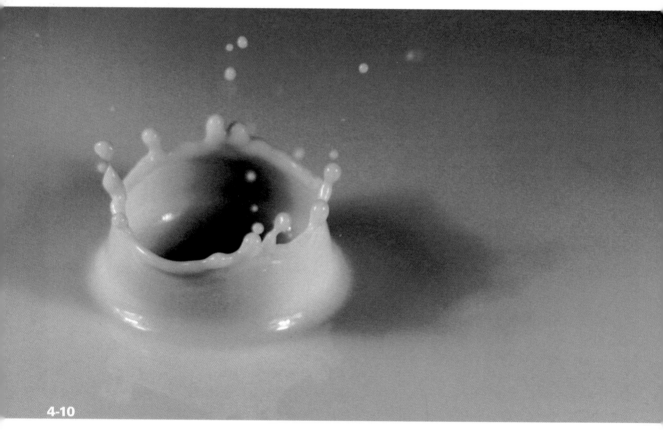

4-10

ABOUT THIS PHOTO *One of my first tries at photographing droplets. Taken with a Canon 135mm f/2.8 Soft Focus, lit by 2x 600 W shop lights. 1/4000 sec., f/2.8 at ISO 100.*

With my shiny new dSLR, I was trapped indoors on a typical miserable rainy day. What could I do other than try to capture some more droplets? This time, I decided to give continuous lighting a try, and I lined up a pair of 600w work lights. Although the light was blindingly bright, in retrospect, there still wasn't enough light: Even the best of my shots that day had a slight tinge of motion blur on them. Although I did get some spectacular photographs, the blur meant that they weren't as perfect as I would have liked.

Throughout my experimentation, however, I did discover one thing: The translucency of water makes it difficult to capture the true dynamic of the fluid. If only there was a purely colored, perfectly opaque liquid I could use — and paint would have created such a mess. My esteemed photography assistant Katherine came up with the idea of using milk, which turned out to be a terrible idea. The hot lamps made the milk turn sour within half an hour, and the smell in my make-shift photo studio stayed for weeks. I've since discovered the perfect liquid: Long-life coffee creamer! This liquid is slightly thicker than water, and doesn't go bad as easily as milk.

When I started writing this book, I decided it was time to revisit the droplet experiment. Armed with a few containers of coffee creamer and using a 28-135mm macro lens with a 25mm extension tube and the Canon Macro Twin Lite flash, I started experimenting again.

There are many ways to capture droplets, all depending on your taste. It's possible to create tranquil photos, like the one Matthieu Collomp shot in 4-11, but personally, I prefer the drama of liquid hitting liquid.

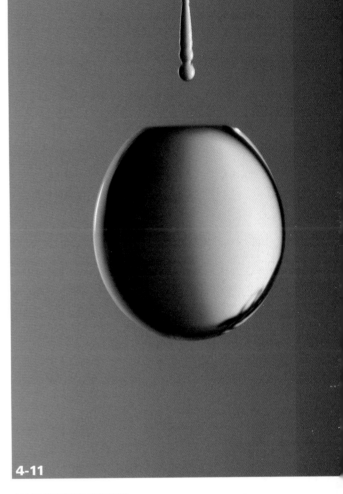

4-11

ABOUT THIS PHOTO *There are many different styles you can use to photograph droplets. This photo shows an elegant way of capturing a droplet in free fall. Taken with a 60mm macro lens. 1/1000 sec., f/3.5 at ISO 100. Photo by Matthieu Collomp.*

For my droplet shots, I used a large, flat surface with a thin layer of coffee creamer in the bottom. I then used an eyedropper to let droplets of creamer fall into the film of creamer. (If you don't have an eyedropper, you should be able to buy one inexpensively at a photography store or pharmacy.) After a few photos, I started getting the knack of the timing (see 4-12), so that I took the photo a fraction of a second after the droplet impacted. From then on, it was four hours of patience, changing the batteries in the flash and camera, and refilling the eyedropper. It is the kind of activity that makes your family and friends question your sanity, no doubt about it, but in the end, I was left with about half a dozen photos I'm very fond of, including 4-13, which is nearly a perfect corona. But only nearly...

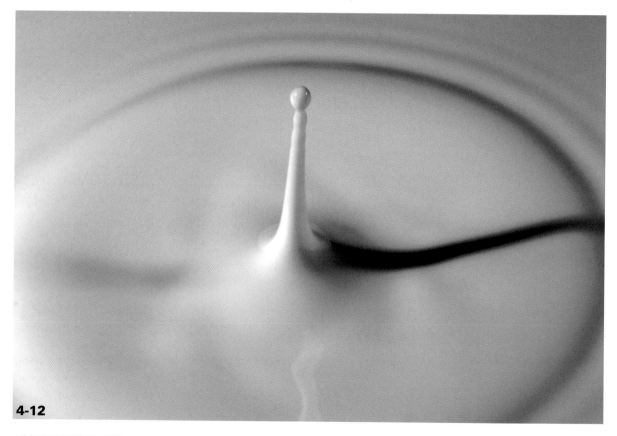

4-12

ABOUT THIS PHOTO *Studying the effect of a droplet's impact is a great way to spend a lazy afternoon! Just after the droplet hit. Taken with a Canon 28-135mm f/3.5 Image Stabilized macro lens. 1/1500 sec., f/8 at ISO 100.*

ABOUT THIS PHOTO
After quite a few tries I finally got the droplet image I hoped for. Taken with a Canon 28-135mm f/3.5 Image Stabilized macro lens. 1/500 sec., f/8 at ISO 100.

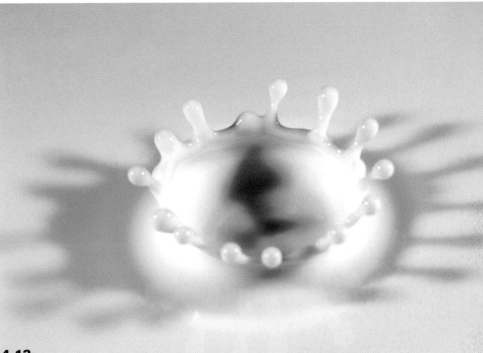

4-13

BURNING MATCHES

Matches are an excellent example of everyday objects that have surprising potential. The allure lies in seeing something common in a new way. Show picture 4-14 to friends and most would be able to guess it is wood. However, they might be surprised to find it's not a tree trunk or a log for a fire, but a match.

The transformation from a boring piece of wood to a flaring ball of fire, via burning a piece of wood, and back to half charcoal, half wood appeals to me for some reason. My first steps

into the world of extreme macro photography were taken specifically because I wanted to take a closer look at how a match appears in its different states of being.

Obviously, working with matches carries an element of danger. Melting your camera lenses or setting your desk or even yourself on fire is not what I would call a pleasant surprise. With a little bit of preparation, the activity can be safe. I use a metal plate on top of my work surface when I work with matches.

4-14

Instead of trying to strike the match and then take a photo of it, I use an empty matchbox as a vice to hold the match I'm about to photograph still. Then I use another match, or a cigarette lighter, to light the match that is in the photo. This way, you can set the whole photo up without any fire being present, and instead of concentrating on your viewfinder, focusing, and manipulating your flashes, you can focus your attention where it should be: On the part of your experiment that is actually on fire. The result of this approach is illustrated in 4-15.

When photographing burning matches, the most difficult aspect to control is exposure. If you don't use a flash unit, the lighting is provided exclusively by the match itself, which is fine, but the light varies a lot. Before the match is lit, there is little light. As the sulfur (or whatever is used on match heads these days) catches fire, there is a colossal increase in the light level, which drops down again after the match is burning normally.

Because no two matches burn the same, it is difficult to plan for every shot, and there is definitely an element of chance involved with capturing these photographs. Normally, in a situation where you can't quite predict the light, I suggest using *automatic exposure bracketing*, or *AEB*, which takes three photos in quick succession, allowing you to hedge your bets on the exposure.

ABOUT THIS PHOTO *Lit by a combination of the fire from the match and a flash unit. Taken with a Canon MP-E macro lens and a MT-24EX Macro Twin Lite flash. 1/750 sec., f/2.8 at ISO 100.*

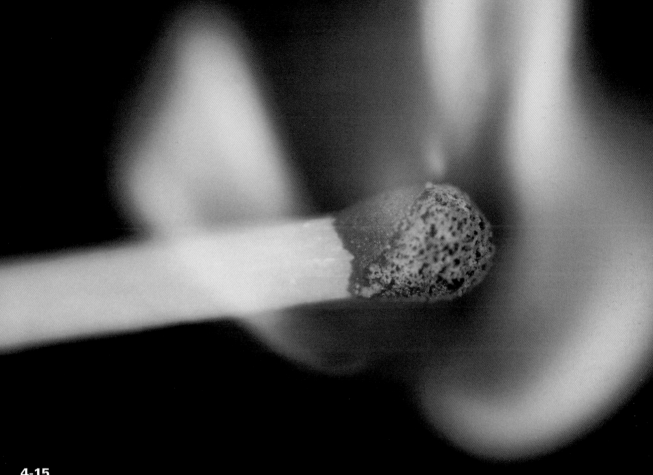

4-15

In this particular case, however, the light situation changes in fractions of a second, and taking three photos with different exposure values is even more hit and miss.

Despite the complications of photographing matches, there is no reason why you need expensive equipment to take good photos of them. Photo 4-16, for example, was taken with a macro extension tube I built myself out of a Pringles can. In terms of quality, it doesn't fall shy of the photos taken with lenses costing more than $1000. It also illustrates the concept of *negative space* — the quality and shape of the area other than the main subject.

ⓟ *x-ref* Photo 4-16 was taken with a home-made lens that cost less than $10. To find out how to make your own, check out the section on extension tubes in Chapter 2.

4-16

ABOUT THIS PHOTO *The contrast of new and burnt wood, along with the negative space, make this an attractive photo. Taken with a reversed 50mm lens in a homemade extension tube. 1/3 sec. at ISO 100.*

LIGHTING A BURNING MATCH The correct lighting for photographing matches that are going through conflagration is best found through experimentation. Try a few test shots until you find a nice balance between getting enough of the texture and detail of the flame, while retaining some of the wood grain of the match.

Personally, I find that the light emitted by the match is best complemented with a slight burst of flash. Setting the flash to manual mode and using only 1/32 of full power seems to be enough to add that little bit of extra definition needed in the wood grain and in the match head itself. The idea is that it is impossible to remove light from an image, so you have to set your exposure to a value that works well for the fire, and then add flash to lift the rest of the match out of the shadow.

PHOTOGRAPHING SHINY OBJECTS

In commercial environments, macro photography is used predominantly in research and advertising. For the latter, jewelry and small mechanisms are most frequently your subjects. Whatever you'll be photographing, it is likely to be a reflective surface, which creates several difficulties for an unprepared photographer. Metallic and liquid surfaces are particularly challenging because the reflections of the room around you are detrimental to the final result of your photos, and the whole situation is made doubly difficult by the fact that any light you shine on the metallic surface causes unsightly highlights on your subject. By using careful planning, like on the droplet shot at 4-17, you can create an even lighting, which helps reduce the reflections you encounter.

What do you do when someone asks you to take a photo of a wedding ring or a wristwatch? Take care in lighting the object and keep a close eye out for reflections.

LIGHTING

Lighting reflective surfaces is complicated business, largely because they don't have color or texture to keep things interesting. As you have only the shape of the object to work with, you have to use lighting creatively to highlight the object itself.

ⓟ x-ref For more detail on lighting and light tents check out Chapter 3.

ABOUT THIS PHOTO
Using a light tent can be useful for many photography genres. This photo, for example, lacks the specular highlights seen in the other droplet photos. Taken with a Canon 28-135mm f/3.5 IS macro lens.

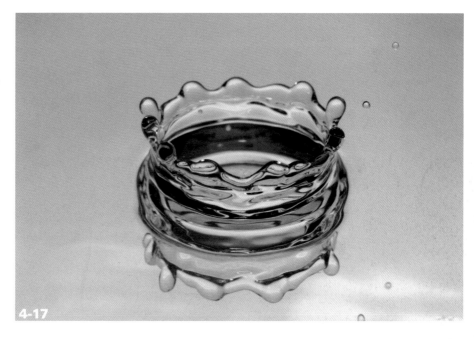

4-17

There are many ways to add interest to lighting reflective surfaces. An old classic is to use Venetian blinds to create a striped pattern on the surface you are trying to photograph. Effectively, you are adding a texture to a surface that doesn't originally have one, but it is a necessary evil in order to capture the shape of your object properly.

Other shapes worth trying include checkerboard patterns or concentric circles. These might seem to be more difficult to project onto your surfaces, but they don't have to be. When photographing reflective surfaces, you want to be careful about what you reflect, so your subject should be in a light tent anyway. This offers the opportunity of sticking shapes on the inside of the light tent in black cardboard. Any shapes stuck to the inside of the tent are reflected in the items you are photographing, and all you need is a bit of creativity to make things interesting!

REFLECTIONS

If the item you are trying to photograph is a rough, matte surface, you're in luck. You won't have too much trouble with reflections. However, if your task is to capture an item that is made from metal polished to a mirror finish, you can encounter challenges. The problem, of course, is that curved items with a mirror finish effectively work as a 180-degree mirror. That means that your photo includes absolutely everything that is around you. In effect, you aren't just photographing the item, but the way it reflects the world around you.

The only way to eliminate all reflections is to remove all light sources. Because you need some light to take photos, that's hardly a useful solution. A better approach is to recognize that you cannot do away with the reflections, and the only useful way of going about photographing these items is to try to create a reflection that emphasizes the shape and surface of the item.

One way to reduce reflections is to place the item you are trying to photograph in a light tent. This is an even-colored enclosure of a single color — normally white — with a hole designed to aim your camera lens through. In theory, the completely white surface means that the only reflection present on the item you are immortalizing is that of your camera lens. Because it is visible only in a small area of your photo, you can choose to ignore it, or use a digital photography editing package, such as Adobe Photoshop, to carefully edit the front of your lens out of the image. The result looks something like the photo in 4-18!

Many photographers feel that the inside of a light tent actually makes the environment too sterile and lacking in feeling, and choose to dress up the inside of their light tent to re-introduce controlled reflections. Running two thin black strips along the top of a light tent, for example, adds definition to a metallic sphere and might also offer interesting results on jewelry and other reflective items.

Lighting a photography tent is an interesting exercise and can be done either with continuous or instantaneous light. Because most light tents are white in color, they can be used as diffusers. By placing a light source on either side of the light tent, its contents are lit in a soft, omnidirectional light, which helps reduce reflections and assists in bringing out the best qualities of the item you are trying to photograph, as in 4-19.

Adding a more three-dimensional feel to the items can be achieved by varying the brightness of the light going into the tent by letting one of the light sources be brighter (or, if the brightness cannot be individually adjusted, by moving one of the light sources farther away).

x-ref | Learn more about diffusers in Chapters 2 and 3.

ABOUT THIS PHOTO
A pair of rings photographed in the studio using a light tent. Taken with a 60mm macro lens, 1/60 sec., f/11, ISO 100.

4-18

ABOUT THIS PHOTO
The level of detail captured on this watch would have been impossible without using a light tent. Taken with a 105mm f2.8 AF-D macro lens. 1/250 sec., f/8, ISO 100

4-19

Assignment

Now You See It. Now You Don't!

Every now and again, you're presented with a scene taken out of context. Without the necessary surroundings, and on an odd scale, how do you know what the photo is of?

There is a special kind of pleasure that can be derived from presenting a photo to your friends that makes them ask, "That's gorgeous! What is it?" Leave them guessing for a while, and eventually, you can reveal your secret.

For this assignment, take an everyday object that most people are familiar with, and try to capture it in such a way that an observer won't realize what it is — until you tell them.

Can you guess what I chose to capture? I took a unique photo of a cigarette lighter, which was held in a clamp on my work desk in my studio. Most people don't notice the flint mechanism, so that's what I focused on. I used a Canon EOS 30D with a reversed 50mm prime lens on a 24mm extension tube. I lit my scene with a halogen desk lamp and took the photo with the lens fully open (f/1.8) 1/45 sec. at ISO 100.

Don't forget to go to www.pwsbooks.com when you complete this assignment so you can share your best photo and see what other readers have come up with for this assignment. You can also post and read comments, encouraging suggestions, and feedback.

Flowers — you give them to people you love because you love them, or maybe because you need to apologize, or perhaps a bit of both. Either way, in the natural world, they're only around for a few months at a time, leaving the rest of the year to be a rather drab affair. Or, in more temperate climates, they can change from season to season.

For those of you in areas where the seasons change to bring cold and even snow, you might be hard pressed to find anything that cheers up those months like having a beautiful framed print of a gorgeous flower hanging on the wall (such as the bright-colored example in 5-1). It's like a

game, and you get extra points if you've taken the photo yourself. There's nothing quite like responding to a guest's compliment of your wall art with "Oh, yeah, I took that in Madagascar last year." (Never mind that you took it in your local botanical garden!)

This chapter shows you how to overcome the different challenges that arise when photographing flowers. It also contains more fantastic photos than you can shake a vase at. With a bit of luck, you will be filled with so much inspiration that you gather up the camera and the book and head to the nearest plant!

5-1

ABOUT THIS PHOTO *This flower was found and photographed at Bristol Botanical gardens. Taken with a Canon 135mm f/2.82.8 lens on bellows. Bellows extended to approx 50mm. Lighting was direct sunlight. 1/1000 sec., f/5.6 at ISO 100.*

CHALLENGES WHEN PHOTOGRAPHING OUTDOORS

When you take photographs indoors you can control the environment fairly easily. Moving outdoors changes everything. Suddenly you need to consider a wide variety of new variables. Some of the challenges include: lighting, wind and weather, finding an appropriate background, and composing a dramatic photo.

LIGHTING

Photography is all about light. The word photography means writing with light. Without light, there can't be any photography. As a photographer, then, you control the light where you can — and where you can't, and you find a way to make the best of the situation. Outdoor photography often falls in the latter category, making it a challenge. Natural lighting — such as the lighting shown in 5-2 — can be your best friend. Of course, it also helps that the camera used in this photo (Canon Digital Elph S500 — a compact camera) has a lens and *digital imaging sensor* that allow you a great degree of sharpness and depth of field, even in macro mode!

In addition to lighting issues, wind can become your worst enemy. Working with macro photography means that shutter times typically are longer than for a snapshot of a person or a building, for example. In addition to camera shake, you have to find ways around your subjects shaking like leaves in the wind, especially if they are, in fact, leaves in the wind.

ABOUT THIS PHOTO
This flower was photographed at St Michael's Mount, a tourist attraction in Cornwall. I like the slightly unreal feel of the photo (along with the unconventional composition). Taken with a compact camera in macro mode, 1/125 sec., f/7.1 at ISO 50.

5-2

AVOID CAMERA SHAKE! Any movement can be enough to ruin a photograph. However, your subject isn't the only thing that can move. Your camera can too, and you need to avoid both types of movement in macro photography. The first step toward avoiding camera shake is to make sure your camera is on a sturdy tripod, with a tightly locking mount. When you are working with macro photography, any movement is disruptive to the photo, even the vibration caused by pressing the shutter release button. Using a remote control is crucial to avoiding such movement.

dSLR cameras have a mirror inside. When you press the shutter button, this mirror moves aside to reveal your imaging chip so the photo can be taken. In some cases, the movement the mirror makes (known as *mirror slap* — it is the reason for the characteristic sound an SLR camera makes) creates enough vibration within the camera to make your image blurry.

Most SLR cameras have a custom function that allows you to lock up the mirror before you take a photo. Consult your camera manual to see how you can turn it on. *Mirror lock-up* means that the mirror moves out of the way of the imaging sensor at the first click of the shutter. The photo is taken on the second press of the shutter button.

WIND AND WEATHER

You can't change the weather any more than you can predict it correctly 100 percent of the time. This means if you plan to take pictures outdoors, you need to find ways to work with the weather you are given.

Your biggest enemy when taking macro photographs outdoors is, in fact, the wind. When working with extreme close-ups, the movement of the mirror inside your camera can be enough to induce visible camera shake. Needless to say, if your subject is moving at all, it can easily render your photos a big blurry mess. To avoid this, you can use an umbrella as a wind shield by placing it next to the flower or plant you are photographing. This makeshift device means you can capture the photograph without getting disturbed by even a slight breeze, as illustrated in 5-3. As an added benefit, the umbrella can work as a diffuser at the same time.

Rain is also a contender in the biggest enemy category; however, if the rain isn't torrential, it is perfectly possible to go take some photos. Dramatic skies make for excellent backgrounds for flower photos, and a bit of fill flash can add enough spark to your foreground, so that people never have to know it was raining just before you took the photo. Not to mention the water droplets on plants during or after a rainstorm can add interest to your photos.

> ℗ *tip*
>
> All photographers should have an umbrella as part of their photo gear. It can be used to shield your photo subjects from the wind and serve as a lighting tool. I suggest investing in a black or a white umbrella. A black one can be used to block out the sun, if necessary, and a white umbrella can be used as a reflector or diffuser.

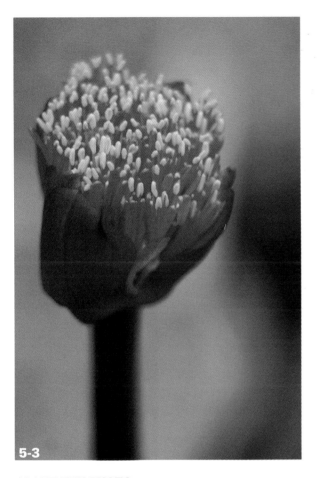

5-3

ABOUT THIS PHOTO *This flower was photographed using a white sheet taped to an umbrella frame as a diffuser, which blocks the wind and provides perfect lighting. Taken with a 135mm f/2.8 lens on bellows extended to approx 35mm. 1/250 sec., f/3.5 at ISO 100.*

CHOOSING A BACKGROUND

Photographing flowers isn't easy; it is tempting to concentrate on getting the right flower, capturing it at its best angle, and making sure the lighting is right. Don't fall into the trap of forgetting about the background, though. With flower photography, if the background color and texture doesn't work with the foreground, it does not matter how beautiful your flower is. Ignore the background and you can ruin a potentially great shot, and the photo will never look as good as it can.

When photographing live plants, if you have to, you can carefully bend the flower to a position in which you can utilize a more suitable background or you can place something in the background yourself. Colors that are quite similar to the color of the flower (light blue on dark blue or vice versa) or contrasting wildly (blue on orange or yellow on red) can create eye-catching photos. Because the background is likely to be out of focus anyway, don't hesitate to use a jacket, sweater, or piece of colored paper — whatever you have handy when you see a good shot — for the background.

COMPOSITION

Choosing an effective composition for flower photography depends on many different factors, and there is no right or wrong way of composing an image. This is true for all genres of photography, but especially for macro photography.

Generally, in photography there are some rules for composing an image. The most applicable rule is the *Rule of Thirds*. Imagine two horizontal lines dividing the image into equal thirds, and then two vertical lines dividing the image into equal thirds. This gives you an image with nine squares. According to the Rule of Thirds, you should try to place the most interesting sections of an image along the lines or (even better) on the intersections of these imaginary lines. In figure 5-1, the focal point of the image is placed in the top left intersection, which means it adheres to the Rule of Thirds. In the case of this particular image, centering the middle of the flower on the middle of the frame was possible but would have been far less interesting. In fact, throughout this entire chapter, only photos 5-4, 5-9, 5-11, 5-16, and 5-18 have not adhered to the Rule of Thirds.

Now that you know the rule, it's time to start breaking it (in photography, that's what rules are

for). As with most rules, it helps if you know the rule, so that you can put consideration and contemplation into how and why you are breaking the rule. For most of the rule breaking done in this chapter, the sole reason for rebelling is quite simple — in some cases (especially in photos 5-16 and 5-18), the centered look is a more powerful expression of the dynamic of the flower.

SELECTING FLOWERS TO PHOTOGRAPH

Flowers are a beautiful addition to any landscape. They add a touch of color to the otherwise rather monotone browns and greens of a typical outdoor lawn. However, there is a big difference between flowers that look good in their natural environment and flowers that look good as prints hanging on your wall.

No amount of photography skills, lighting tricks, selective depth of field, or post-processing can help you if the flower you chose to photograph isn't quite up to par, so it is well-worth investing a bit of time in carefully selecting which plants and flowers to photograph. If there is a particular type of flower you want to photograph, choose the best specimen or the most perfect blossom on the plant.

On occasion, if you just can't find that flawless bloom or it was the color or shape of the petals that interested you more than the flower as a whole, try doing abstract detail shots, like the one shown in 5-4.

5-4

ABOUT THIS PHOTO *This is the underside of the flower. I like the subtle color play and the minimalist composition. Taken with a Canon 50mm f/1.8 lens on a 13mm extension tube, using a flash unit on an off-camera cord. 1/500 sec., f/1.8 at ISO 100.*

WILDFLOWERS

Despite the challenges inherent in trying to photograph flowers in their natural habitat, there are many reasons to try to get out and capture them. It's an excuse to get out into the sunshine for a couple of hours; you're unlikely to struggle with too little light; and photographing anything in its natural habitat makes it easier to get the background right as well.

Finding wildflowers can be harder than you imagine. Sure, finding flowers is easy, but in most areas, the variation of flowers is paltry, and there's only so many ways you can capture a daisy or a buttercup.

There are a few things you can do to spice up your wildflower photography, as I've done in 5-5. Obviously, if you're going on a holiday to a new part of the world, it's a cardinal sin not to bring a camera along with you to document some of the new, strange, and mysterious plants and flowers you might come across.

Of course, you may not have that luxury. So, try these ideas:

5-5

ABOUT THIS PHOTO *I had been eying this Allium over my neighbor's fence for a while. I quite like the impressionistic painted appearance and the composition. Taken with a Canon 135mm f/2.8 soft focus lens. 1/2000 sec., f/2.8 at ISO 100.*

■ **Find new and intriguing settings.** You don't have to jet set around the world to find new settings; however, leafy forests, evergreen forests, wetlands, mountains, rivers, and drier areas all have distinctive floral differences. It is foolish to ignore the array of horticultural options you probably have within walking or driving distance, all of which offer a new set of possibilities for macro photography. On your photographic explorations, if you come across rare, unusual, or particularly beautiful flowers, all you have to do is to capture them as well as possible, because they seem to tell their own stories. The results will be gorgeous simply because the subject is less known, such as the fly-eating plants captured in 5-6. The true test of your photographic skills lies in photographing flowers most people are familiar with in such a way that they realize a previously unnoticed beauty about the flower.

■ **Add drama to your photos.** One way you can lift a flower to the next level is by adding something yourself. A bright orange flower might benefit from having a blue background — so don't hesitate to add one. Most flowers can look amazing with a misting of water droplets on them, so if you think it'll improve the photo, use a mister bottle to add a fine spray of water on the plants you are trying to capture, as I did when I took the photo shown in 5-7. The mister bottles you get with cleaning fluids inside are perfect. Just be sure to thoroughly clean them before you use them to provide a dewy effect.

■ **Go to a botanical garden.** The final place you can look for wildflowers is technically cheating, but nobody who sees the photos is going

ABOUT THIS PHOTO *This picture makes me laugh every time I see it. I can't help but think about two opera singers singing a duet. Taken with a 70-300mm f/3.5 macro lens at 300mm. 1/500 sec., f/9 at ISO 320. Photo by Anna Badley.*

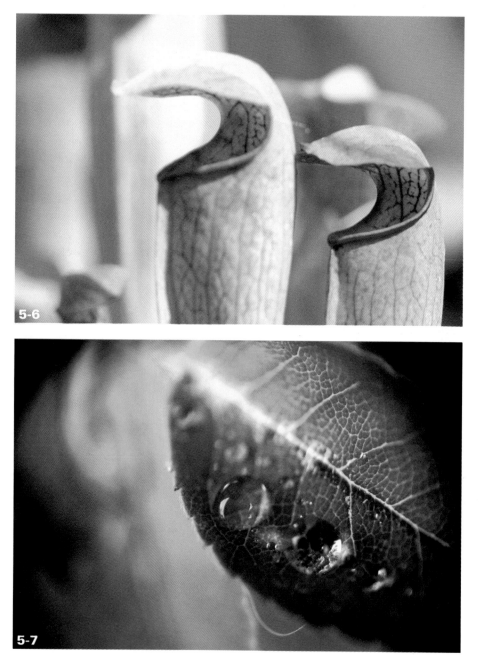

ABOUT THIS PHOTO *Try splashing the plants with some water yourself — they won't mind! Taken with a 55mm + 58mm lens reverse-stacked on top of it. 1/60 sec., f/5.6 at ISO 400. Photo by Hilary Quinn.*

to know unless you tell them. Most cities have a botanical garden that is frequently connected to a university or a zoo. The gardens are usually quiet, have an inexpensive admission fee, and offer a wide array of different plants, weeds, spices, flowers, and so on. Depending what time of year you are going, the gardens might be offering tours of the nurseries. Remember to ask about the nurseries even if such tours are not announced — some of the most surprising photos I've taken (especially of cactuses) have been in hidden-away nurseries at botanical gardens.

BUYING FLOWERS

If facing the grim, cold, outside world doesn't interest you, there is, of course, a way around it in the tried and tested form of capitalism. At any flower shop, you can choose from a wide variety of plants. If you have been thinking about buying someone flowers anyway, seize your chance to get some photography done and to make someone smile.

> **tip** If anyone you know well is getting married, bring your camera and macro gear and get to the wedding location early. Capture some of the flowers that are part of the theme of the wedding. The newlyweds will appreciate a nicely framed photo to remind them of the special day — especially if it isn't one of the classic posed photographs.

If you're going shopping exclusively for photography purposes, the approach is slightly different. I find that as a general rule, photographing flowers on their own gives a more powerful impact than taking photos of them as part of a bunch. It is a good idea to tell the shopkeeper why you're there — you're not after a bouquet of flowers that go well together, you are just after some perfect-looking flowers to photograph. Chances are that they have leftover flowers that have broken off as they were preparing a bouquet. They might have single examples of exotic flowers you can buy at a discount, and if you are particularly lucky, they might even have some spare stock you can have.

When photographing flowers that you've bought, there's no reason why you can't take photos of them outdoors, as done in picture 5-8. An exotic flower against a backdrop of daisies, for example, catches the eye of observers and makes them try to figure out what is going on in the photo. If you manage to arouse their curiosity, the photo is already a success!

FLOWER SHOWS

Of all the situations I've encountered when working with close-up photography, flower shows are amongst the most surreal. They come in many different forms, but often they are combined display and sales shows, run for enthusiasts by even bigger enthusiasts.

I'm a big fan of orchids. There are more than 20,000 species of orchids, and enthusiasts have created more than 100,000 different hybrid species. Orchids come in all colors of the rainbow, and their size varies from barely visible to as big as a human head. Also, they come in the most outrageous shapes, such as the hybrid shown

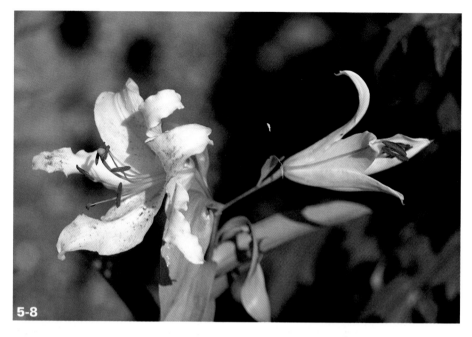

5-8

ABOUT THIS PHOTO
The only way to photograph these lilies was to take them outside. Taken with a Sigma 70-200 DX f/2.8 lens at around 150mm. 1/4000 sec., f/2.8 at ISO 100.

in 5-9. When you start talking about zygomorphs, epiphytes, and in-vitro symbiotic cultures, you know it's time to seek professional help. All joking aside, orchid shows are an amazing source of photo opportunities, and the people who grow the plants are generally knowledgeable, helpful, and enthusiastic about having their wares photographed.

If you are considering going to a flower show, it is worth enquiring when they are expecting a lull in patrons. If you explain you are a photographer, chances are you can arrange to enter earlier or stay later than the regular posted hours.

tip If you want to find a flower show near you, try asking at your local garden center. Frequently, they receive information, flyers, or posters for events. Plugging "orchid shows" into a search engine along with the name of your state or country can also help.

Lighting at flower shows can be extremely varied. Sometimes the show is inside a massive greenhouse, which means that if the sun is out, you'll have more than enough light. Other times, you'll find the flowers lit by strongly directional artificial lighting, heat bulbs, practically no light at

all, or — worst of all — a combination of all the above, which was exactly what weakened the impact of photo 5-10.

Be aware that some flower species don't handle bright light well. If a flower is set apart from all the others and doesn't seem to be lit, it is worth finding a knowledgeable person to ask if your flash might disturb the flower's well-being. There's nothing quite as embarrassing as being escorted off the premises for clumsy mistakes.

Shooting at flower shows can be a challenge — there normally isn't a lot of room to maneuver, there are quite a few people milling about, and setting up and taking down a tripod in the middle

of all this can be daunting. If you have a reasonable flash gun and a good macro lens that allows you to photograph from a small distance, using a *monopod* (a one-legged tripod) can be an excellent alternative to using a tripod. You get a lot of the stability you need, but you will not be in people's way as much, and you are less likely to knock over things.

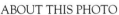 *tip* Passionate about orchids? Many botanical gardens have special displays for these unique flowers. If you happen to be dropping by Singapore, make sure you don't miss the National Orchid Garden in the Singapore Botanic Gardens — it is recognized as one of the most impressive and varied orchid displays open to the public!

ABOUT THIS PHOTO
Wild colors, unpredictable shapes, and dramatic arrangements are typical for orchids, and they can all be experienced at an orchid show. Taken with a compact camera in macro mode. 1/125 sec., f/2.8 at ISO 200.

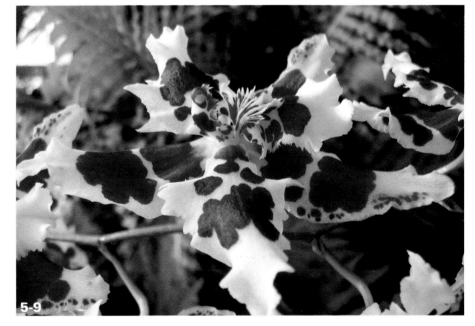

5-9

ABOUT THIS PHOTO *I used a flash gun on an off-camera cord held up and to the left of the flower. Taken with a Canon 135mm f/2.8 soft focus lens mounted on a sturdy tripod. 1/60 sec., f/2.8 at ISO 100.*

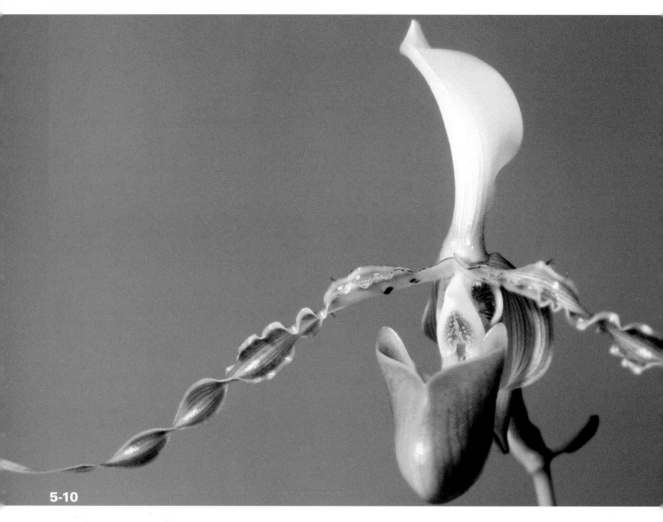

5-10

WORKING WITH DEPTH OF FIELD

Focusing in general is the bane of all photographers, and it is one of the first hurdles a fledgling photographer has to clamber over. In macro photography, focusing in on your subject is a much bigger challenge, because the *depth of field* is so narrow.

WHAT IS DEPTH OF FIELD?

The theory of depth of field (DOF) is extremely complicated, and I think it is safe to claim that the full theoretical implications of the concept are beyond most photographers. Luckily, DOF is easier to understand in practical terms.

Imagine you were trying to photograph this book. Focus your lens on infinity, and look at a period

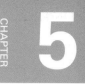

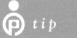 *tip* Explaining the theory of DOF in great detail is far beyond the scope of this book. If you'd like to learn about strangely named terms, such as hyper-focal distances, the circle of confusion, and the mathematics behind DOF, I warmly recommend the well-written and comprehensive article on DOF at Wikipedia (www.wikipedia.com).

at the end of any sentence on the paper. It will probably be blurry and quite large, because it is out of focus. When you start turning the focusing ring on your camera, the dot becomes smaller and smaller until it is in perfect focus. If you continue turning your focusing ring, the dot starts to become blurry again, and seems to grow in size. Return your lens to perfect focus, and move the piece of paper slightly farther away from the camera. The dot is still in "acceptable focus" in an area farther away and closer to the camera than perfect focus. This is the DOF of this particular lens at this particular aperture.

If you select a smaller aperture (a higher f-stop), your DOF generally increases. Whereas selecting a small aperture, such as f/22, gives you a vast DOF in landscape photography, you gain little depth of field when working with macro photography at smaller apertures. The bottom line is that we have to consign ourselves to working with extremely low DOF when working with macro, as shown in 5-11.

Most dSLR cameras have a DOF preview button, which stops the lens down to the aperture selected using Av (aperture priority) or M (manual) mode, or the aperture calculated by the camera in Tv (shutter priority) or P (program) mode. Sadly, doing this usually makes the viewfinder so dark that it becomes nearly impossible to focus properly. When focusing on something, your lens

operates at its largest aperture. That means you get the best idea of where the point of focus is, but don't get any indication of which part of the image is in focus. Luckily, working digitally, you can afford to take a photo and immediately inspect the image on the LCD display to see if the subject of your photo is adequately in focus.

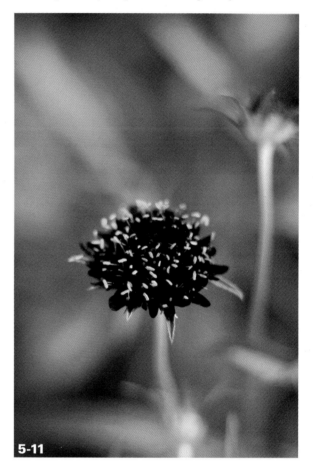

5-11

ABOUT THIS PHOTO *Although the lens was stopped down to f/11, only a very limited amount of this photo is actually in focus. Taken with a set of bellows extended to about 30mm, and a reversed 50mm f/1.8 prime lens. 1/250 sec. at ISO 100.*

WORKING WITH SHALLOW DOF

Shallow DOF can be a pain in the backside for many reasons, but there's an old saying that goes something like, "If you can't beat them, join them." Seeing that we can't do a lot about shallow DOF, we might as well see if it is possible to turn it to our advantage.

One advantage to having a limited area in focus is that you have the opportunity to guide the viewer's eyes to the part of the photograph you feel is important. People are naturally inclined to try to identify what an image is, and to do so, their eyes go straight to the sections of the

photograph that are in focus. This means that the parts of the image that are out of focus are less likely to disturb the photograph. In fact, they offer an opportunity to liberally use *negative space* in your images, like already shown in 5-4, 5-10, and, to a degree, 5-11.

The concept of negative space is present in most art forms, and it is best described as the space that isn't part of the main subject of a photo. The shape and quality of this negative space can have an impact on how a photograph is perceived, as spectacularly demonstrated in 5-12.

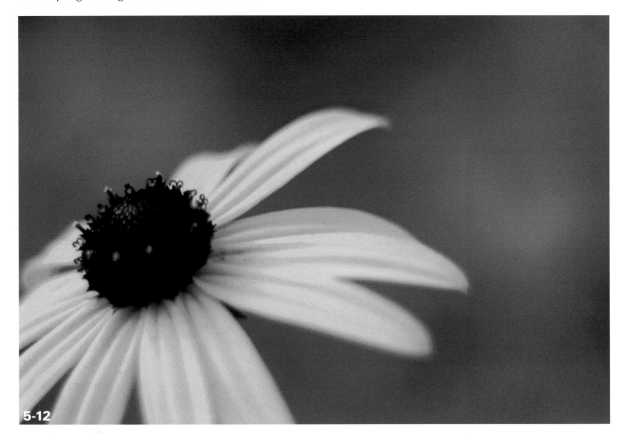

5-12

ABOUT THIS PHOTO *In figure 5-12, the background is a bright blue backpack. The flower is shaded by a diffuser for soft lighting. Taken with a Canon 28-135mm IS f/3.5 macro lens on a 24mm extension tube. 1/250 sec., f/3.5 at ISO 100.*

Because only a thin sliver is in focus when working with macro photography, the quality of the out-of-focus areas becomes important. The quality is known as *bokeh*, from the Japanese word for blur. Different lenses have different out-of-focus areas, and the discussion of why one lens has a more aesthetically pleasing bokeh than another is a controversial one in the world of photography. The discussion seems to center on the photographer's personal taste. Keep in mind that one lens renders a scene differently than another, even though the foreground might be identical.

Getting the background out of focus is easy. In fact, it is practically impossible to get the background *in* focus. There are a few things you can do to achieve a perfect focus on your subjects. First, determine if it is possible to get the whole subject in focus in the first place. If it is, you need to think about whether that's actually a desirable outcome. Perhaps the photo you are trying to compose might look better if only part of the subject were in focus, such as the flowers photographed with selective focus in 5-1 and 5-13.

Deciding on in focus versus partially in focus is something that comes down to preference, and it takes a lot of experience to be able to visualize what a photo will look like if it is partially in focus. For this reason, it is a good idea to take photos using various states of focus and different focal points.

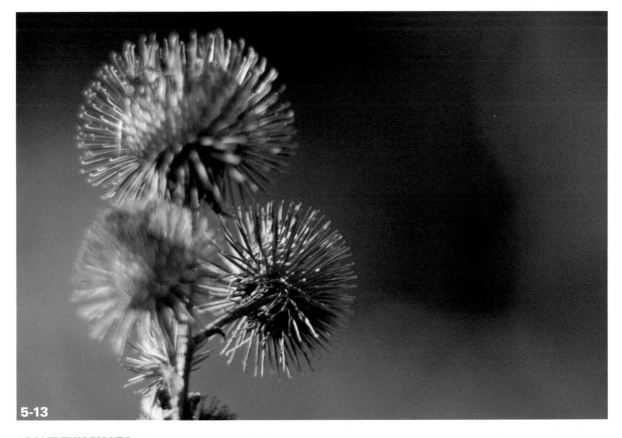

5-13

ABOUT THIS PHOTO *Although the photo in figure 5-13 breaks every rule of composition, the limited focal point makes it much more dramatic. Taken with a 135mm f/2.8 lens on bellows extended to approx. 65mm. 1/1000 sec. at ISO100.*

PARALLELING YOUR SUBJECTS

When working with extreme close-up photography, the extremely shallow DOF means that finding the right focal point can be tricky. In addition, getting the whole subject in focus can be difficult. To get everything in focus properly, the subject has to be parallel with the *focal plane* (the direction of the imaging chip in your camera) of your camera. This is known as *paralleling* a subject.

The purpose of paralleling your subjects is to give the camera a chance to capture the whole subject in focus after the lens is stopped down to an aperture that affords slightly higher DOF than photographing with the lens wide open. By doing this, everything that is at the same distance away from the lens is in focus. In 5-14 the cactus has a beautiful texture. If the whole plant had been in focus though, the image might have lacked a point for the eye to be drawn toward. However, paralleling enabled me to select the flower as the part of the image I wanted to have in focus.

When you are taking a photo of something — say, the striking surface of a match — at a slight angle, parts of the subject are farther away from the camera lens than others. This means that only part of the subject can be in focus. If you would like to capture more of your subject sharply, you have to make sure that the whole subject is exactly the same distance away from the camera lens. Imagine you are trying to take a photo of a playing card. Put it flat against your camera lens, and then move the lens away from the playing card in a straight line. It is now in focus!

Most of the time, you are not photographing playing cards (I have respect for niche photography, but playing cards sounds a bit dull), and the vast majority of your subjects aren't going to be flat, so paralleling your subject is going to be quite a challenge. Frequently, it is impossible to get a given subject completely in focus. One example of this is 5-15: Getting it in focus would

ABOUT THIS PHOTO
Taken with a 135mm f/2.8 lens on bellows extended to approx. 60mm. Lighting was provided by the sun shining into a green-house through a layer of clouds. 1/180 sec. at ISO100.

5-14

ABOUT THIS PHOTO *This plant wouldn't have looked out of place in the movie Alien! Taken with a 135mm f/2.8 lens on bellows. Bellows extended to approx. 35mm. Natural lighting. 1/45 sec., f/3.5 at ISO100.*

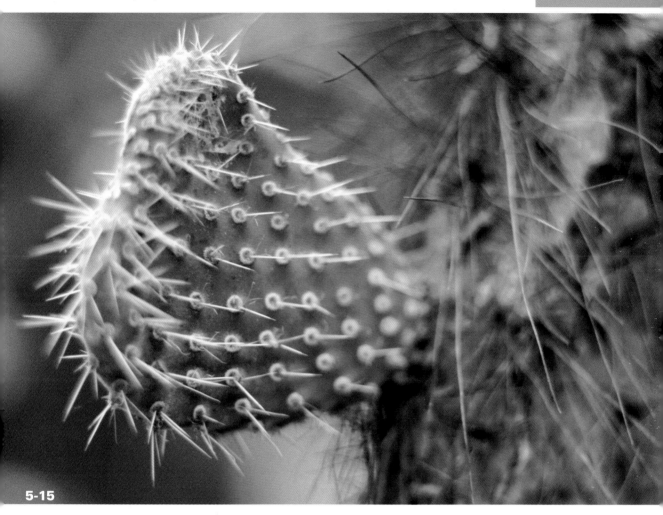

5-15

have meant moving farther away, and you'd lose the interesting angle. Instead, I focused on the fleshy bit of the plant, which drops the rest of the cactus out of focus: A much more interesting composition.

LIGHTING TECHNIQUES

The word photography literally means "writing with light," (from the Greek word "photo" meaning light and "graphos" meaning to write) and it follows that lighting is quite important. It should be obvious that without light there would

be no photography, but it might be a little less obvious that better lighting leads to better flower photos.

NATURAL LIGHT

When working outdoors, it is tempting to just make the best of the natural light that is available. A good idea, to be sure, but natural lighting isn't necessarily the best thing. Direct sunlight, in particular, can be difficult to work with, because it is tricky to control, bathes the subject in strong light, and casts dark shadows.

In some scenes, working with sunlight can be an advantage, because you can almost certainly stop down the lens a little and still enjoy fast shutter times. You can even try to deliberately throw a shadow on the background of the image. If you expose correctly for the foreground and throw a shadow on the background, your flower will seem as if it is hovering in a sea of black. If your subject is strong or light-colored, this can be a rather appealing effect.

Most of the time, however, a cloudy day is more desirable than direct sunlight. The clouds work like a giant diffuser, which means that instead of being bright and throwing harsh shadows, the sunlight is omni-directional, gives more even lighting, and throws softer shadows.

REFLECTORS

You can't control the clouds, and if there are none, you might have to get creative to control the bright, direct sunlight. One way to take the edge off direct sunlight without removing all the lights is to use a reflector to lift the shadows. That's what photographer Amy Lane did to capture 5-16. The best way to position the reflector is to hold or clamp down a reflector at an angle, so that the sunlight is reflected back up onto the dark side of a flower, or to brighten up the background to avoid completely losing all definition in the background.

ⓟ x-ref Discover more about the creative uses of reflectors and other lighting tricks in Chapter 3.

ABOUT THIS PHOTO
Photographing outdoors in bright sunlight can be challenging. This photo had a very dark shadow on the right side, alleviated with a reflector. Taken with a compact camera in macro mode. 1/640 sec., f/2.8 at ISO 100. Photo by Amy Lane.

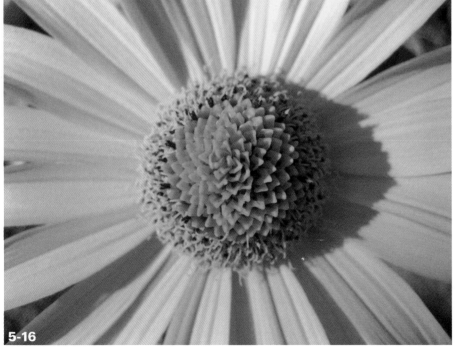

5-16

 x-ref There are many different types of reflectors available, and you can even make your own. Check out the section on reflectors and diffusers in Chapter 2!

For added creativity, reflectors often come in several colors. The most common variations are plain silver, gold (which warms the reflected light a little), and white. White reflectors don't reflect the light as much as silver ones, but they do have the advantage of giving a more even, smooth light. The difference a reflector can make has to be seen to be believed, but it does have a significant impact. Experiment!

FLASH

Photographing flowers with an electronic flash tends to give the flowers a clinical and unreal look, mostly because flowers are normally seen with the light coming from above, rather than from the viewer. If you get really close, however, it can be a useful tool, and nobody is able to tell which part of the flower is up or down anyway, as seen in 5-17.

When using a dSLR, there are several ways to make flash light look more natural. If you are indoors, bouncing the flash off the ceiling by aiming the flash-head upwards gives a much softer and more pleasant light. You can also use a mini-diffuser, which slides onto the head of the flash unit.

5-17

ABOUT THIS PHOTO *It looks like a monster, but it's merely a tropical plant, photographed expertly with a Canon Digital Elph 55 in macro mode, with the internal flash turned on. 1/50 sec., f/2.8 at ISO 200. Photo by Amy Lane.*

FILL FLASH

Even when you are outside in bright sunlight a flash unit can come in handy. Known as a *fill flash*, it works much the same way as a reflector, as it complements the natural light and alleviates some of the heavy shadows.

If your subject is in the shade, but the sun is washing out (over-exposing) the background, you can use a fill flash to balance the lighting. To do this, set your camera to Aperture priority, and meter for the background. Turn your flash on, and take the photo. The flash illuminates the foreground, the aperture set on the camera ensures that the background is correctly exposed, and the photo comes out evenly lit. You can also experiment with underexposing the background slightly (smaller aperture or higher shutter speed), so that the flower in the foreground stands out more.

BACKLIGHTING

Most of the time, you want to photograph the flower from the front, and it makes a lot of sense to also light it from the front. There are some plants that are thin enough to warrant backlighting. To do this, you use a light source (direct or reflected sunlight or a flash, most likely) that lights the plant from behind.

Some plants have an intriguing pattern of shapes inside the leaves, and the idea of backlighting is to shine the light through the plant, which makes the veins of the leaf or details of the internal structure of a flower visible. When using backlighting, you can choose to either use the light source at the rear exclusively, or combine it with light coming from the front. Your decision depends on your subject, but you should experiment to find what works well.

POLARIZER FILTERS

It is possible to use filters when working with macro photography, just like with any other type of photography. Personally, I prefer to do most of the application of filters in *post-production* (everything you do to the photo after it leaves the camera), but there is one particular filter that cannot be easily replicated on a computer: a *polarizer filter*.

When light is reflected by non-metallic surfaces, it becomes polarized. By using a polarizer filter, you can filter out this polarized light. To landscape photographers, this means beautiful dark blue skies; to reproduction photographers, it means pictures without reflections of their light sources; and to macro photographers, it means that the light that is reflecting off plants is filtered out. This means you can lessen the *specular highlights* — the *catch light* in somebody's eye is a specular highlight, but you can get them in any reflective surface, including raindrops — on your flowers, giving them a more artistic appearance.

Most of the photos in this book are taken without a polarizer filter. The main reason for this is that a polarizer causes around two stops of light loss. Seeing as light is a sparse commodity when working with high-magnification macro, I generally don't feel it makes sense to sacrifice light for the sake of the benefits polarizer filters give. You might like the effect enough to make the trade-off, however, so it cannot hurt to try!

Assignment

The 20-Step Challenge

When taking pictures outdoors, one of the biggest challenges is realizing that you are surrounded by scores of photographic opportunities. To appreciate just how much there is out there, take the 20-Step Challenge. The 20-Step Challenge used to be one of my favorites when I went to school and was first learning about photography. I hope you enjoy it as much as I did.

For this assignment, go to a park, a botanical garden, a forest, or another outdoor location (even your backyard will do). With your camera at the ready, take 20 steps, stop, and then find something to take a picture of.

Get creative. After you've taken a picture and are happy with the result, take another 20 steps and find a new subject.

Frequently, you'll find that you come up with some amazing and unusual photos by doing this. In addition to being great macro-photography practice, it helps train your eye for new photo opportunities.

I took the 20-Step Challenge at the Eden Project in Cornwall, England — a huge bio-dome that replicates various climates and has hundreds of types of plants. The 20-Step Challenge was incredibly easy there. I managed to capture some beautiful photos, but the best one I took that day was this one of an orchid that I took with a hand-held compact camera in macro mode at 1/13 sec., f/2.8 at ISO 200.

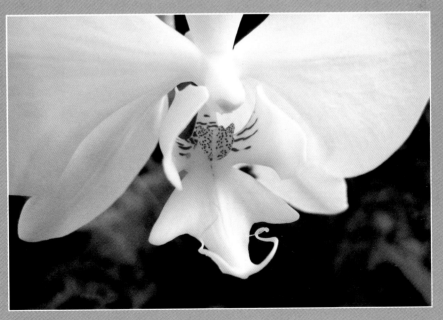

Don't forget to go to www.pwsbooks.com when you complete this assignment so you can share your best photo and see what other readers have come up with for this assignment. You can also post and read comments, encouraging suggestions, and feedback.

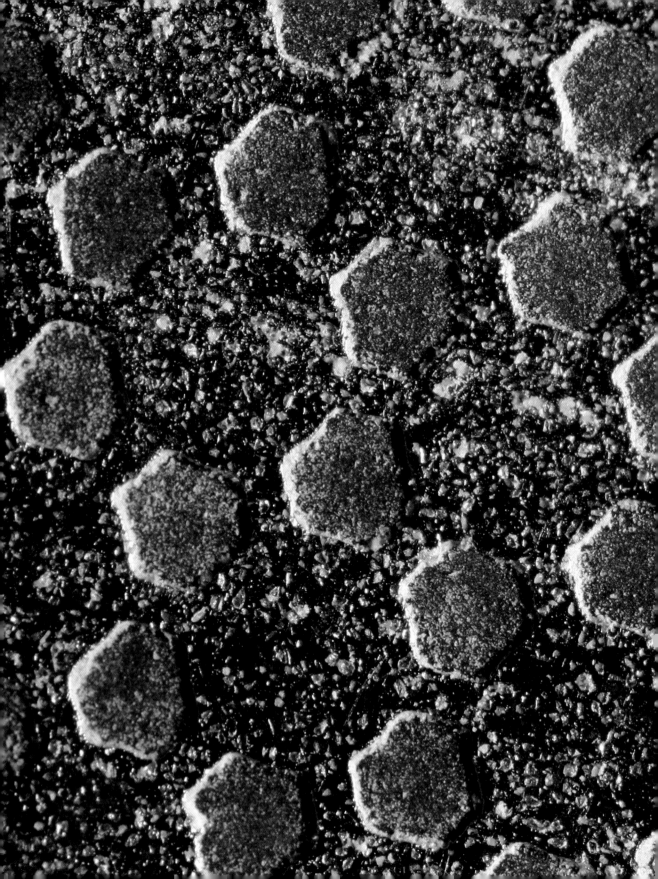

The way something looks is largely dependent on the following four factors:

- The shape of the item
- The item's color
- The physical makeup of the item
- The lighting of an item

Personally, I have a desire to observe these factors separately. Photographing just the shape of something can be done by modeling the item in 3-D on a computer. You can then give it a new color and material, for example. You can study the way something is lit by changing the lighting. You can alter the colors by changing the lighting or by turning the item into a different color — or into black and white — in a software program like Adobe Photoshop.

My absolute favorite is to examine the texture of things. It is what is left after you strip out the color and shape of an object. You'd be amazed at how beautiful conceptual photos that selectively focus on only one aspect of an item can be.

Would you ever have thought that a tree could look like 6-1, for example?

6-1

ABOUT THIS PHOTO *The bark of a tropical tree. Taken with a 135mm f/2.8 soft focus lens on a 24mm extension tube. 1/60 sec., f/2.8 at ISO 100.*

WHAT ARE TEXTURES?

The concept of texture is difficult to define. So difficult, in fact, that quite a few languages don't even have a word for it. Luckily, this is a book on photography rather than semantics or linguistics, so we can get away with leaving the definition as "what something feels like." Or possibly, "what something looks like it should feel like."

When you run your finger over something, whether it is plastic (see 6-2), glass, metal, fabric (6-3), fur, skin, wood (see 6-1, 6-4), or any other material you can think of, you get a completely different sensation. If I were to blindfold you, you could easily tell the difference between a cup made out of glass, stoneware, or metal, despite the fact that all three of them are generally hard, smooth, and cold. Interestingly, you would also be

6-2

ABOUT THIS PHOTO *The plastic surface of a clipboard magnified approximately 4x. Taken with a Canon MP65-E f/2.8 macro lens and a MT-24EX Macro Twin Lite flash set to high speed, 1/350 sec., f/4.7 at ISO 100.*

6-3

6-4

ABOUT THESE PHOTOS *The printed silk in figure 6-3 looks deeply fascinating if you get close enough — especially if you get creative with the lighting. Taken with a Canon MP65-E f/2.8 macro lens and a MT-24EX Macro Twin Lite flash set to high speed, 1/350 sec., f/4.7 at ISO 100. In 6-4, a wooden table, split open by the elements, looks like a canyon. Taken with a 135mm f/2.8 soft focus lens on 37mm worth of extension tubes. 1/90 sec., f/2.8 at ISO 100.*

able to make the same distinction visually. Not only that, but I can think of several distinct plastics (bags, the stuff used on car bumpers, disposable cups, non-disposable cups, and so on), metals (aluminum foil, rusty knife blades, a brass knocker) and types of glass (window panes, mirrors, frosted glass, etched glass, colored glass). With so many materials around you in daily use, it is no wonder that the study of these different materials can invite you to create a whole collection of photographs.

In previous chapters, you looked at how photos should have a story to tell. How can the denim in a pair of jeans, a slab of slate, or a plank of wood tell a story? Many materials are inherently interesting, such as wood grain, the intricate patterns formed by rust, and the beautiful, elaborately interwoven strands of cotton in a bed sheet. Beyond this, I find the juxtaposition of contrasting materials captivating.

PUTTING TEXTURES INTO CONTEXT

If you agree with me that despite (or perhaps because of) being a complete abstraction and showing only a limited part of what something is about, textures can have an allure, it is time to start turning them into something more — creating works of art based on textures alone, as illustrated in 6-5.

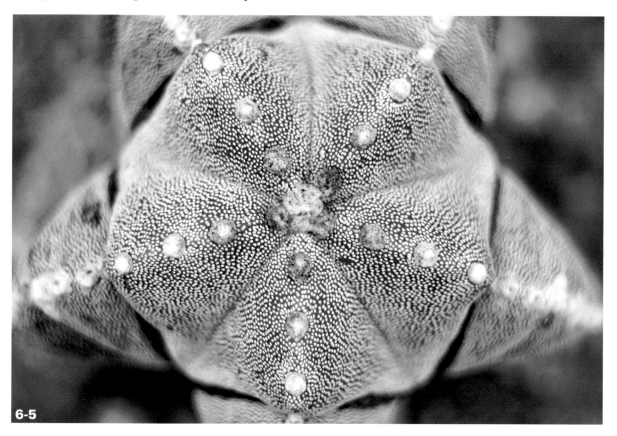

6-5

ABOUT THIS PHOTO *This cactus has an interesting texture and, including some of the background, adds depth. Taken with a Canon 135mm f/2.8 soft focus lens on a 24mm extension tube. 1/90 sec., f/3.5 at ISO 100.*

A way of turning seemingly unconnected objects into works of art is to create a connection between them that wasn't there before. One way to make that connection is to combine them digitally or use the photographs in novel combinations in an *installation*. Installation art in the context of photography is the practice of using photographs in settings that are unusual, for artistic purposes. Projecting photographs onto a surface is often referred to as installation art.

In this case, for example, you can have large, square prints made of each of your textures that you glue onto the surface of a cube. When viewing the cube from one angle, it would appear to be made of one material, and when seen from another, it would be made from a different material.

My favorite, however, is *diptychs* or *triptychs*, which are a fancy way of saying that you combine several photos in a certain setting. The effect can be achieved by using a large frame and combining two or three photos (known as diptych and triptych, respectively) behind the same *passepartout* (a cut-out frame). Alternatively, hanging a number of photos in identical frames close to each other can strengthen the effect. You might, for example, combine a photo of the outside of a cigarette (6-6) with a picture of a cigarette filter (6-7) and then round it off with a macro photo of the tobacco itself (6-8), for a well-rounded, though unhealthy-related, macro triptych.

You can use the diptych or triptych to tell a story comic-book style (new match, burning match, burnt match), or you can combine several elements (wooden cup, steel cup, bone cup) that are somehow related. For example, I envision the trio of cigarette photos hung on the wall with the tobacco photo in the middle and the cigarette paper and filter images flanking it to provide support.

ABOUT THESE PHOTOS *Three photos of the same cigarette — the outside (6-6), the filter (6-7), and the tobacco itself (6-8). All taken with a Canon MP65-E f/2.8 macro lens and a MT-24EX Macro Twin Lite flash, 1/90 sec., f/2.8 at ISO 100.*

If you want, you can even play with the minds of people watching your art by adding three photos that are completely and utterly unrelated. The human brain works in a way that is inclined to identify patterns even when there are none, so you might be pleasantly surprised by the reactions people have to your wall-hangings.

PHOTOGRAPHING TEXTURES

Taking photos of textures is incredibly easy, yet unbelievably difficult. Immovable objects have the most interesting textures. Because they are immovable, they aren't going anywhere. In other words, you have as much time to take your photos as you need. A good tripod is the only item you need. Although I used more sophisticated lighting in 6-9, you can get away with lighting your items with a flashlight or by simply reflecting natural light onto your texture.

x-ref

If you want to get your object fully in focus, you need to parallel your subject. See Chapter 5 to learn how.

Because of the narrow depth of field (DOF) native to macro photography, you have to take great care when focusing. You can, however, use the DOF to your advantage. Parallel your subjects properly to get the whole texture perfectly in focus, or you can shoot the item at an angle and add intrigue by having only part of the surface in perfect focus.

Off the cuff, the thought of three photos of different types of stone mounted next to each other with a band of perfect focus running diagonally through the center of each frame (see 6-10 for an idea of what that looks like) sounds like an intriguing and eye-catching exhibit. After you have the idea, it would take you about two minutes to take each of the photos, and voila — art!

ABOUT THIS PHOTO
Taking a closer look at a cork board. Taken with a Canon MP65-E f/2.8 macro lens and a MT-24EX Macro Twin Lite flash, 1/125 sec., f/2.8 at ISO 100.

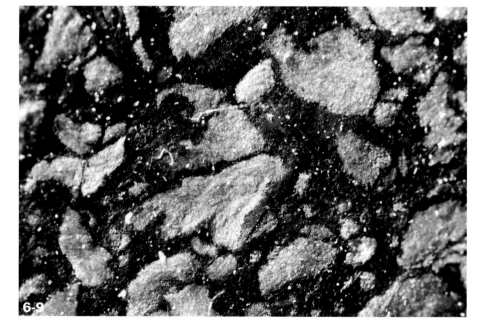

6-9

6-10

At the same time, photographing textures is also hard — deceptively so. That is why it is extremely rare that you see people do it well and produce good results. However, you are constantly surrounded with items, all made from completely different materials. For example, you can take a hundred different macro texture photos from where you are sitting right now. My duvet cover proved interesting enough to warrant publishing in a book: 6-11 is the proof!

The trick is to engage the viewers with the textures they are looking at by finding beautiful ones that are instantly recognizable — but still leave something to be explored. Denim is interesting, but it might be worth looking at the stitching. How about that tiny little rift? What about the buttons?

As with many other photo subjects, I firmly believe that a large part of the allure of photographing textures is what happens when you capture the parts where the texture breaks the monotony. Through this, you find where the imperfections show through and draw attention to everything that is perfect.

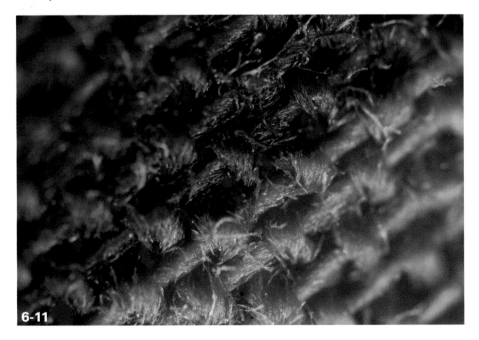

6-11

LIGHTING CONSIDERATIONS

How you light your texture shots is highly dependent on what you are photographing. With most of the photos in this chapter, I am so close to the subject that I needed to carefully manage natural lighting, so that the front of the lens didn't interfere with the path of the light. It is not impossible, as illustrated in 6-12, but generally, natural lighting can be problematic. Personally, I prefer working with a ring- or Twin-Lite flash, but it is a matter of taste and preference.

You can achieve a lot by using colored filters and gels on the lens or in front of the flash heads. However, when working with textures, I find that color comes in second place to the light intensity and direction.

Essentially, there are two extremes you can go for when lighting textures:

- ■ Perfectly even lighting
- ■ Highly directional lighting

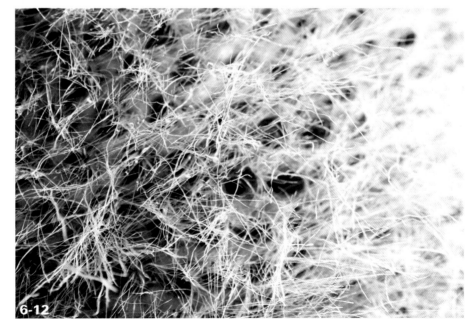

ABOUT THIS PHOTO
A hairy cactus offers a fascinating contrast-rich chaos. Taken with a Canon 28-105mm f/3.5 macro zoom lens on a 24mm extension tube. 1/500 sec., f/10 at ISO 320.

6-12

x-ref | Chapter 3 includes more information on lighting and filters.

Perfectly even lighting highlights the coloration and subtle interaction of the texture with itself. Cork, marble, and glass surfaces spring to mind as obvious examples. Other examples of using flat lighting to highlight the textures are illustrated in 6-1, 6-2, 6-3, and 6-5.

The other extreme is to use a highly directional light source, such as a flash unit, from a particular angle onto the surface you are photographing. This technique excels when the surface you are photographing is uniform in color but has a distinctive pattern or relief. Brick, brushed aluminum, and monochrome-colored textiles can benefit from using this technique, but more subtle textures can also benefit. The roundness of the cigarette in 6-6, combined with strongly directional lighting (from top-left) adds a sense of drama to the photo. The photo of the vinyl record (6-13) would have been impossible without the use of directional lighting.

6-13

Realistically, the best way to light a textured surface is dependent on a lot of factors, including what you are trying to achieve. Based on the advice provided here and a bit of experimentation based on the feel you have gotten for macro photography by now, you should be able to light any texture sufficiently and interestingly.

COMPOSTITION

Composition of texture photographs isn't particularly complicated, but it is slightly counterintuitive. There are a few different techniques you can use, but the first thing you have to consider is what you are trying to achieve with the photograph. If you are shooting a photo for documentary purposes, it is important to get your subject in with enough of its surroundings (a leaf of a flower or a bit of wood grain, perhaps) to get some context in terms of the size of what you are looking at. In addition, it is a good idea to also include enough information to get a feeling for the location, but this is often impossible due to the limited depth of field.

If what you are photographing is a repeating pattern, such as the texture of a sheet of paper (see 6-14) or wallpaper (6-15), there is not much you

6-14

ABOUT THIS PHOTO
Is it wallpaper or a moon land-scape? Well, wallpaper actually. Taken with a Canon MP-E macro lens and an MT-24EX Macro Twin Lite flash, 1/180 sec., f/8.0 at ISO 100.

6-15

can do to include context, but you can photo-graph a corner to give an impression of the shape of the item you are depicting — as I did with the cigarette filter in 6-7.

IDEAS FOR TEXTURES WORTH TRYING

Although everything in the world has a texture of some sort, some are more interesting than oth-ers, and I'd love to offer a few suggestions for tex-tures you can try. Take 6-16, for example, where a simple, cut wooden surface is photographed, while catching enough of the sky in the back-ground to offer a strong color contrast. Its simple composition lends itself well to wall art.

The hottest tip I can offer is to take photos of wood. The organic feel you get from wood is unlike anything else. The bark is strong and weathered, and the grain of cut, untreated wood can be majestic. Look at 6-17 as an example. In addition, wood that has been used to build things takes on a life of its own as the elements take their toll. Picture-wise, 6-4, 6-16, and 6-17 are as different as three pictures can be, but they're photos of wood that has been subjected to wind, weather, and people for a long time. Imagine what else you might find!

Fruit and vegetables often have distinct surfaces. Some are easy to guess: You don't have to see a big portion of a strawberry to know what you're looking at. Others, however, can be more tricky.

6-16

6-17

ABOUT THESE PHOTOS

6-16 is a detail of a log photographed in the golden hour just after sunrise, with a starkly contrasting blue sky behind. Taken with a Canon 28-105 macro lens, 1/125 sec., f/8.0 at ISO 100. The weathered wood surface of a walkway in 6-18 was taken with a Canon 135mm f/2.8 soft focus lens on a 24mm extension tube. 1/180 sec., f/4.5 at ISO 100.

Would you know what the outside of a nutmeg looks like, for example? If not, check out 6-18 and be suitably amazed!

You can use the visual contrasts between various types of wood or other materials to your advantage, though, especially in making triptychs. By using the strong colors of your choice of fruit, you can create appealing combinations. If your Photoshop skills are particularly hot, why not hang a pink orange, a blue strawberry, and a red banana on your wall? It'll get people talking, that's for sure! You don't have to limit yourself to natural subjects, of course: Different road surfaces can be just as interesting from a macro perspective — just look at 6-19!

ABOUT THIS PHOTO *The outside of a nutmeg nut — of the unground variety, obviously. Taken with a Canon MP-E macro lens and a MT-24EX Macro Twin Lite flash, 1/90 sec., f/6.7 at ISO 100.*

ABOUT THIS PHOTO *We can argue about whether this is really a macro photo another time — roads make great textures! Taken with a Canon 28-105 Macro lens at 150mm, 1/350 sec., f/6.7 at ISO 100.*

Assignment

From Blurry to Sharp to Blurry

Throughout this chapter I've focused on taking artistic photos of textures both by paralleling subjects and by shooting them at an angle. Now it's your turn to try your hand at it! Find a fabric or material you find fascinating, and take an extreme macro photo of it at a slight angle, so that the depth of field forms a diagonal line through the material, highlighting its structure, color, and texture.

For my entry here, I used a photo I took of a thick layer of rust and detailing on an old, discarded saw blade. I like the rich textures, the unusual colors, and the fact that you can look at the photo for a long time — discovering new elements of it all the time — while the general composition of the image is quite simple.

Don't forget to go to www.pwsbooks.com when you complete this assignment so you can share your best photo and see what other readers have come up with for this assignment. You can also post and read comments, encouraging suggestions, and feedback.

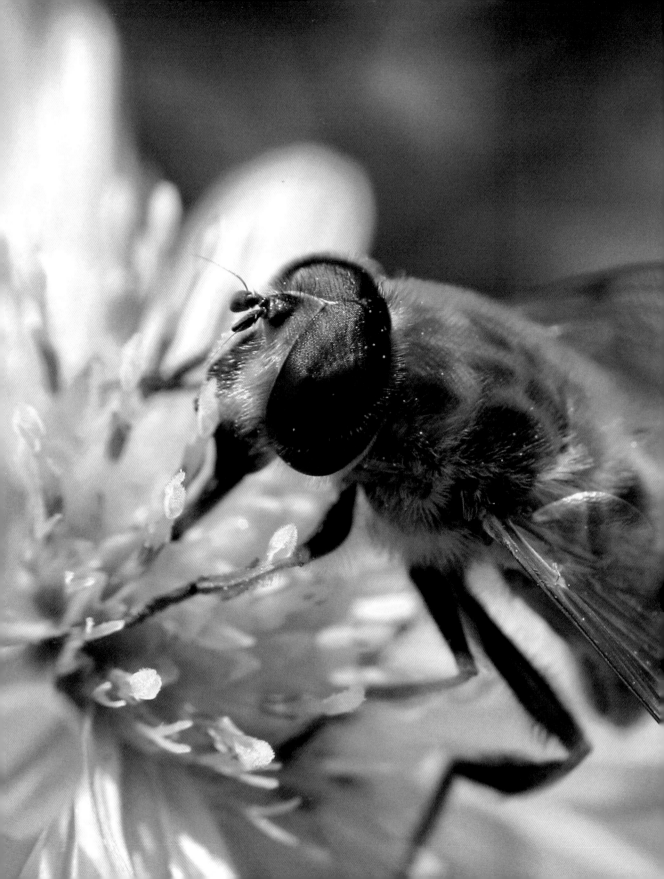

One of the first things that attracts people to macro photography is the pictures that this particular branch of photography became famous for: The ubiquitous macro depictions of dragonfly eyes, menacing spiders, and other insects, like the one shown at 7-1.

Whether you like insects or not, chances are that you still find them interesting. Most insects are too quick for you to be able to get a close look at them. Even when they are sitting still, do you really want to go stick your face that close to a spider — even one as friendly-looking as the one in 7-2? Macro photography offers a safety barrier between the photographer and the insect, while simultaneously offering a way to magnify, explore, and inspect the subject.

Although it is one of the most popular areas of macro photography, photographing insects is also one of the more complicated ones. Most insects are tiny and difficult to find in the first place, and when you do find them, they rarely sit still. Nevertheless, there's a special corner reserved in macro photography heaven for photographers who manage to capture a good photo of, say, a spider.

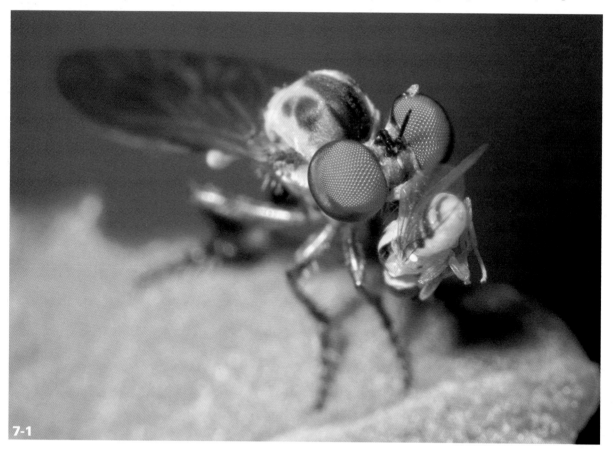

7-1

ABOUT THIS PHOTO *A fly with its prey in direct sunlight. Taken with a Canon 100mm f/2.8 macro lens with Kenko extension tubes. 1/60 sec., f/3.5 at ISO 100. Photo by Chris Nering.*

7-2

ABOUT THIS PHOTO *A spider basking in the sunshine. Taken with a Canon 100mm f/2.8 macro lens with Kenko extension tubes. 1/100 sec., f/3.5 at ISO 100. Photo by Chris Nering.*

A testament to how difficult it is to photograph insects, the imagery in this chapter relies heavily on the contributions from some of my friends who specialize in the field. Don't let this put you off. It is by no means impossible to capture insects well — you just need a healthy supply of patience, a bit of technical know-how, a lot of memory cards, and...did I mention patience?

PHOTOGRAPHING INSECTS

To take photos of insects, the first thing you need is to find the creepy-crawlies. Unlike flowers, most of us don't tend to cultivate insects, and if

you've never been on the look out for them before, you might not know where or when to find them.

I find that springtime and late summer are generally the best times to find insects. You can find lots of exciting bugs everywhere. Butterflies break out from their cocoons; moths become more active; and flies, beetles, bees, and spiders are scurrying about. They are all ready for you to photograph them.

For most photos, you are a victim of the whims of the insect you are trying to capture. When photographing a flower or a pet, you can pick them up

and put them where you want them, but wasps aren't generally inclined to stay where you put them. As such, insect photography is a genre of chance and on-location photography.

Some insects even rely on camouflage, which makes your quest more difficult (see 7-3). After all, nothing can harm or eat what it can't see! These insects are actually some of the most interesting insects out there, but for obvious reasons, they can be difficult to spot. Other insects have brilliant colors and use them as their defense mechanism ("Hey, look how bright I am. I'm probably poisonous, don't eat me"), like the dragonfly in 7-4.

Finding insects isn't that difficult, but be aware that for every insect you see, you have probably missed ten. The art of spotting them requires moving slowly, and observing carefully. Moving slowly not only helps avoid chasing away any critters that are lurking semi-hidden, but it also gives you more time to spot them in the first place.

With most insects, you generally don't have to worry about the sound your camera makes, as the outdoors is a noisy place anyway. Do be careful of quick movements, however, as they are likely to make your subjects run or fly off. Moving extremely slowly is the key. Carefully shuffling your way toward your target seems to be the best approach. You might not move much faster than a few feet per minute, but trust me — your patience will pay off! It is not unusual to spend a lot of time tracking down a single, stunning example of an insect to capture the perfect shot.

Sometimes finding the insect isn't enough. You need to find a way to make it stay still. Most flies don't respond well to a "Stay" command. The photo in 7-5 is impossible without killing the insect. Professional photographers and insect collectors have devised a humane way to take

care of this situation: the killing jar (for more about killing jars, check out the sidebar).

At the same time, many photographers don't feel comfortable with catching and killing insects. The old adage of "Take only pictures, leave only footsteps" is strong among most nature photographers, and you can derive much higher work satisfaction from capturing the little bugs in their natural habitat.

7-3

ABOUT THIS PHOTO *Some insects try to appear invisible by hanging out near objects of their same color. Taken with a Canon 100mm f/2.8 macro lens in direct sunlight with a reflector. 1/250 sec., f/4.5 at ISO 100. Photo by Chris Nering.*

ABOUT THIS PHOTO
The bright colors of the dragon-fly make for gorgeous photog-raphy. Taken with a reversed 50mm f/1.8 lens on bellows. Direct sunlight. 1/125 sec., f/5.6 at ISO 400. Photo by Miha Grobovsek.

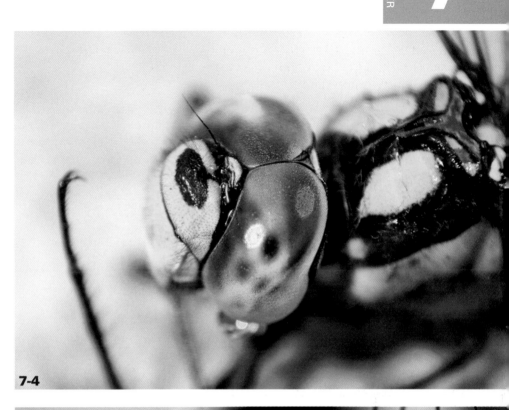

7-4

ABOUT THIS PHOTO
This photo of a fly's legs was taken with a Canon 100mm f/2.8 macro lens with Kenko extension tubes. 1/60 sec., f/3.5 at ISO 100. Photo by Chris Nering.

7-5

MAKING A KILLING JAR If you want to get extremely close to insects, you might have to somehow convince them to stop moving. I have yet to come across tranquilizer darts for bumblebees, so killing them is the only way to persuade them to sit still. It sounds terribly barbaric, but it isn't really.

Entomologists (insect collectors) have perfected the art of killing insects as humanely as possible by using a killing jar. To make a rudimentary killing jar, use a reasonably large jar with a lid that tightly closes. Cut out a circle from an old t-shirt or other thick cotton material, and make sure it fits snugly on the bottom of the jar. You want a few layers of cotton. To this jar, add enough ethyl acetate (you can buy this from lab suppliers and hobby stores) to saturate the cotton, but no more. Put your insects in the jar, and leave them for a few minutes to kill them.

If you want to make a more advanced killing jar, search for "killing jar" on the Internet.

APPROACHING INSECTS

Insects generally have two things in mind: to get on with the task at hand and avoid getting eaten. The task at hand might be finding food, mating, or just basking in the sunshine, but it means that the insects are somewhat predictable.

Bees, butterflies, and similar insects, for example, might be just bumbling about from flower to flower. Instead of bustling about trying to capture an insect, then, you can try to position yourself and your camera where the insects are likely to come. If you don't move much yourself — and don't move your camera much either — you probably won't scare the insects. Unstressed little insects are much easier to capture. You might even be lucky enough to have an insect find you interesting and come closer to have a look. That is exactly what happened when Matthieu Collomp took the photo shown in 7-6.

To set your camera in the best position to capture a great photograph, you need to think like the insect. If you are photographing in a small field or flower bed, imagine you're a bee. Which flower would you be most likely to nibble on? Set up your tripod to photograph that flower and get everything ready. If you've picked a good spot, the insects will practically fly up and pose for you right in front of your camera!

This approach works with many insects, but not with all of them. For slower species, such as butterflies, you can generally just walk around and snap them as they are basking in the sunshine. The trick is to not get in the way of the sun. Casting a shadow startles flies and butterflies. Instead, sneak up from the side, and capture them that way. It worked in 7-7!

The jumpiness of an insect is directly related to how good its eyesight is. Jumping spiders and dragonflies hunt by using their highly developed sense of sight. They run or fly off much faster than you can close in on them. Other types of spiders, such as the types that weave webs, often

142

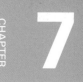

have poor eyesight. As long as you don't touch the web, they'll happily let you take photos all day long.

After trying to photograph insects for a while, you might find it to be too frustrating. They are fast, difficult to catch, and often fly away. To get some practice in photographing small creatures, you can, of course, go hunting for some snails instead. Photographed correctly, as in 7-8, they can be as exciting as insects!

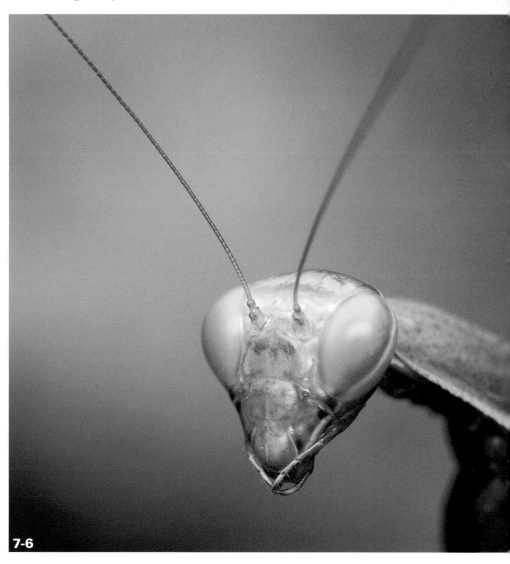

ABOUT THIS PHOTO
Sometimes the insects are curi-
ous enough to come find you,
as this praying mantis did.
Taken with a 60mm macro lens
and a stacked 100mm f/2.8 lens.
1/200 sec., f/6.3 at ISO 100.
Photo by Matthieu Collomp.

7-6

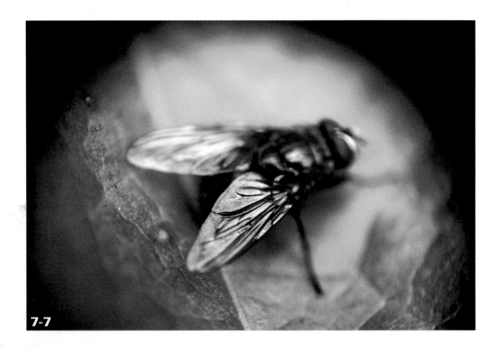

ABOUT THIS PHOTO
Moving slowly is the only way to get close enough to most insects. Taken with a 60mm f/2.8 EF-S macro lens and a stacked 50mm lens. Direct sunlight. 1/200 sec., f/5.6 at ISO 100. Photo by Hilary Quinn.

7-7

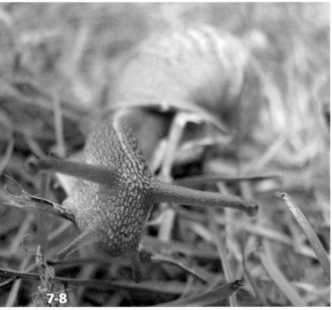

7-8

ABOUT THIS PHOTO *If insects are too scary, why not try snails first? At least they are less likely to fly away. Taken in the shade on a sunny day with a compact camera in macro mode. 1/3 sec., f/2.7, ISO 100. Photo by Amy Lane.*

WORKING WITH INSECTS IN THEIR ENVIRONMENT

With many forms of photography, a single image is heavily context-related. This is particularly true for insect photography. Most people need some help to realize what they see. Photographing a butterfly up close on a leaf of a flower makes it easier to parse the information in the photo than if the same butterfly was photographed on a pane of glass or a brushed aluminum surface. As an example, most people wouldn't recognize 7-9 as an insect if the foliage wasn't framing it.

HERDING INSECTS

By keeping the overall context of a photo in mind, use the whole frame of your photo to tell

ABOUT THIS PHOTO *Colorful larvae in its environment. Taken with a compact camera in macro mode. 1/25 sec., f/2.8, ISO 100. Photo by Katharina Butz.*

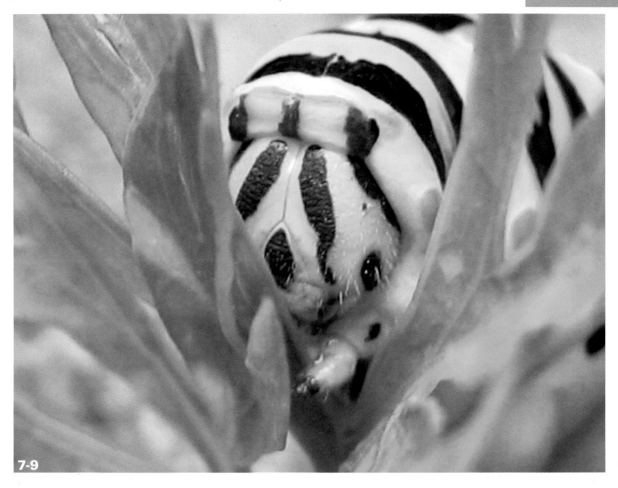

7-9

fragments of a story. A good photo of an insect means nothing unless there is something else there to lift the photo to a level of excellence. A perfect action shot of a bee or a spider about to attack its prey has merit in itself, but due to the limitations inherent in macro photography (shutter times and shallow depth of field in particular), most photos are taken of static scenes, such as insects on flowers, etc.

Apart from chilling, stunning, or killing the insects, your only weapon to move most insects is to scare them into moving. Lazily wafting a hand at a grasshopper makes it realize it is not quite time for it to become breakfast for one of its predators. So, it jumps off to its next hangout. Luck dictates where that spot might be, but with some patience, you might end up with an opportunity for a shot that is pure gold, like 7-10.

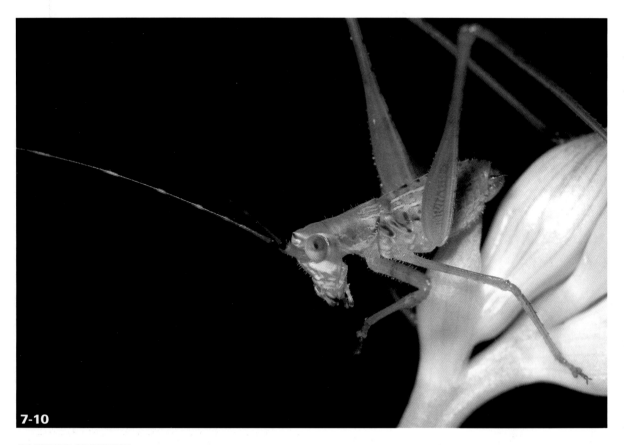

7-10

ABOUT THIS PHOTO *A perfect example of dramatic framing. Taken with a Canon 100mm f/2.8 macro lens with Kenko extension tubes. 1/60 sec., f/3.5 at ISO 100. Photo by Chris Nering.*

This image also illustrates what can happen if you have a shaded area in the background: The contrast between the bright foreground and the dim background rendered a perfect black backdrop, almost as if it was taken in a studio!

Be aware that some insects, especially some butterflies and dragonflies, can become attached to their favorite spots. That means that if you are trying to get close to a dragonfly but you scare it off, don't give up. Get into a comfortable position and hang around for a couple of minutes. You just might get lucky, as the photographer did in 7-11, and the insect might settle down right in front of your lens, strike a pose, and just wait to be photographed.

ABOUT THIS PHOTO
Getting shots like this dragon-fly eye in the wild demands immense levels of patience and a bit of luck. Taken with a reversed 50mm f/1.8 lens on bellows. 1/125 sec., f/5.6 at ISO 400. Photo by Miha Grobovsek.

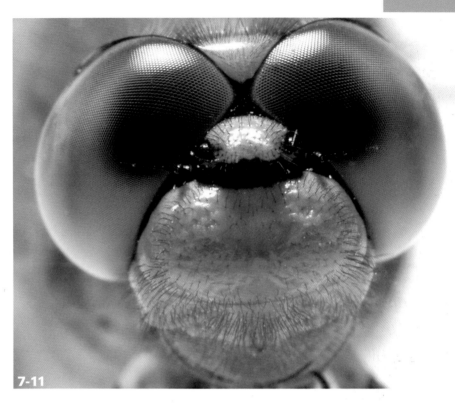

7-11

BUILD AN INSECT STUDIO

With a bit of luck and some planning, it is actually possible to prepare a photo studio for insects. You can create such an area by selecting a favorite spot, such as a beautifully colored group of blooming flowers, for your subjects and cleaning it up. Cut down any reeds or plants that are in the way, use a duster or canister of compressed air to remove dust and other disturbing

elements, and make sure that any clutter in the background is removed. If the area you are photographing in is windy, you can set up a windscreen or otherwise block the wind if it looks as though it might disturb your photos. Don't worry about scaring off your subjects. The studio gives you the control you need to take photos like the one in 7-12.

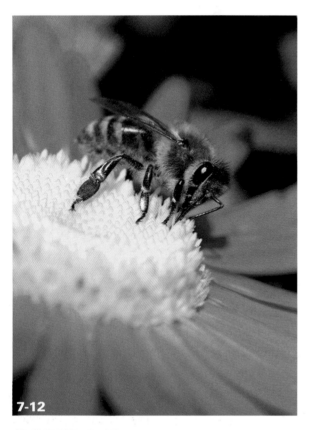

7-12

ABOUT THIS PHOTO *By building an outdoor "studio" for your insects, you can have more control over what happens in your photos. Taken with a reversed 50mm f/1.8 lens on bellows. 1/320 sec., f/3.5 at ISO 400. Photo by Miha Grobovsek.*

 x-ref

To find out more about studio equipment you can use in the field, check out Chapter 2.

If you want to, you can take your studio even further and start manipulating the light. A windscreen can double as a reflector (use a silver screen) or a diffuser (use a white translucent screen). Use studio stands to set up reflectors or diffusers. Most insects seem to ignore rapid flashing light, so you can give yourself a competitive edge by preparing your studio with studio lights or pre-installed flash units. After your studio is ready, leave it alone for a few hours. Sit back, enjoy the sunshine, have a snack, and let the area settle. After the insects continue their food-gathering activities, you'll have a hive of activity, and much more control of what your photos will look like. Obviously, this approach takes a lot of preparation, but it's a reliable way to walk away with some amazing photos without the "oh, it's good, I just wish..." factor you often get when you take pictures in uncontrolled outdoor environments.

A simpler way to have a temporary outdoor studio is to use a light tent. You can buy them or build your own, but the important aspect of these tents is that they need to be relatively stiff. After you identify an insect you'd like to photograph, place the tent calmly over the flower or plant they are sitting on, which traps the insect under the light tent. With a bit of luck, your subject will settle back on the plant. This is your chance. The light tent means you have no wind worth mentioning, perfect and even lighting, and no danger of the insect flying away. All you need to do is get the focus right and press the shutter button, and voila, you can have a result like 7-13!

ABOUT THIS PHOTO *Once again, the in-the-field studio comes to the rescue. Taken with a reversed 50mm f/1.8 lens on bellows. 1/200 sec., f/4 at ISO 400. Photo by Miha Grobovsek.*

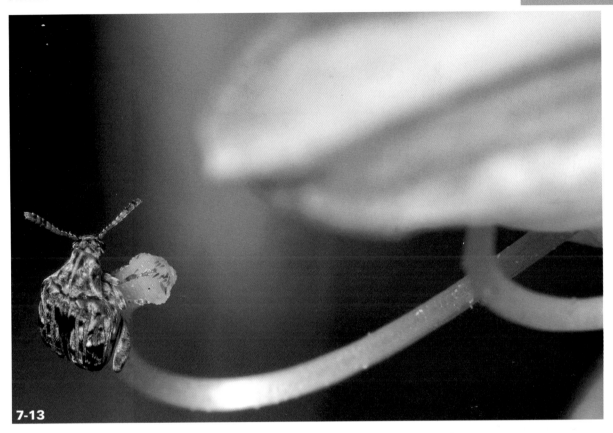

7-13

MOVING SUBJECTS AND SHALLOW DEPTH OF FIELD

When working with macro photography, shallow depth of field is nearly impossible to avoid. This can be bad enough when you are taking photos of relatively inert items, such as bricks, tree trunks, and the ground, but quick-moving subjects, such as insects, make it a complete nightmare. It will take a significant amount of practice to take photos like 7-14.

It can sound like a paradox, but the first trick to photographing insects in the wild is to take pictures of lots of other things first. There is no denying that focusing and lighting macro shots is

tricky, but it isn't impossible — nothing that a little bit of practice can't help. The point is that unless you are adept at finding focus, getting the lens in place, and checking your exposure within a few seconds of deciding what you are going to photograph, you are going to struggle with photographing live insects.

After you've got the knack for framing, focusing, and shooting quickly, insects are within reach. If you don't want to get too close to the insects, you might want to consider using a powerful telephoto macro lens. Such a lens allows you to be about 4 or 5 feet away from your subjects. As you can see from 7-15, it's possible to capture stunning photos from a safe distance.

ABOUT THIS PHOTO *The technical skill and speed required to capture a photo like this is formidable. Taken with a 60mm f/2.8 AF-S macro lens and a stacked 100mm lens. 1/200 sec., f/6.3 at ISO 100. Photo by Matthieu Collomp.*

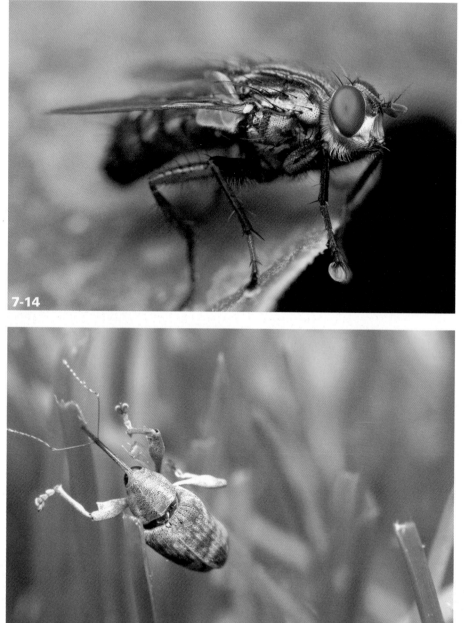

7-14

7-15

ABOUT THIS PHOTO *You don't always have to be extremely close to capture stunning photos. Taken with a Canon 100mm f/2.8 macro lens with Kenko extension tubes. 1/125 sec., f/7.1 at ISO 200. Photo by Chris Nering.*

PHOTOGRAPHING INSECTS IN FLIGHT

There's an old saying that says, "If you're going to get wet, you may as well go swimming." In terms of insect photography, everything you do up until you take a photo of an insect in flight is getting wet. Get ready to swim across a sizable lake, because photographing insects in flight really is the holy grail of insect photography.

A few insects are relatively simple to capture in mid-air. Butterflies move erratically, but they aren't very fast. The same thing goes for hover-flies, although their wings move at such a fast speed that capturing them is incredibly difficult. It might be easiest to start off photographing slightly bigger flying creatures before you graduate to insects. The hummingbird in 7-16, for example, was easier to capture than insects, and the lessons learned are applicable in the macro world as well.

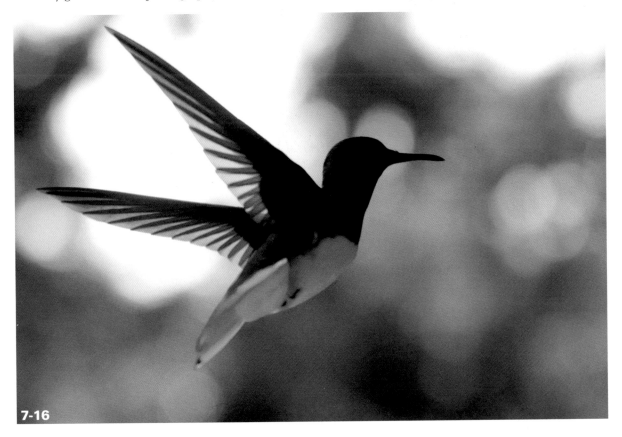

7-16

ABOUT THIS PHOTO *No, it isn't an insect, but before trying insects, it is useful to practice on something slightly bigger, like a hummingbird. Taken with a Sigma 70-200mm f/2.8 lens at 200mm. 1/8000 sec., f/5.6 at ISO 3200.*

For insects you can photograph, it helps to have a lens where you don't have to be too close to the little flying monsters. A macro-oriented tele-photo lens is ideal, because it allows you to follow the insect around with the lens without moving your body too much.

Using a smaller aperture (larger aperture number, such as f/11 or f/16) allows you to ensure that the whole insect is in focus, but you tradeoff the focus against shutter time, and your insects come out blurry. For the purposes of shooting moving insects, it is a better idea to use a smaller aperture

number (f/2.8 if you can, or otherwise just use the lens stopped wide-open) and try to focus as best you can. With some lens and camera combinations, the auto focus is so accurate that you can leave the focusing to the camera itself. This is especially true for cameras built for sports photography, some of which can famously hold a baseball thrown directly toward the camera in perfect focus until it gets too close (a split second before it reduces the camera lens to expensive shards). If your camera isn't quite that hard-core, you can try your luck at manually focusing on the insects. This is usually quite tricky because modern dSLR cameras don't have *focusing screens* that are conducive to high-speed manual focusing, but with practice, it isn't impossible, just have a look at 7-17.

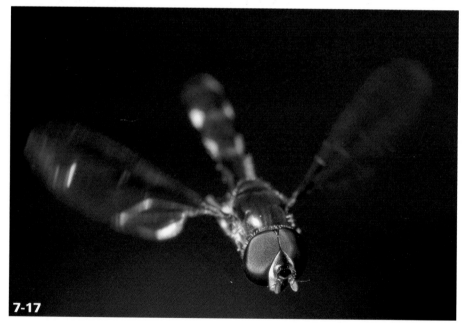

7-17

ABOUT THIS PHOTO
Photographing dragonflies in mid-air without extra equipment is the holy grail of macro photography. Taken with a Canon 100mm f/2.8 macro lens. 1/125 sec., f8 at ISO 400. Photo by Chris Nering.

PHOTOGRAPHING FLYING INSECTS Some photographers have turned insect-in-flight photography into a full-fledged art form, including a photographer who calls himself "Fotoopa" (Dutch for *Photo Granddad*). He has become an Internet phenomenon by building himself a trigger mechanism especially for taking photos of insects in flight. Combining his electronics knowledge with lasers and photography equipment, he has created a tool that uses two laser beams. When an insect breaks both beams (meaning that it is in a particular location in front of the camera), the camera takes a photo, and the flashes fire, freezing whatever is caught in the laser-beams in mid-air.

It all sounds very sci-fi and high tech, and you'd be forgiven if you find yourself reaching for your credit card to get one of these. The device is not in mass production, however, so you're out of luck. If you are determined to make your own, you can find full instructions, building plans, and more knowledge on the subject than I'll ever be able to cram into my brain on Fotoopa's Web site: http://users.skynet.be/fotoopa.

If you're using a dSLR, A technique that might come in handy until you get the hang of manual focusing is *focus bracketing*. Like White Balance Bracketing (WBB) and Automatic Exposure Bracketing (AEB), the idea with focus bracketing is to hedge your bets by using technology to augment your skills. To focus bracket, use the manual focusing ring to focus on your fluttering insect as effectively as you can. Take a photo and immediately change the focus slightly. Take another photo, and then change the focus to the opposite direction. Take another photo. By fine-tuning this technique, you can eventually snap off two to three photos a second, vastly improving your chances at getting a photo that is in focus.

> *idea* Find out more about photographing insects in flight on Fotoopa's Web site — http://users.skynet.be/fotoopa. For inspiration, check out *Insects in Flight*, written by John Brackenbury (ISBN 071372594X) and *Caught in Motion: High Speed Nature Photography*, written by Stephen J. Dalton (ISBN 0297780662).

Assignment

Insects in a Kids' Book

For this assignment, imagine that a friend of yours has written a children's book about insects. Knowing that you are an excellent macro photographer, your friend asks you to photograph an insect to go on the front cover of the book. Insects can be scary-looking, but try to make the photo look as child-friendly and approachable as possible. Choose your most cover-worthy image and post it to the Web site.

Remember that I told you that if you see one insect there are probably ten around? Well, I couldn't find any spiders or insects to photograph. Winter is sometimes a difficult time to find such miniature subjects. However, my friend Chris Nering came to the rescue. Spiders aren't known to be child friendly, but this little fellow looks like a crazy professor out of a cartoon. I love him! The photo was taken with a Canon 100mm f/2.9 macro lens, 1/125 sec., f8 at ISO 400.

I'll complete this assignment myself, too, as soon as spring arrives. You can look for my solution at www.pwsbooks.com.

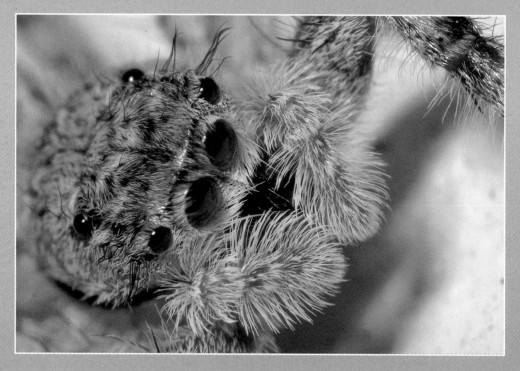

Don't forget to go to www.pwsbooks.com when you complete this assignment so you can share your best photo and see what other readers have come up with for this assignment. You can also post and read comments, encouraging suggestions, and feedback.

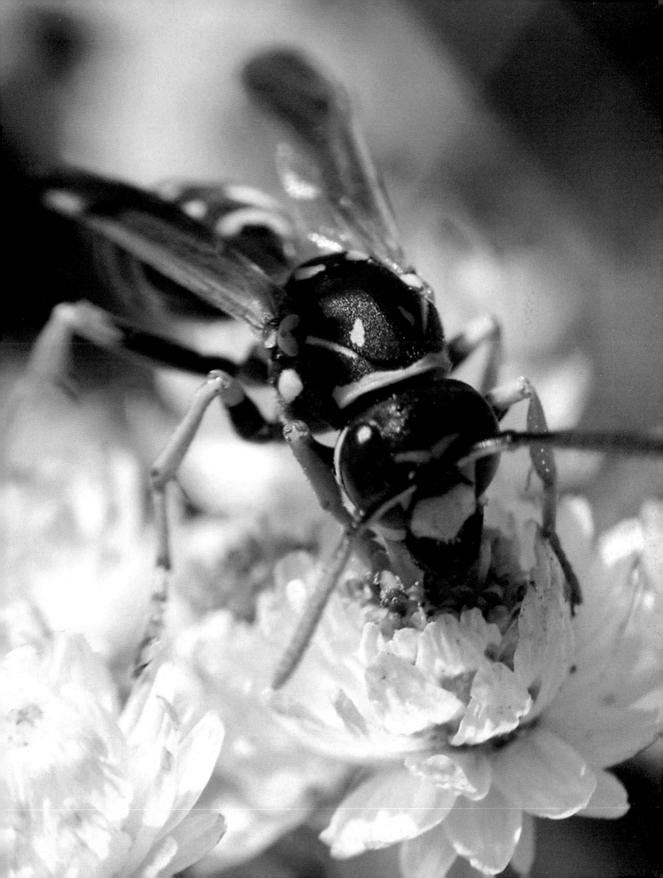

ABSTRACTS

A lot of macro photography is met with the relatively predictable response of "What the heck is that?" Taking the incomprehensibility of macro photography one step further might seem to be a little bit ridiculous. Come to think of it, it probably is, but then again, in the case of abstract macro photography, "ridiculous" can look rather gorgeous.

What is an abstract macro photo, exactly? The term is actually quite difficult to define, partly because both macro and abstract mean different things to different people. Think of macro photography as an attempt to document something small. In contrast, abstract photos are not about documentation or exploration of a particular item, but rather about utilizing techniques used in macro photography to capture shapes and colors that are aesthetically pleasing, like the creative way of photographing macro photography gear utilized in 8-1.

8-1

ABOUT THIS PHOTO *An extension tube lit by a tea candle placed inside the tube. Taken with a Canon 50mm f/1.8 lens on a 13mm extension tube. 1/20 sec., f/1.8 at ISO 100.*

Shedding the demand of having your photos tell a story or be recognizable in any way is liberating. In a way, this chapter about abstracts is a result of all the macro photos that didn't quite work out as planned: Photos that turned out looking unintentionally beautiful. It is a matter of taste, of course, but personally I love the idea of sharing my love of quirky photos with the world.

EXPLORING COLORS

There are a lot of surfaces that can give some truly mesmerizing color. Any surface that reflects a rainbow of colors, for example, can give subtle, yet deeply intriguing macro shots. Commercial CDs, CD-R discs, CD-RW discs, and DVDs all give slightly different reflections under different types of light, which can give dramatically different, yet exquisite effects. Photo 8-2 is a blue burned CD-R disc, 8-3 is a dual-layer DVD-R disc, and 8-4 is a commercially pressed music CD. All these photos were lit with a simple halogen desk lamp, but you can get a huge variety of effects by using different light sources. Candlelight, flood lighting, colored light, and multi-colored light sources all give diverse results. Experiment to find which combination of disc and light works for what you are trying to achieve!

Capturing reflected light from CDs and DVDs is not difficult, but it does take a lot of patience. You have to get everything just right. For one thing, you don't want to catch a reflection of the light source, you want the internal reflections from the disc.

When using this technique, you are photographing into a light source, which means that your photos are prone to stray light (much like the solar flare you sometimes get on outdoor photos). To avoid this, make sure that your light doesn't hit the front element of the lens directly. If you

8-2

8-3

8-4

ABOUT THESE PHOTOS *CDs and DVDs. All taken with a Canon MP65E f/2,8 macro lens at around 3x life-size magnification. All taken at 1/4 sec., f/2.8 at ISO 100.*

have a lens hood, use it. If not, it is easy enough to tape a bit of cardboard to your light. Angle the board in such a way that it blocks any light that might hit the lens.

Cars, bicycles, and other lacquered surfaces are other sources for interesting colors, as the techniques used to paint them can be distinctively different from each other. Flat paint surfaces don't make for particularly exciting photography, but pearlescent, metallic, metal flake, and so-called "flip paints" (a type of automotive paint that appears to be a different color depending on which direction you see it from) all give opportunities for up close photography. When trying macro photography on car paints, I'd recommend using available light, because capturing the intricacies of painted and lacquered surfaces using an electronic flash is extremely difficult.

You'll get the best results by photographing a part of the car body that has a bend or a natural crease or kink in it. If the car you are photographing has a conversion from concave to convex with a ridge in between (such as seen on the BMW Z4 roadster, for example), it allows you to capture a lot of lighting situations in a single photo.

USING SELECTIVE FOCUS FOR ARTISTIC EXPRESSION

I've touched on *selective focus* — deliberately leaving a part of the frame out of focus — before, but this technique really shines as a weapon in your quest to take creative abstract macro photographs. Because you can effectively reduce all but a thin sliver of the photograph to a colorful blur and leave just enough of the photo in focus to pique the interest of your viewers, the selective focus technique opens the possibility of photographing surfaces and items that wouldn't normally be all that exciting, like, say, nuts. What? You say nuts can't be interesting? I think picture 8-5 begs to differ!

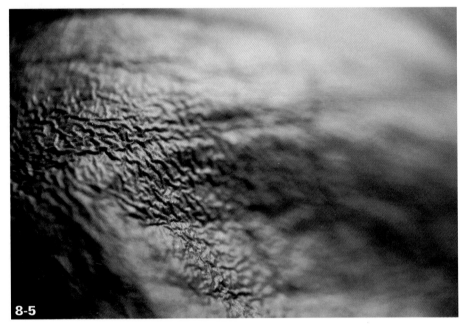

8-5

ABOUT THIS PHOTO
Go nuts for this photo. Taken with a 60mm macro lens and a stacked 50mm lens. 1/500 sec., f/5.6 at ISO 100. Photo by Hilary Quinn.

When using extension rings, bellows, or reversal techniques, your depth of field is limited anyway, and you don't have to take many photos to figure out how to get only part of your frame in focus: By holding your camera at an angle, your subject partially falls out of focus. Personally, I find that a band of focus running diagonally through the image gives an interesting effect. Other gradients, however, such as sharp on one side or in a corner and tapering off to completely out of focus through the rest of the frame can also look attractive.

Although using narrow bands of focus throughout an image can look attractive, it is easy to overdo the effect. I believe 8-6 is pushing it, but 8-7 (which essentially is the same area) doesn't have nearly the same impact. To me, the strength of selective focus lies in the transition between in and out of focus. In other words, if you are shooting with a shallow depth of field, try not to use too sudden a drop-off between the in-focus and out-of-focus areas. A more gradual fading tends to be more captivating and gives the reader more to look at.

ABOUT THIS PHOTO
A rusty sheet of metal. Taken with a Canon MP65-E f/2.8 macro lens and a MT-24EX Macro Twin Lite flash. 1/250 sec., f/2.8 at ISO 100.

8-6

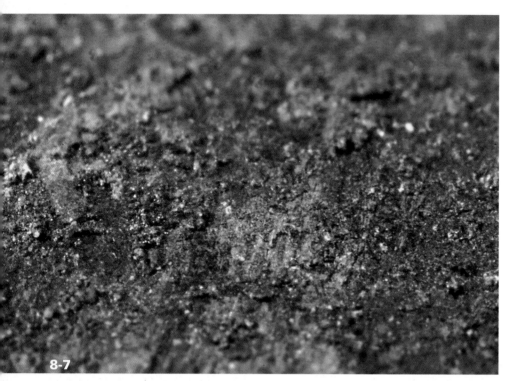

8-7

INTRODUCING GRAIN

Because a lot of what you do with macro photography is to try to uncover or document extremely minute details, it is generally preferable to capture as much of the subject as cleanly as possible. The best way to do this is to use a low ISO setting on your camera. All dSLR and most digital compact cameras have ISO settings that are variable between 100 and 1600. Some even have a high speed setting that allows you to set your camera to ISO 3200. Photo 8-8, for example, was taken at a high ISO speed and illustrates the clean focus possible. Notice, however, that the higher ISO introduces more noise. The trick is to keep the noise from looking noisy — giving it a feeling more like creative grain from film.

The way ISO works is that you trade off noise and resolution against shutter speeds. Here's how the sacrifice works: If you assume that the aperture and lighting conditions stay the same, slower shutter speeds equal lower ISO and less noise. Higher shutter speeds require higher ISO and result in more noise. For most macro work you want ISO 100 or 200.

> *tip* ISO is a way to set the sensitivity of the imaging chip inside your digital camera. A higher ISO value means that you can take photos in lower light, but you introduce digital noise, which lowers the quality of your photo. It is a remnant from the time when you physically had to change the film from 100 (which is standard) to a more light-sensitive film, such as ISO 800 or ISO 1000.

A quirk with many digital cameras is that if you shoot at a medium fast ISO (400 or 640, for example), the resulting photos look as if they have been taken with an old fashioned film-based camera, getting that grainy look. If you go to even higher ISO values, the added noise changes character again, and it can become obvious that this is digital noise, rather than film grain.

One of the techniques I have been experimenting with when working with macro photography is to deliberately introduce a high level of noise into the images by setting my camera to ISOs of 1600 or 3200. Photo 8-8 is an example. At ISO values this high, the digital noise is noticeable and quite disturbing, but it does add a certain organic feel to the photos, more like film grain. In addition, the distraction of colored digital noise can be largely counteracted by converting the image to black and white, as I did on 8-9, which makes the noise look a lot like the characteristic film grain found on the classic Kodak T-Max film.

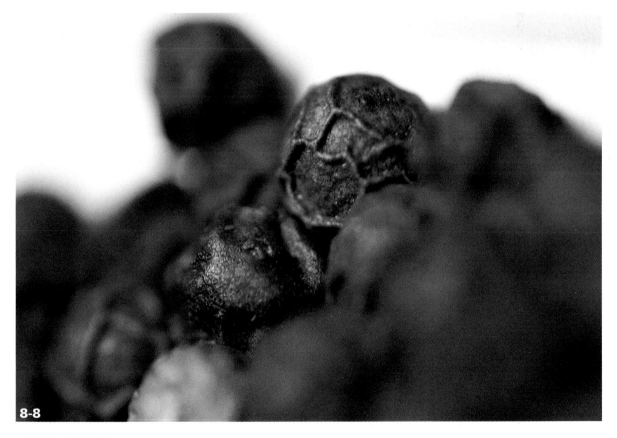

8-8

ABOUT THIS PHOTO *Peppercorns. Taken with a Canon MP65-E f/2,8 macro lens. Lit by ambient light. 1/45 sec., f/2.8 at ISO 3200.*

8-9

ABOUT THIS PHOTO *Brushed metal surface. Taken with a Canon MP65-E f/2.8 macro lens. Lit by a desk lamp. 1/180 sec., f/2.8 at ISO 3200.*

PAINTING WITH LIGHT

Most types of photography lighting are based around fixed lights, such as natural lighting, flash units, and flood lighting. However, there is no reason why you can't use moving lights to light your subjects. That is where painting with light comes in. It's an old technique used with many genres of photography and is especially elegant when used with still life. It does require that you use a camera that can support longer shutter times (2 sec. or longer).

The idea of painting with light is quite simple and applies well to large objects, such as cars. It can also be applied to much smaller objects. Painting with light is accomplished photographically by opening the shutter on your camera and then moving a light source over your subject. If you move the light source quickly in one area and slower in others, the areas get less and more

light, respectively. They show up darker or brighter compared to other parts of the photo. An additional bonus is that you can eliminate shadows under your object, by briefly shining your light underneath. The little figure photographed in 8-10, for example, has a dynamic shadow and even lighting. The streak of light along its back is due to the slow movement of the light source.

8-10

ABOUT THIS PHOTO *A photo of a Fimo figurine painted with light. Taken with a Canon 28-135mm macro lens. 3 sec., f/32 at ISO 100.*

With this in mind, it is possible to achieve lighting effects with a moving light source that are impossible when using any other source of lighting. When photographing small objects with fixed lights, it can be extremely difficult to eliminate all shadows — a problem that is easily overcome by using a simple halogen desk lamp to paint with light.

When painting with light, it is important to keep the light source moving at all times,

otherwise the light tends to look blotchy and unnatural. Even if you wish to highlight or emphasize a particular element of your subject, it is better to move the light in even circles or back and forth over your subject to achieve a more even lighting situation.

In conventional photography, painting with light can be used to apply advanced lighting to larger subjects. In the world of macro, however, this is a lot more difficult, because even small light sources are likely to illuminate a large proportion of your subjects. If you are struggling to achieve the results you want, it is possible to focus the light. Whether you are using a halogen desk lamp or a flashlight, you can make a snoot for your light source by rolling up a piece of black cardboard into a cone. The light is aimed into the broad end of the cone and shines out of the hole in the narrow end of the cone. You can adjust the size of the light beam by adjusting the hole in the cone or by adjusting how far into the cone you place the light source.

Apart from creative applications, I've found that painting with light is useful when photographing electronics. Due to the highly reflective surfaces of print boards, it is nearly impossible to capture them without getting highlights from your light source somewhere on the item. By painting with light, you can make sure that the highlights are less obvious. Or, you can get more creative and keep the highlight present, but let it take on a more appealing form, like a streak of light across the print board, which gives an illusion of speed.

EMPHASIZING OBSCURE DETAILS

Photographing flowers to look like flowers is one thing. Taking the outlandish qualities that some plants have and emphasizing them to turn them into surrealist works of art is a different issue altogether.

There are a lot of plants out there that don't look like anything that should be growing in nature.

Strange colors, extravagant shapes, and stems stretching for the sun and the sky, plants (see 8-11) are the natural extension into abstract artwork. The same is true for many everyday objects, such as paperweights (see 8-12).

x-ref | Methods and tips for photographing flowers are examined in Chapter 5.

8-11

ABOUT THIS PHOTO *A leaf of a flower becomes an alien object by being abstracted further. Taken with a 50mm f/1.8 lens on a 24mm extension tube. 1/30 sec., f/5.6 at ISO 100.*

8-12

8-13

8-14

8-15

ABOUT THIS PHOTO *Paperweight backlit with a desk lamp. Taken with a compact camera in macro mode. 1/60 sec., f/4, ISO 100. Photo by Amy Lane.*

TAKING A CLOSER LOOK AT MAGAZINES

Anywhere you can find interesting patterns is practically screaming out to be photographed up close. You can find inspiration in the oddest places, but did you know that printed goods can actually be phenomenally interesting? Glossy boxes, magazines (see 8-13), book covers, CD and DVD booklets (see 8-14), newspapers, soda cans (see 8-15), and even milk cartons are printed with printing techniques that vary and give interesting results.

ABOUT THESE PHOTOS *A variety of printed goods make for interesting photography. 8-13: Brochure detail. 8-14: DVD booklet. 8-15: Soda can. All taken with a Canon MP65-E f/2.8 macro lens and a MT-24EX Macro Twin Lite flash. 1/125 sec., f/9.5 at ISO 100.*

Even more exciting is paper that is printed in a way designed to make it difficult to copy — bank notes (8-16), checks, passports (8-17), and other valuables or identification papers often use some of the most high-tech printing techniques available. This means that the print is of extremely high quality and can look exquisite up close. In some countries it is even against the law to reproduce these types of papers in full or in part, so in addition to beautiful art, you get to be rebellious and live on the edge.

Photographing printed papers is relatively easy; you just have to make sure that you get enough light on the surface of which you are trying to take a photo. If you are trying to take photos of items that have raised print (a common feature of security documents), you can get a three-dimensional feel to your images by adding a light source that shines along the paper you are photographing from the side.

8-16

ABOUT THIS PHOTO *A portion of an English bank note taken with a Canon MP65-E macro lens and a MT-24EX Macro Twin Lite flash. 1/125 sec., f/9.5 at ISO 100.*

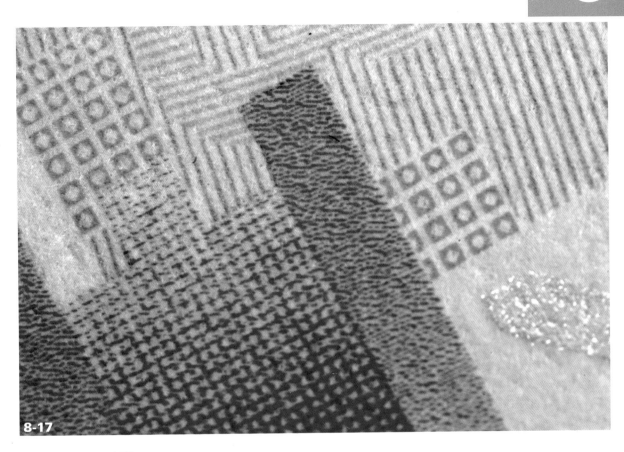

8-17

ABOUT THIS PHOTO *A passport detail taken with a Canon MP65-E macro lens and a MT-24EX Macro Twin Lite flash. 1/125 sec., f/9.5 at ISO 100.*

Assignment

It's a Meeting...

For this assignment, take a photo of two separate materials intersecting. Ideas for materials include paper and plastic, bricks and mortar, and water and glass. Use creative lighting and selective focus to create an original photograph. Post your best image to the Web site.

I decided to explore the intersection of ink and paper: A bar code from the back of a magazine seen up close. I particularly like how the limited depth of field adds to the photo as the ink and the paper fall in and out of focus throughout the photograph. I took my photo with a Canon MP65-E macro lens and a Macro Twin Lite flash, 1/125 sec., f/9.5 at ISO 100.

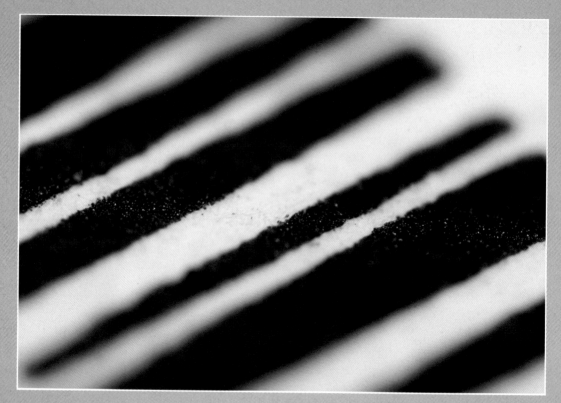

Don't forget to go to www.pwsbooks.com when you complete this assignment so you can share your best photo and see what other readers have come up with for this assignment. You can also post and read comments, encouraging suggestions, and feedback.

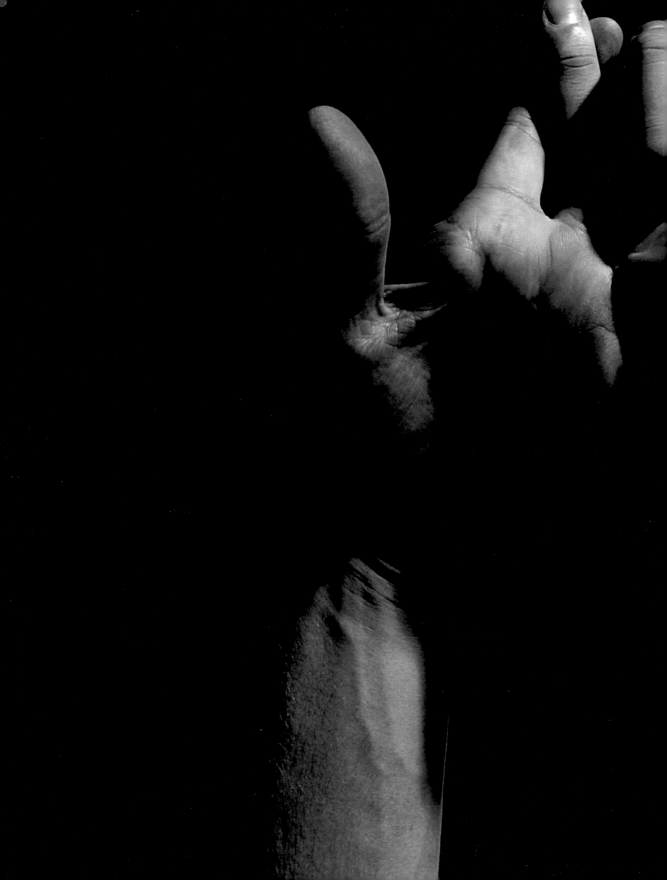

TAKING A CLOSER LOOK AT EYES

MACRO-INSPIRED PORTRAITURE

Spending day in, day out on your knees in front of flowers or running after insects is all good and well, but any good storyteller can tell you that to really connect with your audience, you have to involve people. Isn't experimentation and an attempt at capturing the unique what photography is all about? Of course it is, so consider how you can capture people with macro photography tricks!

The traditional way of doing macro photography with people is to take a closer look at the body parts that display a great amount of detail or the interaction of body and clothing, like in 9-1.

TAKING A CLOSER LOOK AT EYES

Eyes are an excellent choice for study, because they are thought of as the "window to the soul" (see 9-2). In addition, people's eyes are as different as fingerprints. So much so, in fact, that eyes are used in biometrics to discriminate between people. The strong uniqueness of eyes, the fact that eyes are symbolic of vision, and therefore closely related to photography itself, and finally because eyes are exciting to explore and interesting to look at, make them a natural subject for macro photography.

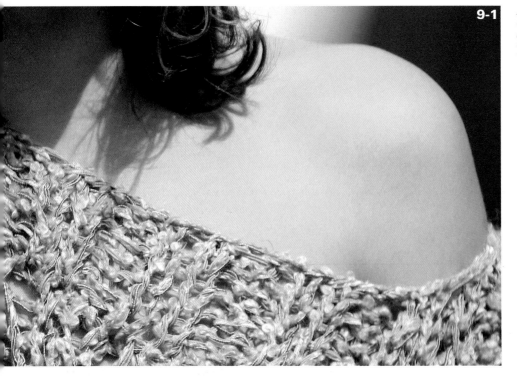

9-1

ABOUT THIS PHOTO
Less is more — sometimes photos become more interesting the less you show. Taken with a Sigma 70-200 f2/8 lens. 1/3200 sec., f/2.8 at ISO 100.

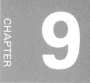

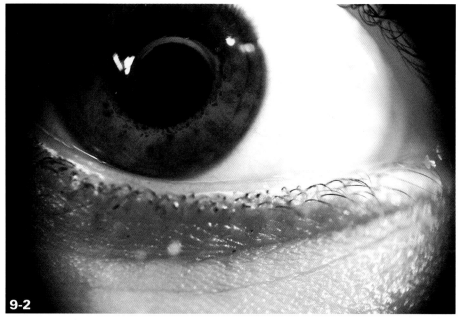

9-2

ABOUT THIS PHOTO
Through the looking glass. Taken with a 60mm f/2.8 macro lens and a stacked 50mm lens. 1/60 sec., f/5.6 at ISO 400. Photo by Hilary Quinn.

TAKING PHOTOS OF EYES

Taking macro photographs of eyes is popular, but it's also one of the more difficult things you can try. First of all, you need a model, as taking macro photographs of your own eyes is close to impossible.

The next problem you face is lighting. If you want to get reasonably close to somebody's eye in order to get a 1:1 reproduction or better of their iris, you need a lot of light. Of course, you don't want to provide that light in a way in which your subject's eyes take on the dreaded glowing red eyes. It is possible to use natural lighting but because the natural lighting is so difficult to manipulate, getting good results is difficult. Using careful lighting is paramount to getting results like 9-3. In addition, I chose to turn the photo into black and white, to illustrate the texture and intricate detail of the iris, rather than concentrating on its colors.

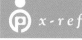
x-ref

To learn more about turning a photo into black and white, turn to Chapter 10. If you want to find out how to get the most out of textures and the detail of an eye, check out Chapter 6.

I've found that the best way to photograph someone's eye is to use a lamp shining at an angle from behind the photographer. If you are capturing their right eye, place the light source to the right of their head and vice-versa.

When you are starting to take the photos, it is important to get your model to relax. Focusing takes a bit of time, and the lights (or flash unit if you're using one) are uncomfortable. Ask your model to stare directly into the camera lens, and then just take the photos. If you find you have to use shutter times longer than 1/60 second, you will struggle to get sharp photos. It is worth trying

to get more light, or to adjust the ISO settings on your camera, to get the shutter time down. Using a twin-head flash or a ring flash, as I did in 9-4, can yield spectacular results.

x-ref Learn more about the various types of flashes available to you in Chapter 2.

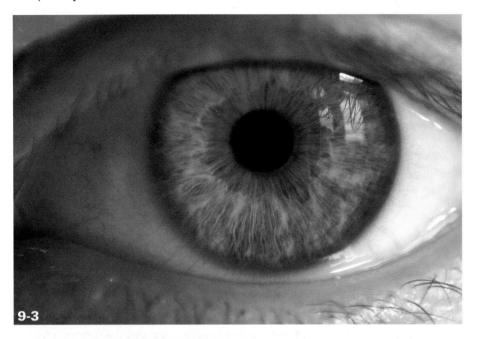

ABOUT THIS PHOTO *It is possible to use natural light when photographing eyes. Taken with a reversed 50mm f/1.8 lens. 1/40 sec. at ISO 100.*

ABOUT THIS PHOTO *No two eyes are the same. Taken with a Canon MP65-E f/2.8 macro lens and a MT-24EX Macro Twin Lite flash set to fire only one of the flashes. 1/125 sec., f/8 at ISO 100.*

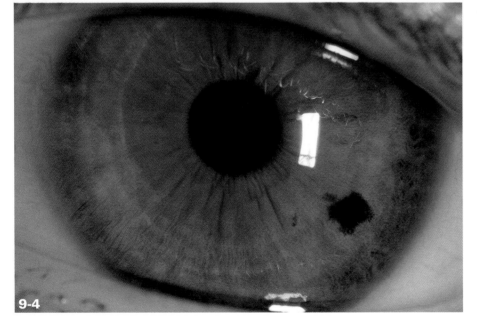

The easiest way to prevent your subjects from moving is to get them to sit on an easy chair that tilts back — kind of like a dentist's chair. If you don't have one, a comfortable sofa will do the trick. By letting your subjects rest their heads and relax, you get less motion. Chances are that you'll experience a few problems with your subjects blinking their eyes. The reason they are doing this is that they are trying to be helpful by keeping their eyes open wider and longer than normal. Their attempts are honorable but this makes their eyes dry faster. The best way to avoid this problem is to tell your subjects to blink "as normal," and blink again just before you are about to take a photo. That way, they don't have to blink just as you are taking a picture, giving you more of a fighting chance to get the photos you want.

RED-EYE EFFECT

The red eyes you often see in photographs are annoying at the best of times, but completely unforgivable in macro photos. The phenomenon is a result of light reflecting out from the back of the eye. The reflection is red because of all the blood vessels inside the eye.

When you take pictures, in particular if you take pictures with a compact camera, the flash (source of light) and the lens (the observer) are fairly close to each other (as illustrated in figure 9-5). Removing the red-eye effect can only be done by changing the lighting conditions somehow, so the light from the flash doesn't bounce back into the lens. Alternatively, you can use an image editing software package like Photoshop to remove the red-eye in *post processing* (editing done to the photo after it has been taken). This takes quite a bit of time, however, and it takes a lot of practice to get these edits to look natural. As a result, it is a good idea to try and avoid red-eye in the first place.

> **x-ref** Diffusing the light can help reduce red-eye as well. Learn more about diffusers in Chapters 2 and 3.

The first option is to not use the flash. Considering how much light you need to get good macro photos of eyes, this isn't a very good solution. The second option is to diffuse the light emitted by the flash. Another solution is to make the pupil

ABOUT THIS FIGURE *The glowing red eyes you can see in pictures sometimes happen because flash light reflects back into a lens.*

9-5

smaller. Making people's eyes contract can be easily done by shining light into them — if you're using a dSLR and a flash unit with modeling lights, turn them on and the problem vanishes instantly. You can also move closer by using extension tubes or similar, as doing so will in effect increase the angle between the flash and your subject's eye. Also, some compact cameras have a pre-flash that is supposed to help prevent red-eye.

If you are using a compact camera and it doesn't have the pre-flash or the pre-flash isn't enough help, your choices are slightly limited, but you can try and use a piece of white paper or cardboard to bounce the flash (*flash bounce* is reflecting your flash unit's light onto your subject via another surface, such as a wall or a ceiling).

The final — and many might say best — solution to the problem of reducing red-eye is to move the

light source farther away from your subject's eyes. If you have a dSLR, an external flash solves the problem instantly, as shown in 9-6. By using an external flash unit instead of the built-in flash, for example, or by using an off-camera cord to increase the distance between flash unit and lens, the light from the flash does not reflect back into the camera's lens from your subject's eye.

A solution that works for both Digital SLR and compact camera users is to turn on more lights in the room where you are taking photos. Increasing the amount of light is beneficial because your camera doesn't have to use as much light from the flash. This gives a more natural light. If you manage to increase the *ambient light* (light already available to you, before you add more via flash and so on) enough, you might even get away without using your flash units at all.

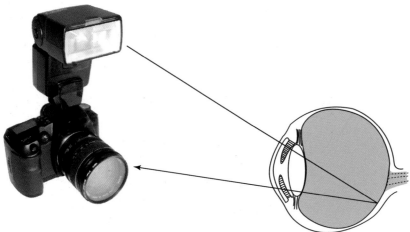

9-6

MACRO-INSPIRED PORTRAITURE

It appears that most photographers seem to stop photographing people when they have achieved a successful photo of an eye. In my opinion, that's a mistake. There is much more to the human body than just the eye. The philosophy of "less is more" can bear fruits in portraiture by applying macro photography techniques and equipment. Just look at 9-7. The reason this photo works well is that the bright lighting on the foreground means that the background becomes completely black (much like photo 7-10 in Chapter 7). The relaxed pose of the hand combined with the gorgeous lighting of the golden hour just before sunset means that the photo takes on a quality of summery relaxation.

To me, a portrait doesn't have to be a straight-on head-and-shoulders photo. In fact, I've seen excellent portraits that don't even have faces in them, or where the face is part of the photo but partially or completely obscured, as shown in 9-8.

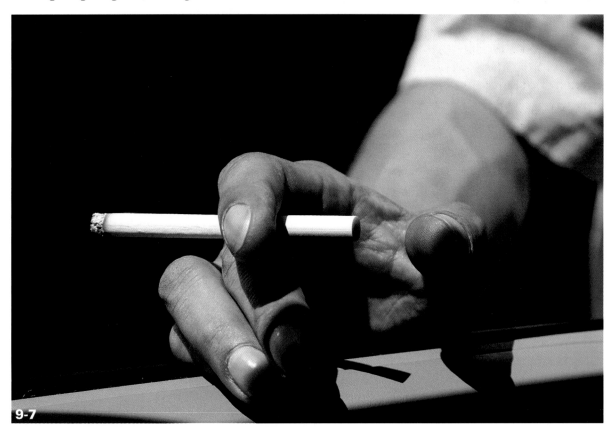

9-7

ABOUT THIS PHOTO *Try using people's defining features or habits to illustrate them as a person. Taken with a Sigma 70-200 f/2.8 lens at around 100mm. 1/350 sec., f/6.7 at ISO 100.*

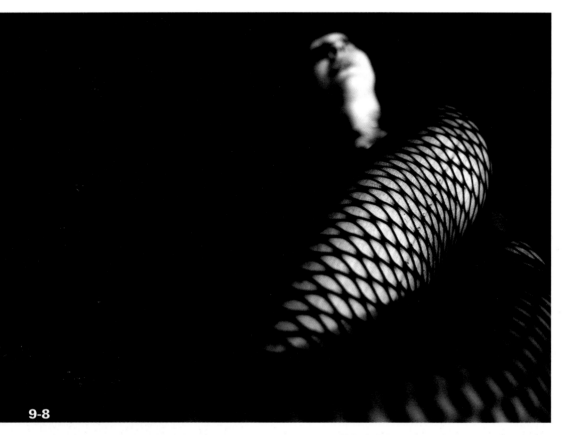

9-8

Of course, it all depends on what you are trying to do with your photos. I believe that all good photographers should attempt classic portraiture. In the end, the question is a question of what portraiture is all about. Personally, I think portraiture is about capturing something that is typical about somebody in such a way that people who know the subject instantly recognize them — and in a way that people who don't know them get enough data to make up some sort of opinion about them.

MACRO-PHOTOGRAPHING YOURSELF

Before you graduate to photographing others, start off photographing yourself. It's an easy avenue of experimentation, and at least your model will show up on time!

I have always had a fascination with hands, so the first macro self-portraiture project I embarked on was photographing my own hands, just see 9-9 and 9-10. The great thing? Although I did use a dSLR, there is no reason why you can't take

this exact same photo with just about any digital camera. To replicate the effect, use a simple but powerful light source from the side. A halogen workman's lamp works perfectly, but you can use a desk lamp or a reading light just as easily. Use a tripod, and put your camera on a timer. It turns out that it is possible to take some visually stunning photographs.

The trick to taking good photographs of body parts is to concentrate on an aspect about them that makes them stand out. In the case of hands, the dexterity and the number of different shapes you can hold your hands in means that you are never short of novel things to show. Add some dramatic lighting and a dash of image editing to increase the contrast of the images, and you are left with a great project you can explore further!

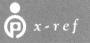 x-ref | Do you like the effect of the black and white photos shown in 9-9 and 9-10? It isn't as difficult as you might think. Leaf through to Chapter 10 to find out how it is done!

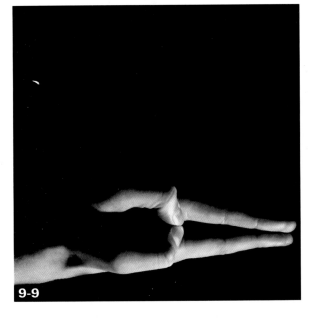

9-9

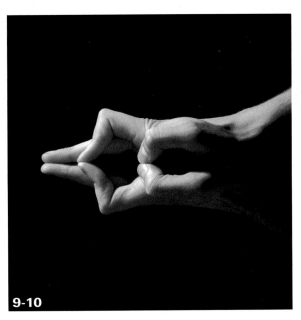

9-10

ABOUT THESE PHOTOS *Taking photos of my own hands was an interesting challenge, with splendid results! Both photos were taken with a 28-135mm f/3.5 IS macro lens. 3 sec., f/13 and ISO 100.*

UP CLOSE AND PERSONAL WITH YOUR MODELS

There are several ways to do macro-portraiture. As a general rule, applying macro photography techniques to portraiture is more intrusive than your average head-and-shoulders portrait because your camera lens has to be a lot closer. As a result, it is a good idea to explain what you are intending to do to your model. I've taken some excellent up close photos, like 9-11, by adding a few macro shots to a standard portrait photo shoot.

When choosing what to photograph, it helps if either you know the person you are photographing quite well or they know themselves better than most. Usually, asking someone to select the feature they like most about themselves results in a confused look, rather than a usable answer.

Sometimes someone's hobbies or profession make the task easier. A singer, combined with a microphone and her quirky signature-move of sticking her tongue out when playing complicated guitar solos (see 9-12) results in an instantly recognizable portrait of the performer to anyone who has seen the artist in action before.

You might have a penchant for photographing favorite body parts, too. I'm partial to the curves of necks (like in 9-13) or collarbones. You would be surprised how tastes differ. For example, I have

9-11

ABOUT THIS PHOTO An Egyptologist/archeologist wearing an Ankh ring resulted in this stunning photograph. Taken with a 28-135 f/3.5 IS macro lens at around 135mm. 1/60 sec., f/5.6 and ISO 200.

ABOUT THIS PHOTO *It helps if you know about your subject's quirks. Taken with a Sigma 70-200 f/2.8 lens at 200mm. 1/60 sec., f/5.6 and ISO 200.*

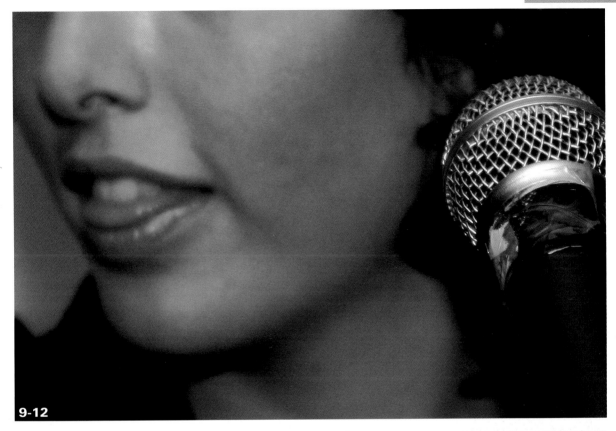

9-12

one friend who is completely obsessed by belly buttons and another who gets sick to the stomach by the thought of them.

A better way to ask the question is, "What is your significant other's favorite part of you?" People don't tend to freeze up. Besides, asking the question in that way gives your models an excuse to camouflage their own opinion as someone else's. This is especially helpful if they are embarrassed to admit that they, in fact, are quite proud of their upper arms. If someone confides in you that they are proud of their hair, though, you might want to think twice about taking a photo that looks like 9-14. It looks beautiful, but it isn't particularly recognizable in the sense of portraiture.

9-13

ABOUT THIS PHOTO *Try to find out which parts of your models' anatomy they are particularly fond of. Taken with a Sigma 70-200 f/2.8 lens at 170mm. 1/2500 sec., f/2.8 and ISO 100.*

9-14

ABOUT THIS PHOTO *Taking a very close look at strands of bleached hair. Taken with a Canon MP65-E f/2.8 macro lens at approximately 5x magnification and a MT-24EX Macro Twin Lite flash. 1/125 sec., f/2.8 at ISO 100.*

After you know what you are photographing, the only limits to what you can do are your imagination and your intended audience. Technique-wise, photographing people is rather similar to photographing plants, but the creative aspect is different. Using theater makeup, you can completely transform the way a person looks. In addition, people are a lot easier to pose than plants, so the opportunity for getting interesting shapes is vastly better with people than with plants.

ADD SOME HUMOR

The easiest thing to forget when you are neck deep in shutter times, exposures, focusing, lighting, and directing a model is that this is about having some fun! It is hard work to get everything right, but some playful experimentation is never amiss. The definite king of this is Allan Teger. His Bodyscapes photographs are some of the most creative instances of macro portraiture I've ever seen.

note For more inspiration on Bodyscapes, or if you would like to buy prints of Teger's unique photos, check out his Web site at www. bodyscapes.com.

Using bodies as landscapes for photography offers the possibility of expressing someone's personality in a unique way: by using their body as the base of one of their hobbies or to illustrate a personality trait. An expectant mother can be shown with a stork (9-15), an avid cyclist (9-16) can be transformed to the landscape she loves, and if you are photographing a woman who loves fishing, why not transform her body into a fishing pond (9-17)?

The possibilities are limitless, and I'd highly recommend you have a go at making some of your own people-as-landscape photographs — if only to make a rainy day pass while having some fun!

ABOUT THESE PHOTOS *Allan Teger's Bodyscapes raise the bar on creative approaches to macro portraiture.*

9-15

9-16

9-17

Assignment

Less is More

For this assignment, take a macro portrait of a person. The photo has to convey an emotion or state of mind. Try to show as little as possible of the model and still get the message across. Take some time to think about the approach you take with your model so you can get the best results and then post that favorite photo to the Web site.

For my solution to this assignment, I went back to the same model as shown in 9-8. She's a video and installation artist, and frequently has strong opinions on matters. As a macro assignment, I wanted to try and capture some of her creative and elusive characteristics.

In this photo, I love how her green ring, contrasting wonderfully with her red hair, along with the clenched fist and the obscured face come together to illustrate at least part of her personality. I also like how the high ISO (800) adds a lot of grain to the image. This helps give the photo a grittier look. I took the photo with a Sigma 17-35mm f/2.8 lens, 1/3 sec., f/4.0 at ISO 800.

Don't forget to go to www.pwsbooks.com when you complete this assignment so you can share your best photo and see what other readers have come up with for this assignment. You can also post and read comments, encouraging suggestions, and feedback.

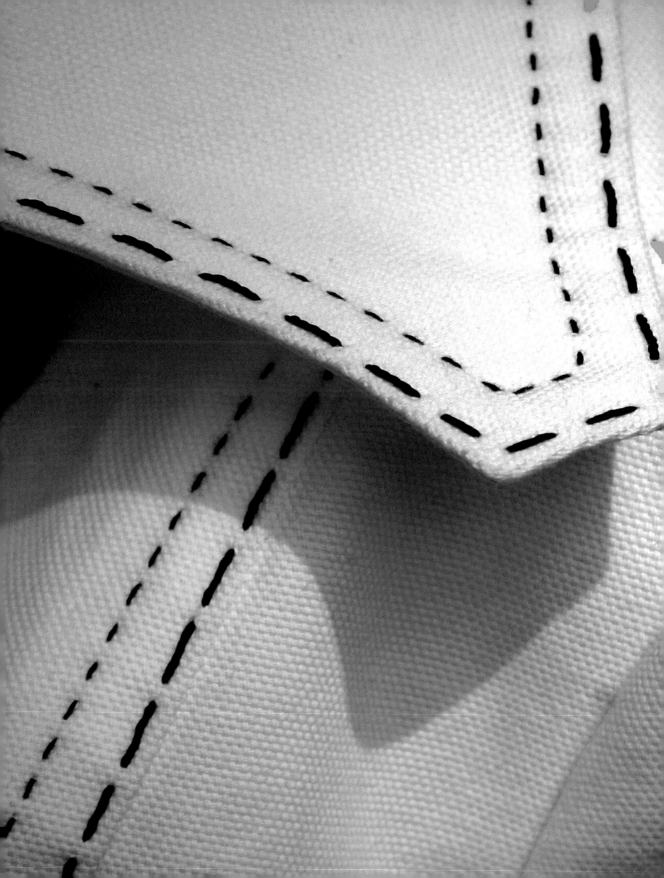

A lot of the focus in this book has been on creating photos. There is no doubt that shutter times, lenses, tripods, and ISO speeds are important to get right. After all, you want the best possible ingredients for the final result. However, over the years of working with digital photography, I have grown to realize that the photos themselves are merely starting points for greatness. A photo that is unintentionally out of focus, excessively motion-blurry, or grossly over-exposed is never a work of art. See 10-1 for an example of a photo that's beyond reprieve despite excessive work in Photoshop trying to rescue it.

In the era before digital photography, a frame of film was the starting block for what happens during developing and copying. By over- or under-developing film on purpose, you can create a variety of effects. By using different grades of paper when printing, you can increase and decrease the contrast of a photo. By using bleach or burning tools, you can lighten or darken part of a photo. I'm sharing all of this to get a simple point across. Working on a photo in the digital darkroom isn't cheating! It's a tool, similar to the dark room of days gone by, that you can use to finish a process that starts in a camera and ends on your wall, on a Web site, or as a file on your computer, stored away for viewing at a later time.

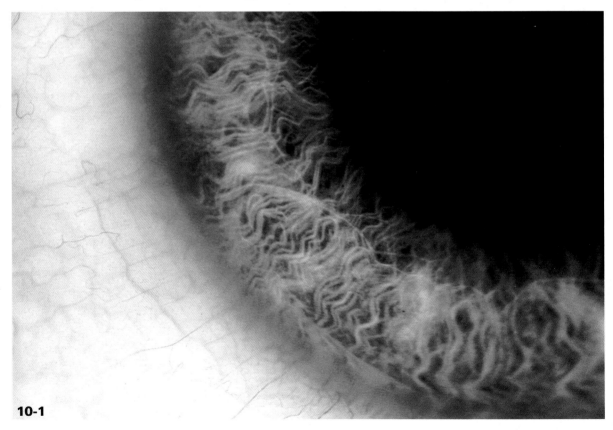

10-1

ABOUT THIS PHOTO *Getting close to someone's eye can be tricky. If you don't get it right, the photos are useless. Taken with a Canon MP65-E macro lens and a MT-24EX Macro Twin Lite flash. 1/90 sec., f/9.0 at ISO 100.*

BUILDING A DIGITAL DARKROOM

I've mentioned in this book that photography can be an expensive hobby, and the digital darkroom component certainly sounds like a rather pricy outfit. Although my own equipment is on the high-end range of digital imaging equipment, you don't have to rob a bank to build a digital darkroom. Provided you already have a computer, putting together a digital darkroom doesn't have to be that expensive.

YOUR COMPUTER

The most important part of your darkroom is your computer. Luckily, it's quite likely that the computer you have is either usable or upgradeable into something that can be used to work on digital photographs.

Although the general rule for choosing an image-editing computer is the faster the better, you can get away with using just about any computer for digital image manipulation. In fact, if you bought your computer in the last three years, chances are it's good enough to use to create your digital darkroom. Any computer with Windows XP or Mac OS X installed should do the trick. It is also possible to use Linux, but if you're computer-savvy enough to have that installed, you're probably wasting your time reading about building your digital darkroom and you can safely skip ahead!

As long as your computer is reasonably recent (any computer newer than Pentium III or Apple G3), you shouldn't have to worry too much about processor speeds. A faster processor means that stuff happens faster, but if you're just getting started and you've got a bit of patience, 500-600 MHz is perfectly acceptable.

The computer you use for digital image manipulation needs a lot of hard drive space. You should, at all times, have about 5-6 GB of free hard drive space to support your work and storage needs. External hard drives are dropping in price rapidly nowadays, and it is possible to buy 250 GB relatively inexpensively. If you're serious about your digital photography, I suggest buying two identical external drives. Use one to store your work, and back up all your data to the other one at regular intervals. Your digital photo files are the equivalent of film negatives. Imagine how you might feel if you lost them all!

The last aspect about the computer itself is the Random Access Memory (RAM). You need lots of it — the more the better. Anything over 512 MB should be good enough, although 1 GB or more is preferable. The reason you need so much RAM is that you are working on large files that demand a lot of processing. Storing information in RAM is vastly faster than storing it on the hard drive, and if you run out of RAM, your computer uses the hard drive as virtual memory. This means that whatever you do on your computer slows down to a crawl, and it takes all the fun out of photo editing.

Finally, you need a good monitor. Both CRT (Cathode Ray Tube — the television-style computer screen) and LCD (Liquid Crystal Display — the thinner monitors known as "flat screens") monitors are useable, but make sure that the color balance and contrast of your screen are correctly calibrated. Otherwise, your photos look different from the way other people see them, and you're back to square one. To find out how to calibrate your monitor, check your monitor's user manual or search the Web for "set screen contrast" or "monitor calibration."

MY DIGITAL DARKROOM SETUP As I work as a photographer, people often ask me what I use as my digital darkroom. You might be surprised by the answer. When I bought the equipment, it was all top-notch, and I haven't felt the need to upgrade. So, it is old hat by today's standards. However, my current setup works perfectly for the workflow I have adopted.

I use a Power Mac G5 Dual 2GHz computer which has two 2.0 GHz G5 processors, 2 GB of RAM, and 320 MB of internal hard drives. I also have a total of 1TB (1 terabyte is 1000 GB, which, in turn, is equal to one million MB) of external hard drives that I use for various projects and as backup discs. I also installed an 18x DVD-R writer, because I frequently store backups of my work on DVDs and was getting tired of waiting for 30 minutes for a DVD to finish writing. My monitor is a 19-inch flat panel screen running on 1280×1024 resolution and is connected to my computer via the DVI digital connector to maximize signal quality and color reproduction. In terms of software, I use Adobe Photoshop.

YOUR SOFTWARE

There is a lot of image-editing software out there, but I can't talk about software without starting with Adobe Photoshop. The first version of Photoshop was launched in 1990 and revolutionized the way photographers worked. Since its launch, it has been through several changes and expansions. The current version is part of the Adobe Creative Suite 3 and is known as Adobe Photoshop CS3.

Photoshop is a fantastic piece of software because it can do just about anything you can think about doing to a photo. However, the full version of the software is aimed at professional photographers, designers, and artists and is rather expensive (U.S. $600 or so). It is also incredibly baffling to new users, because there are usually a handful of different ways to do exactly the same thing. There are five or six different ways to turn a photo into black and white. There are five ways to crop an image. There are a dozen different ways to change the colors in a photo. This flexibility is great for the professionals, of course, but if you don't know where to begin, it can be frustrating. There is no denying that Photoshop is a tool that is far too powerful for beginners.

The makers of Photoshop realized that their full version was too clever for its own good and created a stripped-down version that's much more user-friendly for photographers and beginners: Adobe Photoshop Elements. Priced at about $100 and retaining the most important features for photographers, it is an absolute bargain. Most of the screenshots in this book are from Photoshop Elements.

Another option available to you is a free, open-source image-editing solution called Gimp (GNU Image Manipulation Program), which you can download from the Internet (www.gimp.org). Its biggest strength is the fact that it is completely free. It has many of the same functions as Photoshop and is available for Mac, Windows, and Linux. Personally, I never felt comfortable in the user interface offered by Gimp, but if you're on a tight budget, you might as well try it and see if you like it.

UNDERSTANDING WHAT ALL THE BUTTONS DO

This chapter isn't meant to be an exhaustive tutorial on how to use Photoshop Elements, but more designed to help you understand the basic tools in most image editing programs and how you can use them to improve and finesse the results of your macro photography.

If you have never worked with Photoshop Elements before, here's a quick run-down of some of the different tools and how they work. You can see the tool palette in figure 10-2. If you are using a different piece of software, these tools may vary slightly, but most programs designed for image editing have a similar set of basic tools.

First, a pair of quick tips to make working with the tools a bit easier:

■ **All tools that have a tiny arrow on the bottom right have more tools hidden under them.** Generally, all the tools are grouped logically; so, if you need a Circular Selection tool, it's hidden away underneath the square selection tool. When you move your cursor over a tool in the tool bar, the name of the tool appears (a *tooltip*). To switch from one tool to another, just click and hold the arrow button on the tool in your tool palette. A small menu pops up so you can pick a different tool from that group.

■ **If you want to select a tool quickly, use the keyboard shortcut by pressing the letter on your keyboard that corresponds to the tool.** This letter is displayed when you hover over the tool. For example, press M to display the Marquee tool and for the Lasso tool, press L. If you want to select a variation of the Marquee tool, press M on your keyboard, then press shift+M to cycle through the available tools

10-2

ABOUT THIS FIGURE
This is the tool palette you use in Adobe Photoshop Elements.

(the same ones you see when you open the menu from the small arrow). How can you remember all of this? Just look for the full name of the tool and the letter when the cursor hovers over the tool!

BASIC TOOLS

Tools I've placed in this category are tools you will likely use more often than others.

- **Move tool.** The Move tool (V) is shaped as a pair of crossed arrows and a little arrow. It is one of the main tools in Photoshop Elements. You use this tool to move *layers* (a way of stacking different image elements on top of each other. This is one of the most powerful ways of working with photographs in Photoshop and Photoshop Elements) in relation to each other, and to move text.

- **Zoom tool.** The Zoom tool (Z) is pretty straightforward. Select the tool, and then click inside your image to zoom in. You can also select an area of your picture (for example, somebody's eye) with the Zoom tool to zoom to your selection. Hold Alt/Option and click the Zoom tool on your image to zoom out. And, if you double click the Zoom button, it zooms to 100 percent.

- **Hand tool.** The Hand tool (space bar) is used for looking around the page. Instead of using the scroll bars on the right and bottom of your screen, with the Hand tool, you can grab the document and move it around your screen, much like you can do with a piece of paper. This tool is particularly useful if you are zoomed in on a selection of a large document. You can temporarily change to the Hand tool by pressing and holding your space bar.

 t i p

> If you hold the shift key while moving something or pulling out a box, it moves in a straight line or creates a symmetrical shape.

SELECTION TOOLS

The most important tools when working with photography are the selection tools.

- **Marquee tools.** Photoshop Elements calls its selection tool the Marquee tool, and it's signified by default with a dotted square in your tool palette. With this tool, you make selections in your image, allowing you to change things in small parts of the image, copy, paste, and so on. If you open the menu from the Marquee tool, you find the Square and Elliptical Marquee tools.

- **Lasso tools.** For more flexible selections, you want to use the Lasso tool (which looks like a little lasso). This tool allows you to make selections that are of any shape. Essentially, you draw a freehand shape, which turns into a selection when you let go of the mouse button. There is also the Polygonal Lasso tool, which does the same thing, except that it allows you to make selections using straight lines instead of a free-hand drawing. By using the Lasso tool and feathering your selection (right-click/⌘+click on your selection and choose Feather), you can darken portions of your image. If done subtly, it can really make the foreground of a photo stand out. Photos 10-3 through 10-5 are examples of what a 250-pixel feathered selection and use of the Levels tool can do to improve an image. The Levels tool is discussed in further detail later, but, essentially it allows you to control the brightness and contrast of the image.

ABOUT THESE
PHOTOS *10-3 isn't bad, but
the background lacks focus. By
using the Lasso tool (10-4), you
can do a rough selection of the
background, feather (blur) the
edges, and darken the back-
ground to bring out the subject.
Photo by Matthieu Collomp.*

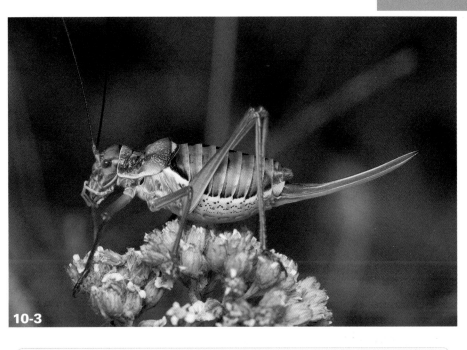

10-3

10-4

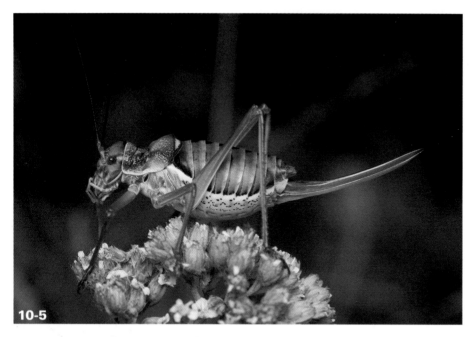

10-5

Among the Lasso tools, you also find the Magnetic Lasso tool, which tries, on its own, to select portions of the image by following the contours of whatever you are trying to select. This is useful on high-contrast pictures.

■ **Eyedropper tool.** To select colors, you want the Eyedropper tool (I). It is a very useful tool. You can use it to select a color anywhere in your image. When you are working with a tool that outputs color (painting tools, text tools, and so on), holding the Alt/option key produces an Eyedropper tool, so you can rese-lect a color.

ADDING AND REMOVING STUFF

Tools that I use to add and remove elements from my photos are included here.

■ **Crop tool.** One tool you will use often is the Crop tool (C). Use the Crop tool to make a selection, and then rotate the crop marks to outline the way in which you want the image cropped. Then, double-click on the selection you've made to crop the photo. Cropping photos ruthlessly is often a great way to improve the impact of a particular photo-graph quite drastically. Compare 10-6 and 10-7, for example.

> ⓟ *note* You can also use the crop tool to rotate images.

10-6

ABOUT THESE PHOTOS *Don't be shy about cropping photos rather drastically — unusual shapes and tight crops can vastly improve the impact of a photograph.*

10-7

Similar to the Marquee tool, you can use the Crop tool in fixed *aspect ratios* (the relation between the height and width of an image). If you want to print your photos out on photo paper later, for example, you can choose to keep the 3:2 or 4:3 aspect ratio your camera outputs.

■ **Clone Stamp tool.** If you want to replace one area of an image with another, you can use the Clone Stamp tool. It's kind of like a paint brush. Use this tool to paint over one area of an image with another part of the image. This can be useful to cover up areas you are less happy with — specks of dust, for example. The Clone Stamp is a powerful tool, but it can be difficult to get natural-looking results.

■ **Spot Healing tool.** The Spot Healing tool is similar to the Clone Stamp tool, but it is far more sophisticated. It's extremely useful for editing out small blemishes in an image. With the Spot Healing tool, if you have small blemishes (acne on somebody's face or

some dust on your imaging sensor, for example) in your photo, you can select them and just paint over them. Photoshop Elements then calculates what it thinks the area should have looked like, based on the immediately surrounding areas.

- **Healing tool.** The Healing tool is a combination of the Spot Healing and Clone Stamp tools. You select what you want the software to use as a source for the replacement, and then paint over the problem areas. Photoshop then calculates the highlights and color to match the surroundings of the target area.

- **Brush tool.** The Brush tool is just what it says, and it does what you would expect of a painting tool. The Brush tool can be used for airbrushing out blemishes on somebody's skin or for more artistic purposes — painting in skies or adding color to areas of an image that need a bit more impact. Keep in mind, however, that Photoshop is for editing pictures, not for drawing or painting. If you need several painting tools, consider *Corel Painter* or a similar drawing package instead. If you need precision drawing, use a *vector graphics* package, such as Adobe Illustrator.

- **Paint Bucket tool and Gradient tool.** I placed these two together in my explanation because the Paint Bucket and Gradient tools are made for filling areas of a picture with a single color or gradient. The tools are used for making evenly colored (or gradient) backgrounds.

- **Dodge tool, Burn tool, and Sponge tool.** Other tools that it makes sense to discuss together are these three tools. The Dodge, Burn, and Sponge tools are interesting tools with brush characteristics. Dodging an image turns it lighter in a part of the image. Burning the image makes it darker. The Sponge tool

desaturates or removes the color from an area of your image. These tools and related techniques are great for accentuating parts of an image through *retouching* it (editing a limited area of a photo).

- **Blur tool, Sharpen, and Smudge tools.** There are many other tools in Photoshop and Photoshop Elements. However, the final set of tools I want to highlight are the Sharpness tools. Sharpness tools include the Blur, Sharpen, and Smudge tools. As their names suggest, Blur and Sharpen are spot tools for blurring and sharpening portions of the image, respectively. I find that the Smudge tool has little use in the world of photo editing, but it simulates what happens if you drag your finger through a wet paint version of your photo.

FIXING COMMON ISSUES IN MACRO PHOTOS

A photograph is only as good as its source materials. If you know what you are doing, and if you have the right software, there is a lot you can do to improve substandard photos. However, spending time fixing silly problems in the darkroom is a waste of time. You really have to get it right the first time. Clutter on the ground behind your photo is easy to remove digitally, but it is easier to just pick it up and move it by hand before you take the photo. Dust on your subject, on your lenses, or inside your camera falls in the same category. It can all be fixed, but it takes a lot of time for no reason. The message is: Try to start with the best possible source material!

Having said that, there are several issues you can solve, and a lot of creative things you can do in the digital darkroom that you can't do any other way. Let's begin...

EXPOSURE

The way you choose your exposure is one of the biggest differences between film and digital photography. When photographing with film, you want your shadows to be as detailed as possible. Because of this, my high school photography teacher would drone on about "Expose for the shadows; develop for the highlights." Digital photography changed this: Perhaps surprisingly, a digital imaging chip works much like slide film does. The more an area is exposed, the brighter it gets — up to a point. Beyond this point, you get burnt out or *overexposed* images, where a larger area of the image is pure white. This is because your exposure has gone beyond its *dynamic range* (the range in which an imaging chip can capture data). An example appears in 10-8, the bottom right of the image is overexposed.

If you think of an imaging chip as a continuous light meter gauge (which it is, essentially), burn out is where the light meter has gone off the scale. If you have problems visualizing overexposure, try this: If you are pouring water into a 1 oz measuring cup, when it is full, the cup still contains 1 oz, even if your entire kitchen floor is full of water. The measuring cup, like the light meter, can only measure to its highest point. Then, any additional water (or light) is added on without being appropriately accounted for. See 10-9 for how overexposure looks on a *histogram*.

In short, if you overexpose an image by accident, there isn't a lot you can do. Because your photo is overexposed, you start losing details in your burnt out areas — details you can't easily re-create. Your photo is ruined, and you have to start over again.

ABOUT THIS PHOTO
This image is overexposed, and there isn't much you can do to rescue it because the image is out of the camera's dynamic range. You can tell this by the spike to the far right of the histogram shown in 10-9.

10-8

10-9

ABOUT THIS FIGURE *Here, the histogram for the image shown in 10-8 shows the overexposure, indicated by the spike to the far right.*

If your photo is *underexposed*, it's an entirely different matter. The way you can tell a photo is underexposed is that the photo is dark or it may be lacking in contrast, as in 10-10. Although overexposed photos are beyond rescue, underexposure can be helped to a degree. The best way to do this in Photoshop Elements is to choose Enhance ⇨ Adjust Lighting ⇨ Levels, or press Ctrl+L/⌘+L.

The resulting dialog box takes some getting used to, but after you understand how it works, you won't know how you survived without it. The Levels tool shows a histogram of the presence of the brightness of the pixels in your photo. Left is perfect pitch black, and right is complete, perfect white. The vertical read-outs show how much data there is for each brightness value: A large

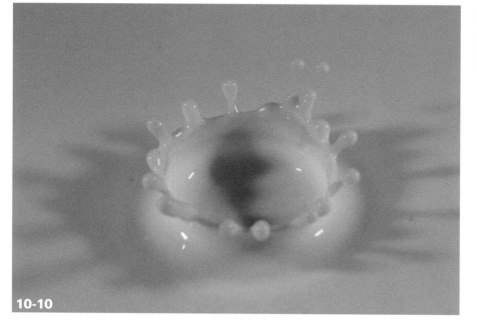

10-10

ABOUT THIS PHOTO
This photo is one of the droplet photos that didn't make it into an earlier chapter because it was too underexposed, lacking contrast.

spike to the far right of a histogram graph is over-exposure. A heavy bias toward the left of the graph can indicate underexposure — but not always! If your photo looks good, don't adjust it to be brighter just because a graph tells you that you should.

As you can see from the histogram in 10-11, this particular image has a lot of image data in the middle, but none toward the outer edges of the space. This means that there are no burnt-out areas, but no completely black areas either. It isn't a prerequisite for a good photograph to use the full breadth of the dynamic range. That is some-thing you have to determine on a case-by-case basis. However, the vast majority of photos need a healthy amount of contrast to look good.

To fully exploit the shadows in an image like this, make sure that the darkest areas of the image are fully black. To do this, click and drag the left-most slider (known as the black point slider) toward the part of the graph where the curve starts going up, as shown in 10-12.

If you go into the curve, you intentionally cut off some of the dark areas, which means you go out of the dynamic range on the dark end of the scale, something that can even be used with great dramatic effect for some photos.

CONTRAST

In the previous section, you looked at the Levels control to darken the shadow areas of a photo-graph. Image 10-13 is the resulting edited image. It is a good start, but the photo is obviously off-balance. To rebalance it, you have to increase the bright areas. You can use the levels to bring out the detail in the shadow parts of your photos. The histogram in 10-14 illustrates the changes. You'll be amazed at the amount of detail hidden there. Just open a few of your photos and play with all three of the sliders.

As shown, the leftmost black point slider discards dark tone information from an image. The right-most slider (known as the white point slider)

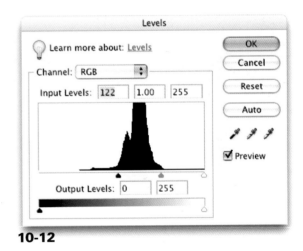

10-11

ABOUT THIS FIGURE *This is the Levels histogram for photo 10-10.*

10-12

ABOUT THIS FIGURE *Adjust the slider to increase the level of black in the photo.*

10-13

10-14

ABOUT THIS FIGURE *Adjusting the highlight slider brings out the details in the shadowed areas of the image.*

discards light tone information, and the middle midtone slider can be used to induce a bias toward bright or dark photos. I could write pages and pages on the intricacies of what each slider does and how best to use it, but the quickest way to learn is to open a few of your own photos in Photoshop Elements and play around with them. Through trial and error you quickly learn what each slider does and how you can manipulate them to improve your photographs.

If I adjust the white point slider on the image in this sequence, I'd get the image shown in 10-15 — it is completely different from what you started with. It isn't the greatest of photos, but at least it is dramatic and interesting! If you take a look at the histogram in 10-16, you can see that I've edited the image to use the full dynamic range.

ABOUT THIS PHOTO
By adjusting the white point slider, you get a much improved photo.

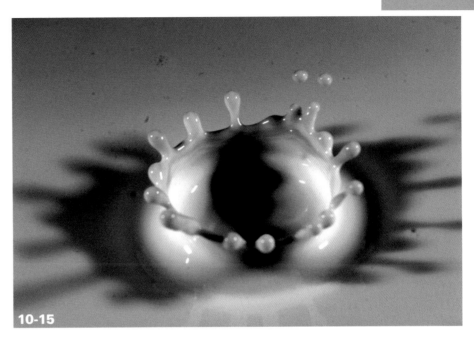

10-15

10-16

ABOUT THIS FIGURE *The resulting histogram illustrates that the edits use a full dynamic range.*

I'm hesitant to generalize on these matters, but out of experience, I don't think I've ever taken a single photo that didn't benefit from some adjusting with the Levels tool. That isn't to say that unadjusted photos are bad, just that even if small tweaks are needed, the photo always comes out better with a smidgen of adjustment. For example, you might remember 10-17 from an earlier chapter. I nearly discarded this photograph because it didn't look very interesting. However, I decided to play around with it anyway — to see if there was anything to be done. It turned out that the image was a lot sharper than I had first thought. After it had been fine-tuned in Photoshop, it was good enough to be used in this book. The only adjustments that were made to that photo before it was ready to be printed were stripping off all color information (there wasn't much to begin with) and increasing the contrast. From a bland image I was ready to throw away to a publish-worthy image (10-18) in half a dozen mouse clicks isn't too shabby!

10-17

10-18

WHITE BALANCE AND COLOR TINTS

If you've played with the settings of your camera, you have probably come across the term *white balance*. This is a setting you can change to tell the camera the light temperature of what you are trying to photograph.

Note that digital cameras don't capture white balance. They simply capture the light that comes through the lens. The white balance is calculated later, based on the measurements the camera has done (in the case of automatic white balance), or what you have told the camera to apply to the image. If you are shooting in RAW mode, the camera stores all available information and leaves the white balance calculation to your computer and the digital darkroom.

Why do cameras need white balance? You need to tell the camera what temperature the light is because the human eye is remarkably adept at adjusting to different lighting conditions, but the camera is not. Regardless of whether you're in a room filled with candles or with light-saving fluorescent light bulbs, you can still identify a white

piece of paper, despite the fact that the candle light has a very warm quality and the fluorescent light has a greenish-blue tint to it. Cameras, however, can't adapt in the same way, which is why they need to be told what is "white."

Digital cameras are getting better at automatically detecting the color balance of a scene, but sometimes, your camera is wrong. As a result, you're stuck with a photo that is excellent, but has a nasty color tint in one direction or another. Normally, you can spot this by the fact that your images look either too warm (red tint) or too cool (blue tint). See 10-19 and 10-20 for examples of problems with white balance.

Luckily, white balance is relatively simple to fix using image-editing software. In full versions of Photoshop, you have about a dozen different ways of correcting colors. In Photoshop Elements, the number of ways is a lot more manageable. Newer versions of Photoshop Elements have become extremely clever at this and have a Remove Color Cast tool.

ABOUT THESE PHOTOS
These images are the same photo with two different color balances applied. 10-19 is too blue and cold, whereas 10-20 is pretty close to neutral.

UNDERSTANDING LIGHT TEMPERATURE

Light temperature is based on a measurement used in physics called black body radiation. Imagine heating a pane of black metal. The color of the metal is dependent on the temperature to which it is heated. This is related to the phrases "red hot" or "white hot" when referring to metal.

In digital photography, light temperatures are measured on the *Kelvin (K) scale*. Confusingly enough, colors people normally perceive as being warm are at the lower end of the scale, whereas colder colors (such as daylight and the blue tint of televisions and lightning bolts) are toward the higher end of the scale. Here are some standard color temperatures:

- Lit match: 1,700K
- Regular lightbulb: 2,800K
- Daylight: 5,500K
- Flash units: 5,500K
- High intensity discharge lights in new cars: 6,500K
- Lightning bolt: 25,000K

A lit match has a color temperature of around 1,700K, a regular lightbulb is around 2,800K, daylight and photographic electronic flash units are around 5,500K, high intensity headlight lights found in new cars are around 6,500K, and a lightning bolt is around 25,000K.

Obviously, color temperature is not a measure of the physical temperature of the light source, but the measurement is relevant in terms of how your camera perceives the ambient color of light.

Open an image that is not quite where you want it to be. Choose Enhance ⇨ Adjust Color ⇨ Remove Color Cast. A dialog box opens giving you some detail about the tool, and when you place your cursor over the image, it appears as an Eyedropper tool. All you have to do is select a section of the photograph that should have been a neutral gray but isn't. To find an area which is neutral gray, just look closely. Can you see anywhere that looks like it doesn't have a color cast? When you select the neutral gray, Photoshop Elements recalculates the colors based on your selection, rectifying the color cast.

It's a clever system when it works, and it can save you a lot of time. Sadly, many photos don't actually have any areas that are supposed to be neutral gray, and the tool has a tendency to overcompensate for any errors. The only way to get it right, then, is to do it yourself. The easiest way to get some manual control over what is happening is to use Color Variations. To find this function, choose Enhance ⇨ Adjust Color ⇨ Color Variations. A Color Variations dialog box opens that has your photo on it several times (see 10-21). It gives you the option to increase or

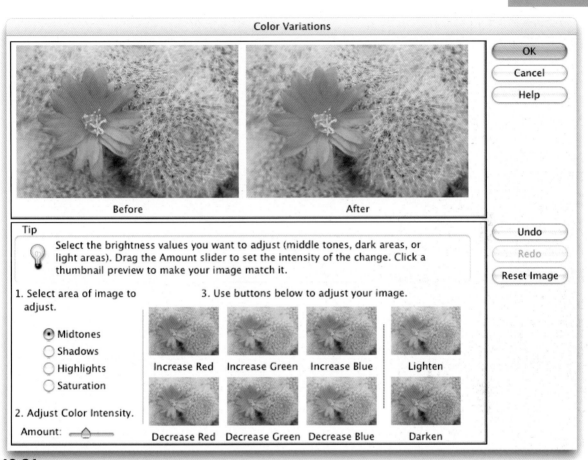

10-21

ABOUT THIS FIGURE *The Color Variations dialog box in Photoshop Elements.*

decrease each of the *color channels* (red, green, or blue) and to adjust the brightness of the photo.

The Color Variations tool is self-explanatory, but keep in mind that there's a slider for "Amount." Instead of making drastic changes, consider moving the slider a little bit to the left. This reduces the impact of each variation you make to the image, and is handy for fine-tuning your image.

If you are a proper control freak (and you should be because these are your photos at stake after all), you can go into the full nitty-gritty of tweaking colors and color casts with a utility you encountered previously in this chapter — the Levels control! When you open the Levels tool (Enhance ➪ Adjust Lighting ➪ Levels or press Ctrl+L/⌘ +L), there is a drop-down menu that

reads RGB. When RGB is selected, your changes affect all three color channels equally. You can, however, set it to Red, Green, or Blue separately — and make adjustments to your heart's content. See 10-22 and 10-23 for examples of what the individual channels of the same image might look like.

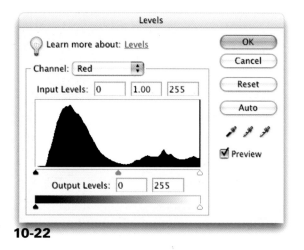

10-22

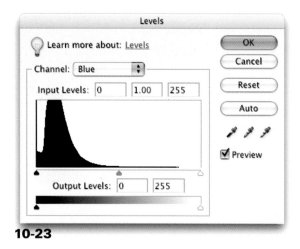

10-23

ABOUT THESE FIGURES *If you're particularly picky, you can adjust the color values of each channel separately using the Levels tool. See how different the red and blue channels are?*

tip If you want to get more advanced in your color balance adjustments, you can use the Curves tool to enhance your control. For this tool, however, you need the full version of Photoshop. Use of this tool is beyond the scope of this book, but if you have the full Photoshop suite, search the Internet for "Photoshop" and "curves" to get you started!

SHALLOW DEPTH OF FIELD

Shallow depth of field is a problem that is introduced at the photo-capture stage. In other words, when you click the shutter, it's too late. However, there is a unique way to compensate for poor DOF when working in the darkroom: Combining several photos into one!

If you have a subject that doesn't move, such as a flower, it is possible to gain some DOF by taking a photo of the subject and then changing the focus so another element of the photograph is in focus. Take a photo with this focus and repeat this process as many times as necessary. You then layer the photos one over the other. The technique works very well. Photo 10-24 is a single photo out of a series. Photo 10-25 shows you how the combined photo looks. Have you ever seen such an amazing depth of field and sharpness?

It helps to visualize your DOF as a slice of image that you can capture closely, like a slice out of a loaf of bread. Now, all you need to do is to take photos to cover enough slices of the area you need.

10-24

10-25

ABOUT THESE PHOTOS *10-24 shows a single photo out of a "stack." Photo 10-25 has been processed by Helicon Focus to combine a series of these photos into one. Photos courtesy of Helicon.*

Although it is possible in theory to do this kind of work by hand in Photoshop Elements, it takes a lot of time and is a challenge to even the most advanced image-editing aficionados. If you're a Windows user, you're in luck. There are several software packages that do the processing for you. *Helicon Focus* (http://helicon.com.ua/pages/) is the most well-known of these. It allows you to stack an unlimited number of photos (see 10-26).

There have been examples of people stacking more than 100 different focus planes into a single photo with absolutely stunning results. You can purchase a full version for around $70. This version includes high-tech functionality and allows more tweaking of your final photos. A light version with less powerful functionality is also available for around $30.

10-26

ABOUT THIS FIGURE *HeliconFocus is easy to use, as it helps you along every step of the way. It is also supremely powerful and renders gorgeous results.*

RETOUCHING IMAGES

You're a busy photographer, life is short, and you are impatient. The result of this is that your lenses are dirty, your backgrounds are cluttered, and you don't always have time to get the foreground looking exactly the way you want. Not to worry, there is help at hand.

So far in this chapter, I have written predominately about image manipulations that take care of the whole image at once. Color balance manipulations, cropping, DOF, exposure, and contrast are generally all applied to the whole photograph at once. All these techniques are useful when working with photos. However, there are many situations where you want to work with only a small sub-section of the image. This technique is known as *retouching*.

Retouching is especially applicable in macro photography because a lot of the things you photograph are so small that they are difficult or impossible to clean. ("Hi there, Mr. Bee, you have a dust particle in your eye and it's screwing up my photo. Would you mind if I... HEY YOU STUNG ME!") In addition, when you are working with macro photography, switching lenses and lens accessories comes with the territory. The result of this is that you get dust gathering on your lenses and on your imaging chip. That can really affect the quality of your photos. See 10-27 to find out what dust can do to a clean shot. So, you have to clean up your photos after they have been shot.

With the tools outlined earlier in this chapter, it is easy to do corrections to your photos, like

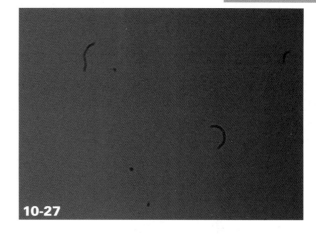

10-27

ABOUT THIS PHOTO *Dust on your imaging sensor is particularly visible on even-colored, light surfaces and can ruin a photo, unless you fix the problem in an image-editing package. Oh and get your camera cleaned, too.*

removing dust. You've probably spotted that the droplet photo that I use throughout this chapter has a lot of rather annoying dust marks on it — especially in the increased-contrast version shown in 10-15. That is because the inside of my camera was distinctly filthy at this point — a result of not cleaning my camera properly when I was taking photos in a field full of flowers and pollen.

To clear away all the dark dots, I can use the Spot Healing Brush to paint directly over the affected areas. Photoshop Elements recalculates what it thinks the area should look like and usually gets it right. It takes a bit of patience to get all the imperfections (there's a lot of dust inside that camera; I've since had it cleaned, don't worry), but it's not difficult, and the whole process took about 10 minutes at the most — see 10-28 through 10-30 for the examples.

10-28

10-30

10-29

ABOUT THESE FIGURES *Dust and annoying objects, such as those in 10-28, can be easily removed by just painting over them with the spot healing brush, as I did in 10-29. The result, shown in 10-30, is far cleaner.*

To complete this photo, I gave it an unconventional crop. Using the same technique as when editing the spots of dust, I decided to edit out the highlights caused by the flash units as well. You can see my result in 10-31.

The final manipulation needed to make our starting image a truly magnificent one was to strip out all the colors off the photo by clicking on Enhance, then Adjust color, and finally, Remove Color. The end result? Figure 10-32.

> ⓟ *tip* If you are interested in exploring advanced Photoshop techniques further, why not check out the *Photoshop Bible*, written by Laurie Ulrich Fuller (ISBN 978-0-470-11541-1)? It's a big book, but it'll teach you everything you ever wanted to know!

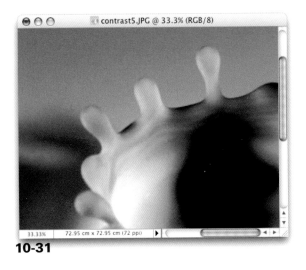

10-31

ABOUT THIS FIGURE *You can use the Healing Brush to remove any element from an image. In this case, I cut out the burnt-out high-lights on the edges of the droplet.*

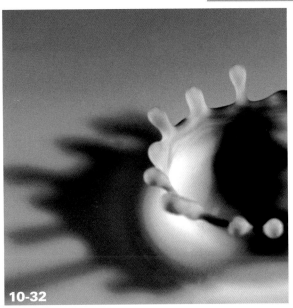

10-32

ABOUT THIS PHOTO *You can see the result of stripping out the color. I used the Remove Color tool in Photoshop Elements.*

PHOTOGRAPHING IN RAW FORMAT

All digital SLR cameras — and many digital compacts — have a RAW setting for saving the image files. This setting means that every one of your image files will be several megabytes in size. Although the file sizes are quite large, they offer a great number of advantages.

The biggest advantage of RAW is that you are taking the camera's decisions out of the equation. When you save your image as a JPEG, the camera takes a series of things into consideration before it saves the photo, all of which degrade the image

quality from an image manipulation point of view. When a digital camera saves a JPEG file, it applies sharpening, color balance, color satura-tion, contrast, and several other parameters to the photo. The RAW format allows you to make all those decisions yourself, on your computer.

If you can live with having space for fewer photos on your memory cards and the fact that processing times on your computer are vastly increased (even very fast computers are challenged by the extra pro-cessing power required to decipher and manipulate high-resolution RAW camera files), there's no excuse to shoot in anything but RAW.

USING HIGH-LEVEL DIGITAL EDITING TECHNIQUES

After you start to get the hang of things with Photoshop Elements, you might want to consider graduating to a full version of Photoshop. Although you can do a lot with Elements, the full versions offer a whole new level of control, and dozens upon dozens of new tools. Don't worry though, after you master Photoshop Elements, you won't be baffled by the full version of Photoshop. It's similar, but just more professional with more ways of doing the same things.

When you are working with photography, it is hard to tell where photographs stop and digital art begins. Some photographers feel this is cheating when you do more with a photo than you can do in a conventional darkroom. I understand where they are coming from; however, photography is ultimately about creating the best-looking photos possible in my opinion, based on using the tools you have at hand. If those tools happen to be computer software, well, so be it.

To illustrate what is possible, I've asked for some help from Jasmin Junger. She isn't a photographer or a graphical artist; she calls herself a "photo manipulator" or "compositioning artist," which essentially means she combines several photos to create new artworks. She does this by using Photoshop's extremely powerful layers, which allow a photo editor to use different blending modes to combine different images in different ways.

If you want to use textures to give your macro pictures an extra spark, choosing the right picture to work with is essential. If the picture itself already is a texture, it is hard to add to that in a way that doesn't destroy the picture altogether. Also, adding textures to black and white pictures might prove difficult because of their usually high contrast.

Just to give you a taste of what can be done with some relatively simple compositing and painting tools, I've chosen a photo from an earlier chapter and asked Jasmin to walk us through how it can be improved. Don't worry if you don't quite understand it yet — it's mostly meant to be an illustration of what is possible.

Image 10-33 is a perfect candidate for improvement by adding texturing. The image draws its contrast from the colors and not from contrasting brightness. This is important because to add texture to this photo, you use the advanced layer blending mode called "Soft Light." This blending mode doesn't work too well on white or black areas.

Jasmin started by choosing some photographs of rust. These photos were added in separate layers on top of the image of the flower. The new layers block the view of the flower underneath. To combine them in an artistic fashion, changing the layer blend mode to Soft Light resulted in a beautiful texture.

By using the selection tools, Jasmin deleted the part of the rust image that she didn't want to cover the flower itself — in this case, mainly the flower itself and the upper portion of the canvas.

For the rest of the photo, Jasmin used another layer — a photograph of water drops on plastic foil. Adding them to a separate layer and adjusting the blend mode, Jasmin added further grittiness to the photo.

The finishing touches were done using a soft brush, brushing with black on a new layer set to Soft Light to give some shadowed areas (specifically, at the edge of the canvas and to the right of the flower) as well as using the same technique but with a white brush for highlighted areas (on the flower and above). By combining photographs, Photoshop, and a bit of good old-fashioned painting techniques, Jasmin managed

to transform 10-33 into the rather stunning 10-34. The photo illustrates what an incredible difference Photoshop can make to a photograph. If you're new to Photoshop, it's probably far too complicated for now, but don't give up: You'll pick up new tricks as you get used to the software, and there are a lot of excellent tutorials and books out there that can teach you the ropes!

ABOUT THIS PHOTO
This original photograph is the canvas for your introduction to Jasmin's Photoshop Magic.

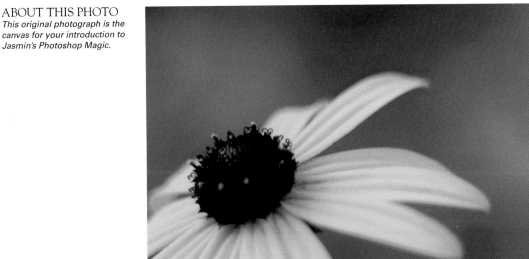

10-33

ABOUT THIS PHOTO
This photo illustrates what an incredible difference Photoshop can make to a photograph.

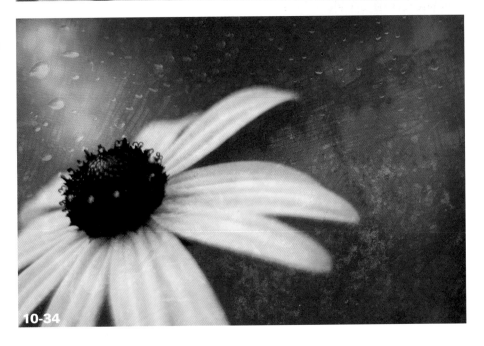

10-34

Assignment

It Doesn't Matter if It's Black or White... As Long as It's Both!

Take one of your photos from an assignment in a previous chapter, and turn it into a black and white piece of art. Choose carefully so you get the best shadows and highlights — something that has a lot of contrast as a color photo will have the best results. However, ultimately, choose something that you like and post your before and after images to the Web site.

I decided to use the photo from figure 5-2 as the basis for my assignment. I turned it into black and white by using the Photoshop Elements Desaturation tool (Ctrl+Shift+J/⌘+SHIFT+U), and subsequently adjusted the contrast by using the Levels tool.

I like the final result on this assignment image because it makes the flower look unnatural and alien. The bright background combined with the strangely monotone flower means that something doesn't look quite right, and it causes the viewer to do a double take to find out what's actually going on. Call it my twisted sense of humor, but any photo that gets looked at a second time to discover what's going on is worth it to me!

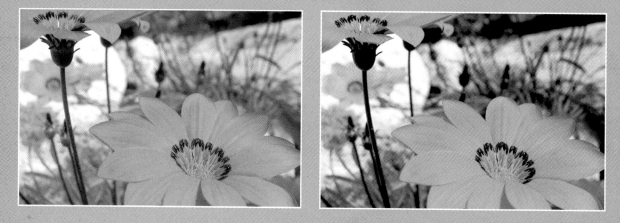

Don't forget to go to www.pwsbooks.com when you complete this assignment so you can share your best photo and see what other readers have come up with for this assignment. You can also post and read comments, encouraging suggestions, and feedback.

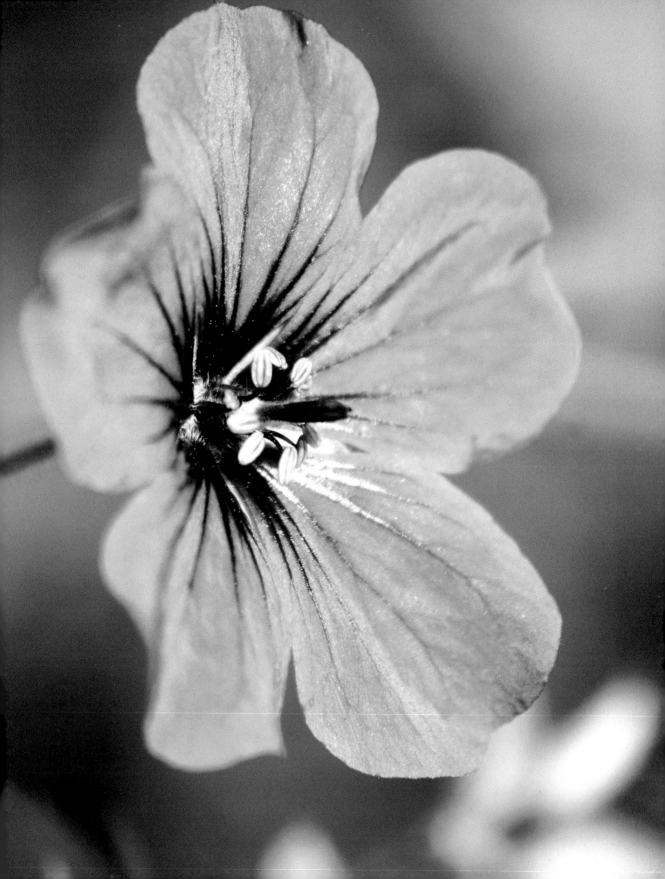

INTERNET RESOURCES

PHOTOGRAPHY COMMUNITIES

LEARNING MORE ABOUT PHOTOGRAPHY

STAYING CURRENT

As you improve your grasp of macro photography, your photographic senses and instincts take over, and this book can become more of a source of inspiration than a source of knowledge. You'll start inventing your own tricks to achieve certain photos and will be well on your way to becoming a world-famous photographer — or at least one who can confidently create a macro reproduction of a quality that surpasses the photos in this book.

Perhaps you now give away some of your prints to your friends and family as birthday and Christmas gifts. You might have sold a few images commercially. Your local bar might have a massive print of one of your photographs hanging over the bar. Or perhaps you're just a living legend among your Internet buddies, who compulsively check your *Flickr* or *DeviantArt* accounts in the hope that you've posted your next stroke of photographic genius.

Either way, after you've outgrown your masters, it's time to find new ones. Although you might struggle to find anything quite as brilliant as this book, you can do a lot worse than checking out some of the following Web sites. There are a lot of phenomenal photographers out there, and the best way to develop your skills is to learn from your peers!

PHOTOGRAPHY COMMUNITIES

There are surprisingly few Web sites that cater specifically to macro photography. There are, however, some excellent resources that are parts of other sites. One of the best ways to learn is to join a community of other photographers. Web 2.0 has become the most despicable buzz words of the current millennium, but the concepts of user-generated content and online community sites are some of the best things that have happened to photography since someone discovered that silver halides react to light, and thus invented modern photography.

PHOTO.NET

Philip Greenspun's Photo.net (www.photo.net) is an excellent Web site in general and is one of the first photography Web sites to be created on the Internet. It was founded in 1993, only a few years after the World Wide Web was invented. At www.photo.net/learn/macro/primer, they look at some of the ground already examined in this book, but the real strength of Photo.net is its extremely active forums. A large number of highly talented photographers frequent the forums, and if you have any questions about any photography topic, this is a good place to turn.

PHOTOWORKSHOP.COM

In many ways, the Photoworkshop.com (www. photoworkshop.com) Web site is one of the new kids on the block. At the same time, it started off by hitting a homerun. The site is one of the most potent learning resources for budding photographers. While most professional-level photographers don't have the time to hang out on Internet communities, Photoworkshop.com is in the enviable position of attracting some of the big names in photography. You can find a whole range of experts, from the dyed-in-the-wool, old-school photographer who refuses to give up slide photography to some of the hottest new digital studio photographers to grace the earth.

Visiting Photoworkshop.com is as much an overall learning experience as a way to get fantastic feedback on your photography, enter competitions against other photographers, and pick up thousands of tips and tricks on just about every photographic topic you could imagine!

FLICKR

Flickr (www.flickr.com) started off mostly as an image-sharing Web site, but it has since grown into so much more. It's now a massive community of amateur and professional photographers alike, covering just about any type of content you can imagine.

The Web site works by allowing people to tag their photographs with words or phrases. This means that it's a brilliant tool for finding photographic content. Type *macro* into the Flickr search box, for example, and you get well over half a million photographs in return. Keying in *insect macro* gives you over 50,000 photos to choose from.

Needless to say, as far as inspiration goes, Flickr is a fantastic resource, but that doesn't take into account the number of functions the Web site offers you. Tagging, leaving comments on a photo — or just on parts of a photo — and the option of joining or creating groups with people who enjoy the same types of photography as you do are just some of the other opportunities the site provides. My best advice is to create a Flickr account for yourself and start exploring! To get you started, add me to your Flickr friends: www.flickr.com/people/photocritic.

DEVIANTART

Deviant Art (www.deviantart.com) is known as "dA" among friends, and has been around since 2000. Although it is an older site, it is one of the strongest arts communities on the Internet. The site currently has more than 1.5 million users and over 30 million submitted pieces of art of varying quality. It caters to all sorts of visual and written arts, but photography is heavily represented.

Where Flickr seems to be aiming mostly at offering a place to post and share your photographs with friends quickly and easily, DeviantArt is aimed more strongly toward people who take photos for art's sake. The community is outfitted to be an efficient way of asking for — and giving — critiques on photographs. There are quite a few talented macro photographers on dA, and the number of great all-around snappers is downright humbling. It's a great place to get some feedback and to learn!

PHOTOSIG

PhotoSIG (www.photosig.com) is a photo criticism site, implementing quite a few of the functions found in DeviantArt and Photoworkshop. Sadly, they implemented a rating system that seems to bring out the worst in people and tends to turn the site into a massive popularity contest. Having said that, there are some rather talented photographers who post their work on PhotoSIG. The fact that you can read the comments other photographers have left means that you can indulge in the most effective way of learning known to man: Learning from *someone else's* mistakes!

DIGITAL PHOTO CHALLENGE

Digital Photo Challenge (www.dpchallenge.com), also known as DPChallenge or DPC, is a photo critique site with a difference. It is based around the general idea of a series of challenges. The challenges are presented with a time limit for submissions. Photographers have to take the photos for the challenge between the time that the challenge is announced and its closing date, which can be as much as a month, or as little as 24 hours later. Because of the strong limitations imposed on photographers, DPC can be used as a learning tool. Forcing yourself to submit an entry to every challenge is a quick way to increase your breadth as a photographer. The relatively in-depth comments you receive on your challenge entries

also provide you with feedback that can help you further develop.

DPChallenge isn't for everyone, but if you like its restrictive format, it can be your way to improve as a photographer and get a gauge for what other photographers like and dislike.

LEARNING MORE ABOUT PHOTOGRAPHY

There are a lot of Web sites on the Internet that are dedicated to doing a bit-by-bit introduction to various photography topics. Some sites are called *photoblogs*, which revolve largely around posting a photo a day (or whenever the blog maintainers feel like it), rather than using text to convey a message. Other resources are pure news resources and examine what's going on in the world of photography, while still others are learning and exploration resources. Most Internet resources fall somewhere in-between these categories.

STROBIST

Photography is nothing without lighting. That was established back in Chapter 3. However, this book merely touches on the surface of all the exciting things you can do with creative lighting options. If you want to go deeper, go to Strobist (www.strobist.blogspot.com), which is a site dedicated to getting the most out of flashes and flash photography

EXPOSURE

Michelle Jones's Exposure blog (www.michelle jones.net/exposure/) is one of those rare Internet sites where you can follow the ebbs and flows of what happens when a talented photographer spends a lot of time on the Internet. While many other blogs have a tendency to copy each other

quite heavily in terms of subject matter and what is the cool thing of the moment, Exposure moves in its own ways. Frequently interesting and always well-written, it's worth adding to your RSS feed reader.

FOUND PHOTOGRAPHY

Every now and again you come across a site where every single article just makes sense. Adrian Hanft's Found Photography (www.foundphotography.com/PhotoThoughts) is such a resource. Follow in the footsteps of Hanft; he is a graphic designer by day who takes steps to expand his love for photography with the rest of his time. Amazing stuff.

MATT GREER PHOTOGRAPHY

Not all photographers focus exclusively on the art of photography itself. Matt Greer (www.mgreerphoto.blogspot.com) is a writer who has a gift of explaining Photoshop in words that even my mother would be able to understand — and not just the simple stuff either. This site is definitely worth checking out!

PHOTOJOJO

If you're into keeping track of the funky, exciting side of photography, Photojojo (www.photojojo.com) is a good bet. At its core, it is a newsletter that is guaranteed to bring a smile to your face, but it also has a fine blog (www.photojojo.com/content). The guys running it have a phenomenal skill at finding all the quirky, inexpensive, and cheerful ways of spicing up your photography life.

PHOTOCRITIC.ORG

Finally, I'm going to use the opportunity to plug my own site, www.photocritic.org. It seems to have taken up a rather unique position on the

Internet, in that it allows me — and a few select guest bloggers — to talk about subjects that interest us. The blog is quite heavily do-it-yourself based, with a show-and-tell approach to photographic techniques. The blog started off being purely about DIY, but has since evolved into a "whatever I darn well want to write about" type blog. It currently has well over a hundred entries on all sorts of photographic topics, including quite a few on macro photography, of course!

STAYING CURRENT

If you have more time than sense, you might want to stay on top of everything that moves in the world of photography. As someone who used to run a photography news site, I would like to plead with you: Don't fall to that temptation! The loss of sanity quickly follows anyone who tries to keep tabs on all that scurries. Having said that, there's nothing that impresses people quite like someone who knows everything, so here goes nothing...

DIGITAL PHOTO REVIEW

If you've been on the Internet searching for information on cameras, you've probably stumbled across Phil Askey's marvelous DPReview (www.dpreview.com). It is, or should be, your first port of call for any digital photography reviews and news. Oh, and it has a pretty useful set of forums, too!

PHOTOGRAPHY BLOG

The wildly imaginatively named Photography Blog (www.photographyblog.com) is a commercial blog that keeps track of everything photography related. Personally, I find the art of photography more interesting than knowing about every new gadget that's launched, but if you are a gadget-head, Photography Blog should probably be your first stop.

LIVINGROOM PHOTO BLOG

Rather similar to the Photography Blog, Darren Rowse's Livingroom (http://livingroom.org.au/photolog) is obsessive about tracking the developments and news in the world of photographic technology.

CONTRIBUTING PHOTOGRAPHERS

ANNA BADLEY

DANIELA BOWKER

KATHARINA BUTZ

MATTHIEU COLLOMP

MIHA GROBOVSEK

JASMIN JUNGER

AMY LANE

CHRIS NERING

HILARY QUINN

ALLAN TEGER

Do you know how many photos went into this book? I didn't either. I lost count at Chapter 1, and that was only part one of a dozen or so chapters. I have a massive library of photographs, and a lot of it was macro photography, but my taste in photography is angled toward high-contrast black and white photography and using unique framing and cropping on my photos. In other words, using only my own photos would give a rather skewed image of what is possible, stylistically, with macro photography.

To bring some balance to the table (or book, if you will), I approached several of my friends and colleagues — people I've worked with in the past, or people whose work I have admired from a distance for a while. The photographers listed here have all allowed me to use their work in this book. Without them, the book would have been impossible. I owe them more thanks than simple words can convey, but I hope they'll call in a favor from me at some time in the future. Folks, I owe you one.

I present the admirable contributors to you here in alphabetical order.

ANNA BADLEY

Anna Badley works for Oxford University and is an avid amateur photographer. I've known Anna for about as long as she has been taking macro photos. She keeps reminding me of how much fun it is to explore new photographic avenues. Applying her natural curiosity, patience, and creativity, she has been the guinea pig for a lot of the material examined in this book, learning new skills and offering valuable feedback at an incredible pace. See figure AB-1 for an example of her work.

For her macro work, Anna uses a Canon EOS 350D with a Sigma 70-300 macro lens or a reversed 50mm prime lens. Her photos are used in Chapter 5.

Check out Anna's work on www.evelynzee. deviantart.com.

AB-1

ABOUT THIS PHOTO
Wedding rings. Anna Badley has a rare talent of spotting photography opportunities where others don't see anything special.

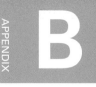

DANIELA BOWKER

Daniela is a PhD student and a teacher based in Bristol, UK. She is an amateur photographer who only recently started working with macro work, but as figure AB-2 shows, she is already on her way. She has read large portions of this book before anybody else to find out if it makes sense in the slightest. As it turns out, it mostly does.

Daniela's photo is used in Chapter 1.

ABOUT THIS PHOTO
Eyes up close. Daniela Bowker's macro work is a diamond in the rough.

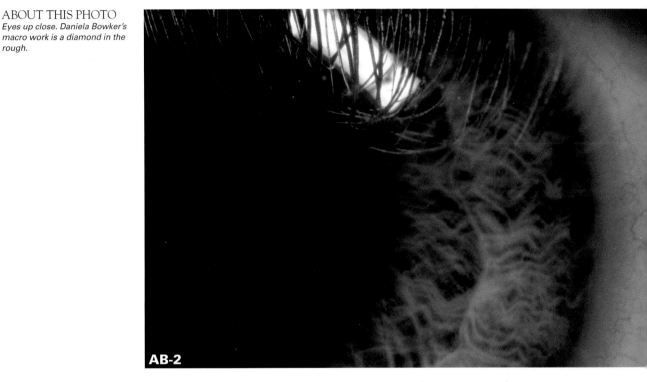

AB-2

KATHARINA BUTZ

Katharina is an amateur photographer based in Germany. She uses a variety of photographic equipment, but all the photos she has taken for this book were taken with a Canon Ixus 55 (known as Canon PowerShot SD450 in the U.S.) digital compact camera, set to macro mode. Rather than feeling limited by her photographic equipment, Katharina seems to see the limitations

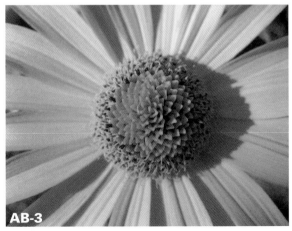

AB-3

ABOUT THIS PHOTO *Flowering talent. Katharina Butz proves that compact cameras are not a barrier: You can achieve great results even with relatively simple cameras!*

inherent to using a digital compact camera as a challenge, as figure AB-3 illustrates. The photos shown in this book and in her Flickr stream are almost defiantly good, in fact.

More of Katharina's work is available on www.flickr.com/photos/xatharina.

Katharina's photos are used in Chapters 3 and 7.

MATTHIEU COLLOMP

Quickly becoming one of my favorite photographers, Matthieu lives in the south of France. He hesitantly admits that he has only been taking photos for about two years, but not without pointing out that his new-found obsession has taken him into a brand new world. Check out figure AB-4 for an example of why being new to photography is a brilliant excuse to try new things.

Trying to explain his newly discovered fascination for macro photography, Matthieu says, "I like trying to photograph the invisible. All the things you can't see at first glance — a droplet of water hitting a surface, for example." Matthieu uses a Canon EOS 360D and Canon EF-S 60mm f/2.8 Macro USM lens for his macro photography work.

For more of Matthieu's work, check out his photography at www.flickr.com/photos/matth30 and his Deviant Art gallery at www.matth30.deviantart.com/gallery.

Matthieu's photos are used in Chapters 3, 7, and 10.

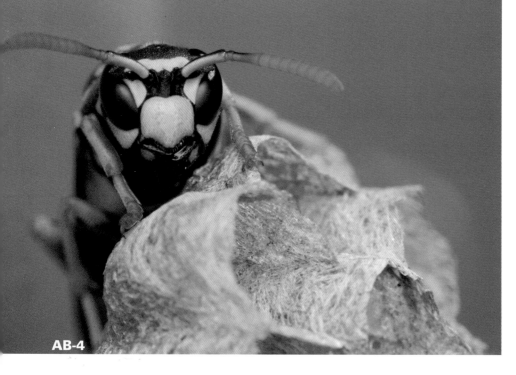

AB-4

ABOUT THIS PHOTO
Wasp on flower. Matthieu Collomp's photos are a testament to what you can pick up with a bit of determination and talent.

MIHA GROBOVSEK

Based in Vuzenica in Slovenia, Miha Grobovsek is a passionate amateur photographer who decided to give macro photography a try on a whim. He uses a Canon EOS 350D lens and takes his macro photos by reversing his Canon 55-200mm or Canon 50mm prime lenses against the camera body.

"Because I don't have an adapter," Miha explains, "I do all of the shots with the lens in one hand and the camera in the other." That is a technique that works perfectly fine — as illustrated in figure AB-5. However, if you're as butter-fingered as I am, check out Chapter 2 to learn more about reversal rings!

You can find more of Miha's photos on Flickr. Review his work at www.flickr.com/photos/zerox981.

Miha mainly contributed insect photographs to this book, and his photos are used in Chapters 2, 3, and 7.

JASMIN JUNGER

Rather than being a photographer, Jasmin classes herself as a photo manipulator. Her tool of the trade is Adobe Photoshop. Despite choosing an unconventional photo tool, she is highly respected among photographers for what she can do with photographs — check out figure AB-6 for an example.

Jasmin's contribution to Chapter 10 illustrates some of the things you can do in a digital dark-room to lift photographs to a new level.

You can find more of her work on www.kuschelirmel.deviantart.com/gallery. She is also responsible for the Photoshop Tutorials group (www.photoshop-tutorials.deviantart.com) on DeviantArt, which is a great starting point for learning more about advanced Photoshop techniques.

Jasmin's photos are used in Chapter 10.

ABOUT THIS PHOTO
Fly on Flower. Miha Grobovsek's insect photos are a reminder that you can take phenomenal macro photos without buying any additional equipment.

AB-5

AB-6

ABOUT THIS PHOTO *It is amazing what can be done in the digital darkroom, and Jasmin Junger's work is some of the best I've seen. For a full description of how it's done, check out Chapter 10!*

AMY LANE

Amy is an amateur photographer based in Swindon, UK. She is one of the few photographers contributing in this book who takes photos exclusively with an *SLR-like* camera. That is, she uses a camera that does have a lot of the characteristics you'd expect of an SLR camera (5 megapixel with a 12x image-stabilized optical zoom equivalent to 36–432mm on a *35mm* camera), but without the option of changing lens units.

Amy supplied several stunning macro photos taken with her Canon S2 for the book. Her work, as seen in figure AB-7, illustrates that you don't necessarily need a *dSLR* to take good macro photos.

"I'm still coming to grips with everything the camera can do," admits Amy, "but these things will come with time! I love taking photographs, and rarely leave the house without my camera."

You can see more of Amy's work at www.flickr.com/photos/emelia1502.

Amy's photos are used in Chapters 1, 2, 7, and 8.

AB-7

ABOUT THIS PHOTO *The bark of a tree. Simple composition, strong colors, and high impact — just like all of Amy Lane's photographs.*

CHRIS NERING

Like Miha, Chris is passionate about insect photography, and with the results he produces (see figure AB-8), who can blame him? Based on the quality of the photos, you might believe that he was a professional macro photographer working with ridiculously expensive equipment. In reality, he is a 23-year-old amateur photographer. His camera of choice is a Canon EOS D20 combined with a Canon 100mm macro lens and Kenko extension tubes.

A true inspiration to macro photographers, he has become a bit of a legend for his work on Flickr. It is certainly worth visiting his page to look at his photos if you're interested in getting some ideas for how to push the envelope on your macro insect work!

You can admire more of Chris's photography at www.flickr.com/photos/airbrontosaurus.

Chris's photos are used in Chapters 3 and 7.

ABOUT THIS PHOTO
Hello, Mr. Insect. Chris's macro photos are world class, yet taken with relatively inexpensive equipment. Visit his Flickr photo gallery for more of his excellent work.

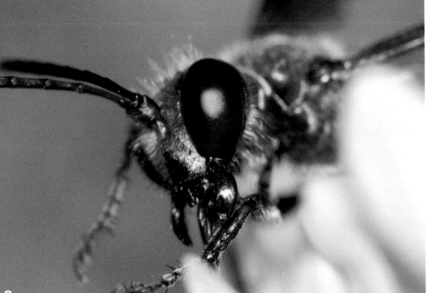
AB-8

HILARY QUINN

Hilary is a graphic designer based in Ireland who takes photos on an "as-and-when-needed" basis for work, but also takes photographs during her spare time. She started out in macro photography by using an old SLR lens, back-to-front to a 58mm prime on her Canon D350. The technique causes extremely heavy vignetting, but that's one of the reasons why I decided to use her photos in the book. As illustrated by figure AB-9, her photos show a completely different style of macro photography than my own.

She says, "The thing I love the most about macro photography is that you don't need an expensive lens to achieve it! I have seen photographers use magnifying glasses, homemade extension tubes, all kinds of things, to create a macro lens, and the results are so unusual and striking. Macro

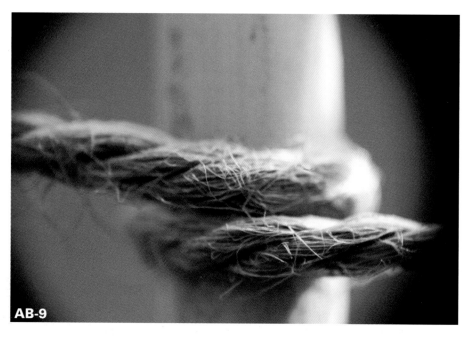

AB-9

photography is a very creative area, where new things can always be learned and new techniques and equipment discovered!"

You can see more of Hilary's photos at www.flickr.com/photos/hilaryaq, or on her Web site at www.draiochtwebdesign.com.

Hilary's photos are used in Chapters 1, 3, 7, 8, and 9.

ALLAN TEGER

One of my photographic heroes for a long time, Florida-based photographer Allan Teger's contributions to this book are some of the most creative works found in the world of macro photography (see figure AB-10). The novel idea of turning nude bodies into landscapes for a unique form of portraiture became vastly popular via his Bodyscapes Web site.

Interestingly, Teger didn't start the Bodyscapes project out of a love for photographing nudes, nor from a studio photography perspective.

"Self-taught as a photographer, I was originally trained as a social psychologist," he reveals. "As such, the Bodyscapes project actually evolved from my study of psychology. The theme that occupied my thoughts was one of multiple realities. I had read many accounts of adventures in mystical consciousness and was certain that the most basic concept to understand and accept is that two realities can exist simultaneously. Both can be correct even though each is different."

As such, in the mid-1970s, the Bodyscapes project was born. To learn more about Allan Teger, the amazing Bodyscapes project, and to see more photos from the series, visit the Bodyscapes Web site at www.bodyscapes.com.

Allan's photos are used in Chapter 9.

ABOUT THIS PHOTO
Fisherman. Some of my favorite macro photographs belong to Allan Teger's Bodyscapes project.

AB-10

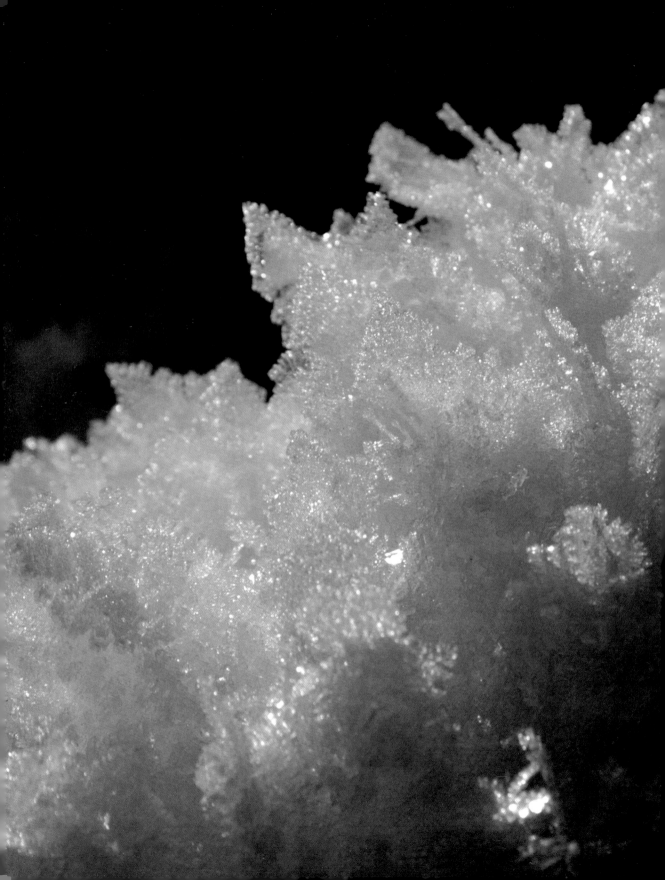

GLOSSARY

35mm film It is the standard film size, also known as 135 film. It is 35mm wide, and the individual film frames are 36mm × 24mm.

Adobe A software company whose products include Photoshop (for professional artists and photographers) and Photoshop Elements (for amateur or hobbyist photographers).

AEB A common abbreviation for auto exposure bracketing.

aperture Refers to the opening in the lens that allows light into the camera. When I refer to f-stops, I am talking about the size of the aperture.

aspect ratio The ratio between the width and height of an image. Traditional television has an aspect ratio of 4:3, 35mm film is 3:2, and wide-screen television is 16:9.

auto exposure Letting the light meter in the camera determine which shutter time and aperture should be used for a given scene.

auto exposure bracketing (AEB) When using AEB, the camera takes multiple photos in succession with slightly different exposure settings in an effort to hedge the photographer's bets against the camera's internal light meter measuring the lighting conditions incorrectly.

auto focus When using automatic focus, the subject in front of the camera lens is brought into focus by letting the camera determine when the subject is sharpest. Electric motors in the camera focus the lens.

backlighting Lighting a subject by placing it between the camera lens and the light source.

bayonet fitting A quick-release fitting that attaches a lens to a camera; it is common on all current SLR cameras. The alternative is a screw fitting, but most newer cameras have the bayonet fitting.

bellows A contraption made of dark cloth, rubber, or plastic that allows one lens element to move significantly in comparison to another. It aids in allowing the photographer to focus closer to the subject. See Chapter 2 for an extended discussion.

bokeh The shape and quality of the out-of-focus highlights in an image, usually in the background.

catch light A small dot of white in a person's eye. It gives the person in the photo a glint in the eye that, although not natural, often makes a photo look more natural than if it were omitted.

CCD chip A Charged Coupling Device chip is an imaging chip used in many digital cameras. It records the light that comes through the lens and replaces film. See also *CMOS chip*.

close-up filter A filter that screws into the threading of a lens. Essentially a magnifying lens that allows you to focus closer to a subject than you usually can.

CMOS chip A Complementary Metal-Oxide Semiconductor chip is an imaging chip used in many digital cameras. It records the light that comes through the lens and replaces film. See also *CCD chip*.

CMYK Stands for Cyan, Magenta, Yellow, and Key (black) — the four colors used in printers when reproducing photographs and other graphics. See also *RGB*.

color channel Information about the brightness of a single color. Digital cameras capture three color channels: red, green, and blue (RGB).

continuous lighting The opposite of flash lighting. Desk lamps, shop lights, and the sun are examples of continuous lighting.

contrast The difference between an image's brightest and darkest points are a manifestation

of the contrast of the image. The greater the difference, the higher the contrast.

Corel Painter A software package geared toward people who use their computer as if it were a canvas.

crop factor Because imaging chips in cameras are generally smaller than 35mm film, lenses made for SLR cameras take on different characteristics when mated with a dSLR camera. It appears that your images are cropped, thus the crop factor. For example, a 100mm lens becomes a 160mm lens on a camera that has a 1.6x crop factor like the Canon EOS Digital Rebel XTi. Or, a 75mm lens becomes a 113mm lens on a Nikon D50 with its 1.5x crop factor.

CRT Cathode Ray Tubes are an older technology used in televisions and computer monitors. The technology is rapidly being replaced by the much flatter and lighter LCD technology. See also *LCD*.

depth of field The amount of an image that is in focus is known as depth of field (DOF). Shallow DOF means little of the image is in focus, and deep DOF means more of the image is in focus.

diffuser A photography prop used to make light appear less harsh. See Chapter 2 for an extended discussion.

digital camera A camera that uses an imaging chip instead of film to capture a photograph.

digital darkroom A term referring to the act of using digital image manipulation software to retouch, adjust, and manipulate images, similar to what one does in a film darkroom.

digital zoom A form of zoom in which the camera crops or resizes your image after the photo has been taken. The more effective option for zoom is optical zoom. See also *optical zoom*.

diptych A way of presenting photos using two photos in the same frame. See also *triptych*.

directional light Light that comes from a particular direction — like direct sunlight or *flash* light — is known as directional light. See also *omnidirectional light*.

display On digital cameras, the display refers to the small LCD monitor on the back of the camera that allows you to preview your images.

dSLR A digital SLR camera. See *SLR*.

dynamic range The range of shades an imaging chip or film can capture between perfect black and pristine white.

exposure The combined settings of aperture, shutter time, and ISO setting used when taking a photograph is the exposure of that photograph.

exposure bracketing See *auto exposure bracketing*.

extension tube A mechanical device that allows a lens to be held securely in place a distance away from the camera body. It is used to extend the close focusing range of a lens. See also *bellows*.

fill flash The practice of using a flash to reduce heavy shadows or to highlight the foreground to make it stand out more compared to the background.

filter In photography, filters are generally glass items that screw into the front of a lens. They change the quality of the light. You can also apply software filters in a software package, such as Photoshop or Photoshop Elements.

fixed focus lens A lens that cannot change focal length. See *prime lens*.

flash A single-strobe light used in photography.

flash unit A highly portable *flash* system, often designed to attach to the *hot-shoe* of a camera.

focal distance See *focal length*.

focal length The distance light has to travel between the front lens element and the *film* or *imaging chip*; it is measured in millimeters.

focal plane An imagined plane where all points are in *focus* with a given lens.

focus The way to adjust a lens to concentrate light that provides a sharp image on the *imaging chip* or *film* of a camera.

focus bracketing To increase your chances of having your *subject* in *focus*, with focus bracketing you essentially hedge your bets. You can bracket your focus by taking three photos with a slightly different focus. Take one photo at what you believe is the correct focus, then take one slightly closer, and finally take a photo slightly farther away.

focusing screen A thin pane of ground glass found in *system cameras* that often have a micro-prism or a special grind pattern. Focusing screens geared toward *manual focusing* make it easier to determine whether the photographer has achieved perfect *focus* on the *subject*. Most modern *dSLR* cameras have simpler focusing screens that are harder to use for automatic focusing than the older split-screen style focusing screens.

Froogle A search engine based on price that was created by Google (froogle.google.com). It is good for finding good prices for photographic equipment.

golden hour The hour just after sunrise or just before sunset, named after the warm quality of the sunlight. This is usually a great time to take photos.

gray card A piece of plastic or cardboard that is calibrated to an exact 18 percent neutral gray. It allows you to do light measurements and white balance measurements.

grain See *noise*.

Helicon A software company that makes photographic software specifically for macro photography. See www.helicon.com.ua/pages.

histogram A histogram is a graph that represents exposure values. It is available in some cameras and in digital editing programs and can help troubleshoot exposure problems. See Chapter 10 for more information.

honeycomb filter A studio flash attachment for creating directional light. The filter is named after its honeycomb shape.

hot-shoe The metal connector on top of all *SLR* and some digital compact cameras that allows you to connect an external flash unit.

imaging chip A light-sensitive chip that converts light into electrical signals. An imaging chip is used instead of film in digital cameras.

incandescent light Light from lightbulbs.

installation Installation art in the context of photography is the practice of using photographs in settings that are unusual for artistic purposes. For example, projecting photographs onto a surface is often referred to as installation art.

JPEG A Joint Photographic Experts Group file is a lossy image file format. A lossy format loses detail as it saves the image. The file size is smaller than TIFF and RAW files, but due to its compression algorithms, subsequent open-edit-save procedures degrade the image quality. Most digital cameras can save images in JPEG format, as it is seen as a good trade-off between quality and file size.

layers A powerful way of working with photographs in an image editing program, it allows you to separate and stack different image elements on top of one another.

LCD A Liquid Crystal Display is often found on the back of digital cameras for framing and previewing images.

lens flare When light hits the front lens element you can sometimes see a lot of specks of light in a photo. You usually see a series of them in a row.

light tent A way of diffusing light and reducing reflections when working with macro photography in a studio. See Chapters 2 and 4 for more on light tents.

lossless A file format that does not lose detail regardless of the number of edits and saves performed. See also *TIFF*.

lossy A file format that loses detail as it saves the image. See also *JPEG*.

macro lens A lens built specifically to be sharpest at shorter *focal distances*.

macro mode A button on digital compact cameras that allows them to *focus* up close.

macro photography Taking photos of small things, or small areas of larger things, up close, generally with magnification factors between 1:2 (0.5x) and 5:1 (5x life-size). See Chapter 1 for more information.

manual focus Manually adjusting a lens by adjusting a focusing ring or by moving the whole camera closer or farther away from a subject in order to bring it into focus. This is in direct contrast to automatic focus.

medium format Medium format cameras are film-based photo cameras that use larger negatives than 35mm film.

memory card A card that holds the images you photograph. They come in different sizes, generally from 64MB to 8GB. They replace the storage element of film in digital cameras.

micro photography Taking pictures of things at high magnifications, usually with magnification factors of 5x life-size and higher.

mirror lock-up A technique in which the mirror in a dSLR camera tucks away before the photo is taken. This reduces the problem of mirror slap when you take a photo.

mirror slap In a dSLR camera, a mirror in front of the imaging sensor allows you to frame your photo through the viewfinder. When you take a photo, the mirror moves out of the way and gives the characteristic click sound of SLR cameras. When working with extreme macro photography, the mirror slap can cause vibrations. To avoid mirror slap, use mirror lock-up.

monopod A one-legged tripod used to stabilize a camera. Although using a monopod is better than photographing free-hand, it is not as good as using a tripod when you take a photo. See also *tripod*.

negative space The shape, location, and quality of everything that isn't the actual subject of the photo.

noise Digital noise in an image manifests itself as specks of brightness throughout the image. It is often prevalent at higher ISO settings and at long shutter times.

omnidirectional light In contrast to directional light, omnidirectional light comes from many directions at once, such as sunlight diffused through clouds.

optical zoom Zoom achieved by the use of optical elements in a zoom lens. The distinction exists because of the inclusion of digital zoom on many digital compact cameras.

Passepartout A cardboard sheet with a cutout that is placed under the glass in a photo frame. It prevents the photo from touching the glass and enhances the visual appeal of the photo.

photoblog A Web site where a photographer — or a group of photographers — posts favorite photos. Most photo-a-day sites are photoblogs.

Photoshop The industry-standard professional digital image manipulation package.

Photoshop Elements The easier to use and less expensive consumer version of Photoshop is called Photoshop Elements. See Chapter 10 for more information on software.

pixel Stands for picture element. A pixel is a single dot of color and brightness information. Camera resolutions are often measured in megapixels (mpx), which is an increment of one million pixels.

post production Everything that happens to a photograph after the shutter has closed; it includes in-camera processing, digital darkroom, and printing work.

prime lens A lens that has only a single focal length. These lenses are generally of high quality and low price, compared to their zoom lens counterparts. The most common focal lengths are 28mm, 50mm, 85mm, and 100mm. See also *zoom lens*.

RAW A lossless format like TIFF. Unlike other formats, RAW saves all the data available to the imaging chip, which means you have more raw photo data to work with in your digital darkroom. You cannot work directly with a RAW file; it must be converted — usually to TIFF or JPEG — before work on the image can begin.

reflector A photography prop used to reflect light.

retouching When working in an image-editing software package, retouching refers to manipulations done only to a part of an image, such as with a brush or another tool. In contrast, filters manipulate the image as the photo is being taken and generally affect the whole photograph at once.

reversal ring A ring that screws into the bayonet fitting of your camera and allows you to attach a lens by its threading. This mounts the lens on the camera in reverse. See Chapter 2 for more information on how to use reversal rings.

reversed lens Using a reversal ring to mount a lens back-to-front on the camera.

RGB The common abbreviation for Red, Green, and Blue, which are the three normal color channels used in digital image manipulation, sometimes referred to as color space. See also CMYK.

Rule of Thirds The theory that most important image elements should be along imaginary lines cutting an image into nine sections by using two each of imaginary horizontal and vertical lines.

shutter time The time that a shutter is open. Typical shutter times in macro photography range from 1/1000 second up to about 2 seconds.

SLR A Single Lens Reflex camera is a type of system camera that uses a single, interchangeable lens connected to a camera body. Focusing, framing, and measuring exposure are done through the lens. As you focus, you look through a prism and a mirror.

snoot A cone-shaped attachment with a hole in the end used for aiming light from studio flash light sources.

specular highlight A small dot of bright white on a subject, such as a catch light, usually from a reflected flash.

stacked lens Putting one lens in front of another. The front lens elements face each other. This technique allows for large magnification.

step-down ring See *stepping ring*.

step-up ring See *stepping ring*.

stepping ring To avoid buying the same filters or reversal rings for several lenses, buy stepping rings. These are filters without glass in them, and

with a different size thread on each side. A 52-55 stepping ring is known as a step-up ring. This screws into a 52mm lens thread and accepts a 55mm filter. Conversely, a 55-52 stepping ring is a step-down ring. The first number is always the number closest to the camera.

stone bag A triangular shaped piece of cloth suspended from the legs of your tripod. The cloth is filled with stones or other heavy objects and serves to stabilize the tripod.

system camera A type of camera that uses different types of lenses, flash units, and other accessories. The opposite of a system camera is a fixed-lens camera.

tele converter An accessory that fits between your lens and your camera body on a dSLR camera. It increases the focal length of the lens. A 100mm lens with a 2x tele converter becomes a 200mm lens.

threading adapter An adapter used on the front of a digital compact camera that allows it to accept filters and other attachments that need to be screwed into the front of a lens.

TIFF A Tagged Image File Format (also known as .tiff or .tif) file is a lossless image file. Because they retain the details of the images, they are larger in size than a JPEG file. You can save and open the file as many times as you like without degrading image quality.

tripod A three-legged stand used to stabilize a camera when taking photos. See also *monopod*.

triptych A way of presenting photographs: Three photos in the same frame.

TTL An abbreviation for Through The Lens. It is anything measured or viewed through the taking lens of the camera. With respect to flash technology, the camera measures the actual flash output as seen by the lens.

vignetting A creative technique in taking and editing images. Vignetting occurs when filters or lenses shield light along the corners of the frame. The only way to avoid it is to zoom in further (it lessens the effect of the vignetting), or by using step-up rings and bigger filters.

washing out This occurs when an over-exposed image has areas of white in it. These white areas are called washed out areas.

white balance A way to tell your camera which color is supposed to be white. White balance is set automatically by most cameras, but can be manually adjusted with some. See Chapter 10 for a more in-depth discussion on white balance.

white balance bracketing An in-camera setting that saves a captured image several times with several preset white balance settings. If you are worried about your white balance, it is generally a better idea to shoot your photographs in RAW format.

zoom lens A photographic lens that has more than one possible focal length, such as 28-100mm. A lens with a fixed focal length is known as a fixed focus lens or a prime lens. See also *prime lens*.

Develop your talent.

Go behind the lens with Wiley's Photo Workshop series, and learn the basics of how to shoot great photos from the start! Each full–color book provides clear instructions, ample photography examples, and end–of–chapter assignments that you can upload to pwsbooks.com for input from others.

978-0-470-11433-9

978-0-470-11876-4

978-0-470-11436-0

978-0-470-14785-6

978-0-470-11435-3

978-0-470-11955-6

For a complete list of Photo Workshop books, visit **photoworkshop.com**. This online resource is committed to providing an education in photography, where the quest for knowledge is fueled by inspiration.

Available wherever books are sold.

Now you know.